BRITISH
PREHISTORIC
ROCK ART

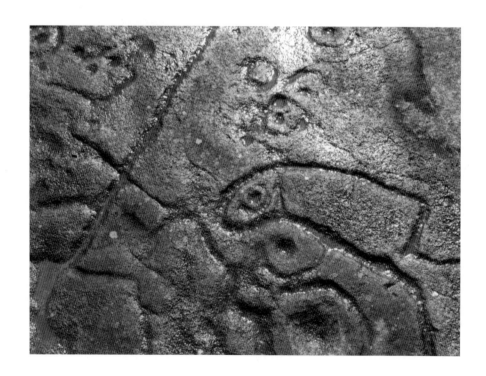

*This book is dedicated to
my wife, Jane, family and friends, and especially to our grandchildren:
Lauren, James, Caitlin, Michaela, Danielle, Helen and Georgia.*

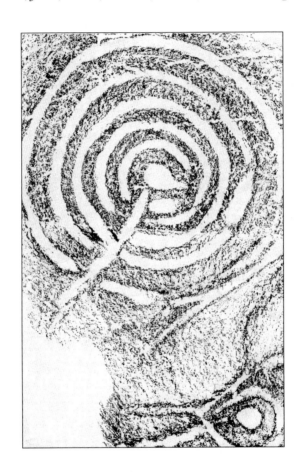

BRITISH
PREHISTORIC
ROCK ART

STAN BECKENSALL

TEMPUS

First published 1999.
First published in paperback 2002

PUBLISHED IN THE UNITED KINGDOM BY:
Tempus Publishing Ltd
The Mill, Brimscombe Port
Stroud, Gloucestershire GL5 2QG

PUBLISHED IN THE UNITED STATES OF AMERICA BY:
Tempus Publishing Inc.
2 Cumberland Street
Charleston, SC 29401

British Library Cataloguing in Publication Data.
A catalogue record for this book is available from the British Library.

ISBN 0 7524 2514 5

Typesetting and origination by Tempus Publishing.
PRINTED AND BOUND IN GREAT BRITAIN.

Contents

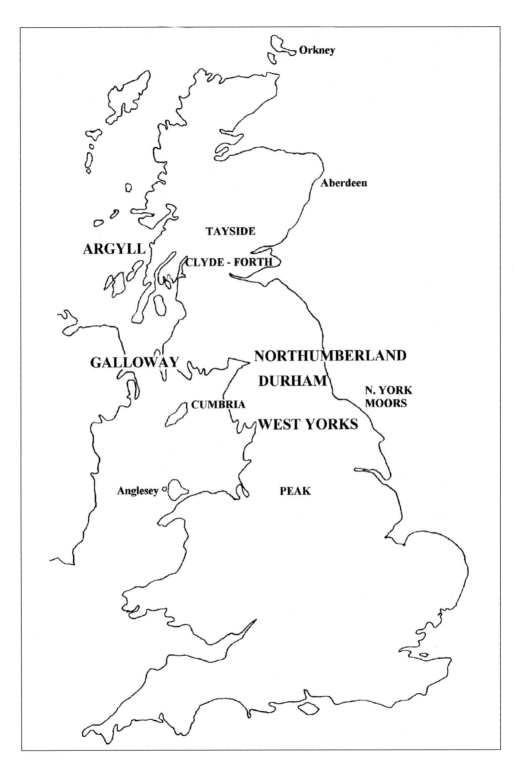

Orkney

Aberdeen

TAYSIDE

ARGYLL

CLYDE - FORTH

GALLOWAY

NORTHUMBERLAND

DURHAM

N. YORK
MOORS

CUMBRIA

WEST YORKS

Anglesey

PEAK

1 *Map of Britain, showing the main areas of rock art described in this book*

Introduction

A block of sandstone the size of a minicar loomed out of the mist. The top, sloping surface spread out its message as the mist lifted and the rock was sun-warmed. Deep shadows threw into relief a series of concentric rings around cups from which grooves ran down the rock. The effect was of inter-connection, fluidity that grew out of simplicity: cups and grooves were the symbols fashioned into motifs. This rock on Old Bewick Moor, Northumberland, commanded vistas of many kilometres, and smaller marked rocks shared its position.

I came here in the late 1960s after two years in Malta. What were the motives for the decoration of Mediterranean Megalithic temples with stone tools, in which tendrils and spirals played a large part, 5,000 years ago, and the symbols pecked onto outcrop and earthfast rocks and on some monuments in northern Britain and Eire? Who? Why? When?

Since then, some of my spare time has been spent in pursuit of answers, beginning with a search for new data. Like others before me, I had some vague hypothesis in mind, but I have many times changed my mind.

Once thought of as a purely Bronze Age phenomenon, it is now generally regarded as Neolithic, with a use over at least 1,000 years into the early Bronze Age. Its position in the landscape on 'living' and earthfast rock, mainly horizontal, opens it up to the sky. It is not found on the most fertile areas that would have been most attractive for arable farming, but in the upland, marginal areas of thinner, poorer soils that supported wild and domesticated animals — a food source that continued to be of prime importance even when arable farming intensified. Much of it 'signs the land' at the best viewpoints, often on ridges overlooking fertile valleys and plains. One imagines the pastoral nomads moving through well-known and well-marked territory, being able to see the migration of game from an advantageous height.

Tracing its location, taking into account changes in vegetation, allowing for destroyed panels of rock art and hidden ones, is part of the recording. Some were not exposed for long. Some motifs cannot be seen until you are almost on top of them, and people must have known where to look. We can sometimes predict where we might look for 'new' ones. Their locations may coincide with strikingly visible natural features, such as cliffs, but they don't give themselves away easily. And who knows what message they conveyed to which group of prehistoric people?

Some of the rock surfaces are large, like those at Achnabreck in Argyll, and some are small pieces of earthfast rocks carried by ice, such as those on Barningham Moor, Co. Durham.

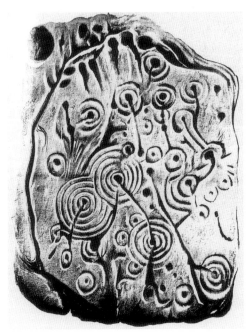

2 *Old Bewick. Bruce*

From such simple beginnings as a cup and groove, people who chipped their patterns were familiar with many common motifs, but others expressed some individuality. If you like, they shared the same language, but some were more articulate than others. Rosettes, radiates, multiple concentric rings, crowded motifs and well-spaced motifs are just a few variations on the theme. Spirals, much rarer, have their own mystery. What is really stunning is that almost all British rock art is abstract. This opens it up to people reading into it what they will, and leads to some unsubstantiated conjectures. Ronald Morris, a solicitor, listed 104 meanings and gave them marks out of ten!

Open-air motifs blend sympathetically with the landscape, and use surface irregularities on the rock in their design.

If all rock art were in the open air like this, we would find it very difficult, or impossible to date. It can be linked to a mobile way of life, that's all. But the motifs also appear on a small number of monuments; even then they can't be dated. Long Meg, for example, a tall pillar of red sandstone outside the portal entrance to a massive circle of volcanic standing stones in Cumbria, is covered in motifs. Whether or not this legendary witch, turned to stone for dancing with her daughters on the Sabbath, lay flat, or was part of a cliff, is unknown, but the raising of this huge stone creates a totally different impression from horizontal outcrop. The motifs are linear, spiral, concentric, half ovoid, some finished and others roughed-out, and include recent initials. The early motifs may have been added when the monument was erected, or much later; or Long Meg may have been brought to the site covered in decoration centuries ago. A spiral and lozenge-shapes have recently been recorded at Castlerigg stone circle. Rather plainer designs occur on standing stones in the Kilmartin valley. These examples are interesting, but at what stage they became part of the monuments is not known. That they are *there* means that they were clearly regarded as important to whatever rituals were enacted there.

What has always attracted people's attention is the presence of motifs on stones in a few early Bronze Age cairns. On close examination, however, it has been found that many of the decorated cist slabs were eroded before being inserted, and some were broken off larger surfaces. An example is an early Bronze Age cist at Balbirnie in Fife. In the Neolithic dateable tombs of Ireland's Boyne valley some decorated slabs were purpose-made, and others had been re-used. What we now make of the re-use of decorated surfaces taken from open-air art is that its purpose had changed.

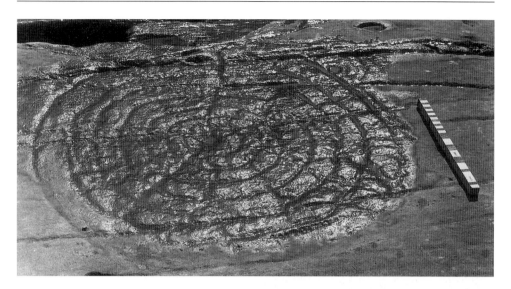

3 *Achnabreck, Argyll*

Whatever the meaning of these abstract designs, they eventually went out of use; it may be that their Neolithic symbolism was irrelevant to, and perhaps hopelessly incompatible with, the basic cosmology of the Bronze Age which gave rise to the interment of important individuals in single graves, or to the burial of several such individuals in the same mound. The fact that some early Bronze Age cists contain re-used panels of formerly open-air rock art, however, may represent the last vestiges of a belief system, at a time of change and probably of crisis in many ways, which still recognised the power of the old symbolism. It can, perhaps, be likened to the way in which in some Anglo-Saxon burials are clearly Christian, but hang on to some old pagan traditions.

It is beginning to be recognised that some decorated slabs were produced specially for the monuments in which they were discovered. In these cases, however, the decoration had been used in a way that suggests its meaning had changed — or was in the process of change. It was buried, often face-down, and no longer to be seen. An example is the recently-excavated cist at Witton Gilbert, near Durham, where the cover was purpose-built and decorated on two sides, the more elaborate cups and rings on the underside of the cover. Not only that, but two freshly-decorated stones were placed inside the cist.

Similarly, in the material used to build stone cairns, some stones are now being found with freshly-decorated cups and rings mostly face-downwards, like wreaths brought to a funeral. One such double-kerbed mound at Fowberry, Northumberland, was built on profusely-decorated outcrop rock. There are other round cairns on decorated surfaces that reinforce the significance of these places. Thus the motifs can continue to be used, perhaps for as long as hundreds of years, but in a different way and with a different meaning.

Northumberland has rock-shelters with motifs, but Food Vessel and Beaker burials in two of them could be later than the making of the motifs. Establishing a chronology for the motifs is very difficult.

I doubt whether we will ever know precisely what the symbols mean, whether some of the people who made the motifs were clear about their origins, and why the markings have so much in common with those, for example, in Galicia or California. We may speculate that the motifs may also have been tattooed on the skin, painted on wood, or woven into material, but these do not endure like stone. We know in part: we prophesy in part.

We are left with a precious and fragile heritage. What matters now is that what we have learned must be meticulously recorded, and that threats to the rock must be defined and brought under control.

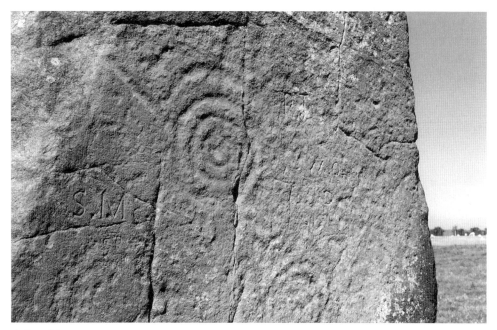

4 *Long Meg*

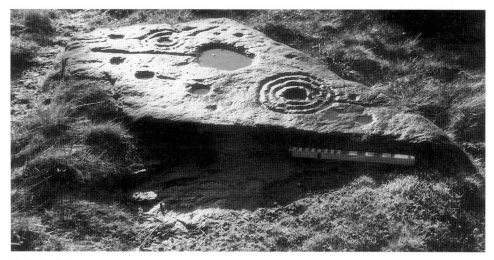

5 *Gayles Moor*

1 Symbols and motifs

A monument captures and stores meaning, and is meant to be enduring. Why is it that most of our prehistoric monuments are circular? Not only do we have records of over a thousand stone circles in Britain, but also there are circular ditched enclosures, embanked enclosures, circles of wooden posts, and thousands of round burial mounds.

There is something intrinsically satisfying about a circle. A group discussion where people are arranged in a circle proceeds differently from one in which people sit as though on a bus. The circle includes everyone and there is a sense of physical equality. The circle also excludes, but can allow an outsider to observe what is going on inside, provided that there are gaps or a place to see over the top.

The huge circle at Avebury is approached at one point by a winding avenue of stones that gives the traveller the maximum visual impact of the first sight of the huge ditch and bank that enclose a circle of standing stones that in turn encloses other stone settings. This is designed for maximum ritual impact. You can stand on the outer bank, look through stone settings to more stone settings, and have glimpses of rituals from which you may be excluded. On the inside, perhaps from a more privileged position, you look outwards. At Stonehenge the effect is quite different. From the Avenue approach your eye is drawn upward to the sky-piercing monoliths with a unique arrangement of supported curved horizontal blocks that enclose bluestones and trilithons that increase in height opposite the Avenue.

At Newgrange chambered tomb in Ireland the huge quartz-faced dome hides its mysteries from all who are not allowed to enter the narrow passage, to observe the sun funnelled through a box-opening above the entrance to strike the back of the chamber at a turning point of the year. It is like an orderly cave, rich in symbolism, mysterious, and looking into the earth.

Many of these ring-shaped structures have survived. Many have a high profile, and the interest in what they might be used for has grown. Burial mounds have attracted legends and curiosity, and although hundreds have disappeared, many remain.

The circle obviously is a symbol of great importance in Britain; its meaning may be much more complex than we realise or will ever know. Rock art makes use of a similar symbol, but its distribution depends upon the availability of suitable rock surfaces on which to chip decorations. Much of the south of England is excluded, despite the presence

of the giants of Avebury and Stonehenge. So is the Stanton Drew site, where the massive stone circles enclose even more spectacular rings of timber posts, only recently discovered by geophysical survey. Rock art on the stones of Stonehenge is confined to axes and a dagger, put there in an age of metal after the monoliths were erected.

The circle is the most common element in rock art; its simplest form is that of a *cup*, a circular depression chipped into the rock by a pointed tool that is harder than the 'canvas'. The people who first drew our attention to the phenomenon of rock art called the markings *cups and rings*, a fair description of many of them. Cups can be scattered apparently at random over a rock surface, and some become the focus of one or more rings. In such a central position, the cups may have grooves leading down the rock slope. *Grooves* can also be linear, curved, arranged in chevrons or serpentine shapes, and form links between different groupings on a rock.

Spirals of different kinds make up a small proportion of rock art, and do not have the same universal use as the cups and rings.

A vocabulary of rock art

Although *Rock Art* has become an acceptable, all-embracing term, it is arguable whether many of the designs can be regarded as 'art', for this pre-supposes that there is a skill in the way the markings are arranged on rocks that gives them an aesthetic quality.

There are many terms used to cover the general phenomenon. *Petroglyphs*, from Greek, means *Rock Carvings*, which may be unacceptable because 'carving' means to cut, and is often used synonymously with 'sculptures' and 'engravings'. Carving, according to the OED ' is now usually restricted to work in wood, ivory, etc., sculpture being work in stone.' However, *Rock Carvings* is now the most frequently used term. *Rock Markings* is also used.

Two terms used to describe the constituents of Rock Art are *Symbols* and *Motifs*:
A *symbol* is a representative sign or mark. For example, bread and wine in a Communion service represent the body and blood of Christ. A symbol is a summary. To 'symbolise' is also used to mean 'to combine, to unite with elements to form a harmonious union' (OED).
A *motif* is 'a constituent feature of a composition, an object or group of objects forming a distinct element in a design' (OED). This definition allows it to be a single cup or a single groove, or the combination of the two elements in a design.
I have long used *symbol* to mean a single element such as a cup, and a *motif* to mean a combination of symbols, but I acknowledge that it could be stated the other way round. The arrangement of symbols/motifs on a rock forms a *panel*.

Depressions were made in the rock with a hard stone tool that was impacted with a mallet. In freshly exposed rocks this process can be seen very clearly. The size of the pick varied, to allow heavy blows or light, delicate peck marks. The tool chosen had to be of a rock harder than the surface being marked.

Elements

There follows a series of sketches of the main elements in rock art:

Cups are the most common symbols, and can appear (1) singly, (2) randomly clustered, (3) in domino patterns and parallel lines, (4) a rosette, (5) in a straight or curved line, and (6) countersunk.

Cups at the centre of curved grooves
(1) Cup and ring, (2) cup and multiple rings, (3) cup and penannular, (4) cup and multi penannulars, (5) cup and arc (or semi-ovoid), (6) cup and multiple arcs. In these drawings the rings, penannulars and arcs are concentric.

Cups with grooves running from them (sometimes harshly called 'gutters')
(1) Cup with groove cutting through ring, (2) cup with groove cutting through multiple rings, (3) cup and groove with penannular, (4) cup and groove with multiple penannulars, (5) cup and groove with arc, (6) cup and groove with multiple arcs.

Rings, penannulars and arcs
(1) Ring, (2) concentric rings, (3) penannular (or gapped ring), (4) multiple penannulars, (5) arc, (6) multiple arcs.

Keyhole patterns
The seven examples illustrate a number of variations on the theme.

Grooves enclosing multiple cups
(1) A rosette enclosed by a ring. (2) a rosette enclosed by two concentric rings, the central cup having a groove that cuts the rings, (4) an oval groove enclosing cups, (5) a heart-shaped groove containing cups, some connected, and one with a groove leading out, (6) multiple rectangular grooves enclosing cups.

Grooves
(1) Linear, (2) parallel, (3) chevron, (4) serpentine, and (5) grid/ hatchings.

This isolating of a number of motifs is only a beginning. A study of rock art must take into account factors such as the shape and surface area of a marked rock, the way in which its irregularities may have been used in determining what is to be pecked onto it, the way in which motifs relate to each other, and the spacing of motifs over the rock surface.

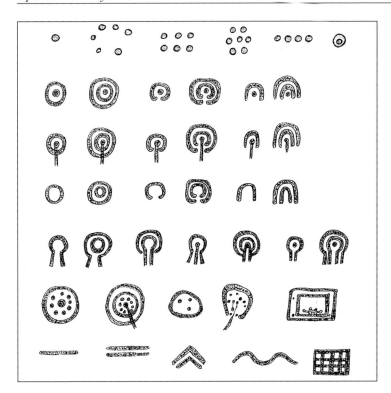

6 *Elements*

Here first are some sketches of a number of markings taken out of context, from all over Britain, not drawn to scale, that illustrate many variations on the themes outlined above.

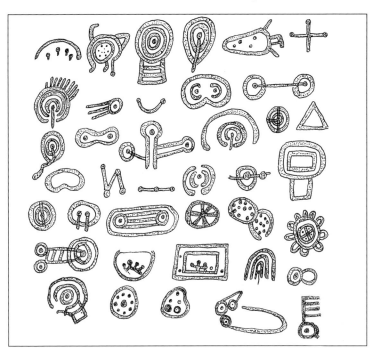

7 *Variations*

Spirals

Spirals occupy a special place among the motifs and, although some are linked directly to cups and rings (as at Little Meg and Lilburn, for example), they form a distinct type. Some 'hybrid' spirals have been identified, but as we see frequently that some patterns of motifs are incomplete, or badly executed (for example, where rings are incomplete or 'miss' joining up), one should only accept a few of them for this category.

Some of the best-made spirals occur in Passage Grave art in Ireland, and it is thought that there were direct links with England, Wales and Scotland. Ireland is outside the scope of this work, so what follows will be limited to those three regions.

We begin with a most interesting British site, at Morwick in Northumberland. On the River Coquet, close to Warkworth and the North Sea coast, a cliff of reddish-coloured sandstone rises vertically from the river at a fording place, and still has a wide variety of spirals despite the loss of some of the rock in the river. For those people who like to draw arrows on maps to establish links with other places, this place is a puzzle. If, as some claim, spirals spread from Ireland, then what are they doing on the East Coast?

Many different types of spiral are represented, as the illustrations show, including horned spirals, triple linked spirals, running spirals, and others unparalleled anywhere else in Britain. There is nothing close by to give any chronological association with them.

If the river level today is the same as it was at the time the spirals were chipped into the rock, some means of reaching the high points, such as a ladder or lowered cradle, must have been used.

Elsewhere in Northumberland there are only two other sites with spirals; one is at Lilburn (NU 013 256), where a pillar-like rock with horned spirals and concentric circles was buried in a pit which held layered cremation burials, and a spiral on outcrop at Horton. The probability is that the pit burial was Neolithic.

A spiral connected to concentric circles also appears at Little Meg (NY 576 374) in a possible burial context, this time on one of the large kerbs that surrounded a cist burial containing two eroded cup and ring stones. Close by is the famous stone circle of Long Meg and her Daughters (NY 571 372), where the large outlying sandstone monolith is covered with motifs that include spirals.

In the context of a huge, plundered mound at Old Parks (NY 569 398), a row of upright stones had simple 'shepherds' crooks' spirals, with the unfolding curves turning both to the right and left, individually. This again is in a burial context, of uncertain date, but earlier than the Food Vessels and Beakers deposited subsequently.

The most recently-observed spiral is at Castlerigg stone circle (NY 292 236), placed significantly at the end of the box-like setting of stones that intrudes into the circle, facing inwards.

At Hawthornden (NT 280 632), near Edinburgh, spirals occur in a similar place to those at Morwick — a vertical cliff face, not easy to reach. The spirals in this case are interlocking, formed of a single groove, leaving two spirals in relief instead of being recessed. There are other possible, eroded spirals on the same surface.

So far, it is clear that spirals occur in an open-air context and on monuments. Galloway has the greatest concentration of spiral rock art sites in Britain, and examples are given in

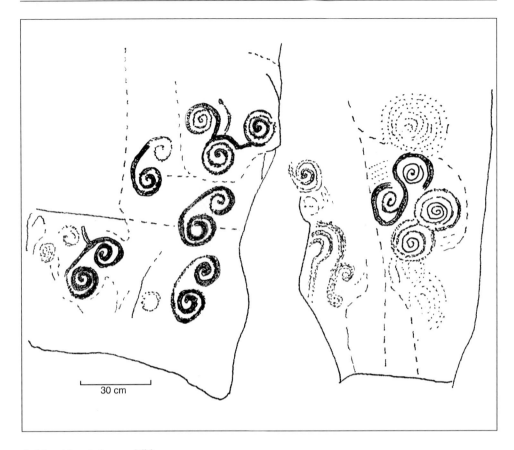

8 *Morwick: spirals on a cliff face*

some illustrations. For those looking for links with Ireland, it has to be said that no Irish example occurs in an open-air context.

At Temple Wood (NR826 978) one stone of this important circle has a set of three interlocking spirals linked to two interlocking spirals that join to form a complex horned spiral.

North East Scotland has another phenomenon: carved stone balls. Fourteen out of 411 have spirals. Elsewhere in Britain, some spirals appear on a carved macehead from Garboldisham, Norfolk, and on various pottery sherds. There are no rock-cut spirals in southern England, and mazes such as those at Tintagel are not the same as spirals, and of uncertain date.

Chambered tombs outside Ireland may include spiral decoration that echoes that in the Irish tomb. Some fine examples come from Orkney (Pierowall, Eday Manse) and from the Anglesey tomb at Barclodiad y Gawres.

Further reference will be made to spirals in the text, but meanwhile the geographical and artistic range has been sufficiently illustrated to show that spirals are a form distinct from the cup and ring tradition, but in at least two cases can occur at the same time in a joint design.

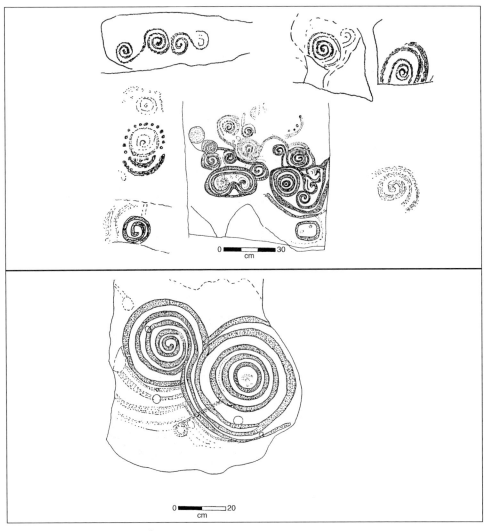

9 *Morwick, (top); Little Meg (bottom)*

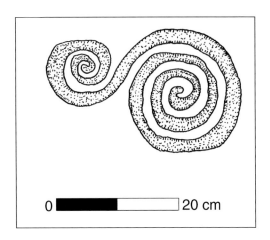

10 *Spiral, Gallows Outon, Galloway*

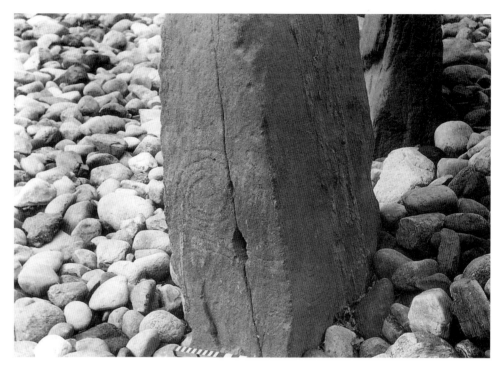

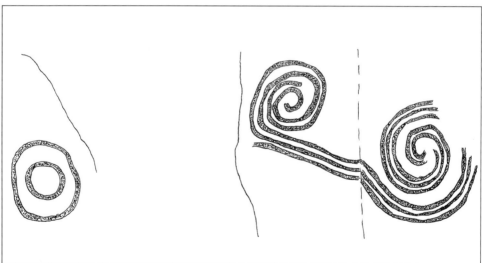

11 *Temple Wood: Concentric rings on one stone, and linked spirals on another*

3 Panels of Rock Art

Although it may be interesting to compare similar motifs and designs throughout Britain, or the world, it is very likely that no diffusion process is necessary to account for similar motifs separated by big distances. The symbolism is limited, and it is quite possible for someone in north Scotland to hit upon the same combination of motifs as someone in Ilkley.

Of more importance is the way in which the motifs are arranged on a rock surface as a total composition. Immediately, what stands out is that multiple rings are rare, and cups or cups with a single ring most common.

If we plot these decorated panels on a regional basis, and use the tightly-controlled statistical methods developed by Richard Bradley, we may see with him that the more complex art is generally at a higher level in the landscape. He argues that it must therefore be there for an audience different from those people who used the messages of the simple art. To be effective, its placement had to be predictable — you had to know where to look as well as what it meant when you had found it.

The actual position of rock art in the landscape will be examined more closely later, and meanwhile we shall look at some panels of rock art from a design point of view only. We can look at how the motifs are spaced: widely-spaced, close-spaced, linked, abutting, or sub-divided, for example. We shall look at their arrangement on the rock by examining some examples from different parts of Britain.

Decorated boulder on Gayles Moor (Co.Durham) (NY116 058)

The drawing is a flattened-out representation of a gently rounded, ice-borne rock. Although it does not have multiple rings, this is a complex design that involves dividing the rock into zones and utilising some fine cracks to achieve it. A circular groove surrounds a rosette of cups (the central cup with a groove running out of an already established line from the centre). It is linked to the rest of the motifs on the rock by two main grooves, one from the centre of the rock, the other leading towards another dominant motif: an ellipse containing four cups. The main groove that links them forms a distinct panel that includes cups and a faint cup and ring. There is a deep cup inside this panel round which the main groove curves. All the grooves appear to be made with the same tool.

The fluidity of grooves, which vary in depth and width, ending in, or starting from, cups, also exclude other cups, which remain isolated, some strong, and others faint. On a

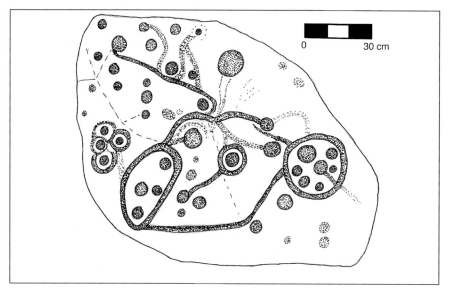

12 *Gayles Moor*

near-vertical edge of the boulder a little space has been filled in by a huddle of cups and single rings, not all deeply executed, where they seem to jostle for position.

Zoning, interconnection, wide spacing and fluidity of movement are what the modern eye sees on this rock.

Dod Law outcrop sheet (Northumberland) (NU 004 317)

The horizontal rock, on two levels, has been cut off at the top, some of it since it was first recorded in c.1850.

The RHS motifs are much fainter than the rest, and it could be that the top surface of the rock was taken off in prehistoric times, perhaps in the construction of graves, for the next level has well-defined, deeper, crisper motifs.

The rock is zoned, and cup marks play little part in the choice of design; instead, the emphasis is on rectangular, square and heart-shaped grooves, some concentric, enclosing clusters of cups. In the case of those enclosed by four concentric rectangles with rounded corners, the cups form a straight line of 4, an arc of 7, and 3 others, the central cup of which has a groove leading out of the enclosure. Some cups enclosed by the heart-shaped groove are linked by grooves, and again a groove leads out from one of them from the enclosure, with two tiny cups on either side. One curvilinear groove, enclosing only one small cup, does not join up with anything, including itself. Another groove begins at a crack, and ends at the rock edge.

A square with a central cup uses a crack as one of its sides without any further pick work.

The top LHS has been broken recently, and appears to be the remains of a large square enclosure containing a serpentine groove and a square around a cup. The RHS has two penannulars, the gaps in which face in opposite directions, with a diametric groove that runs through the central cup to the rock edge. An oval with three cups inside touches the edge of this enclosure.

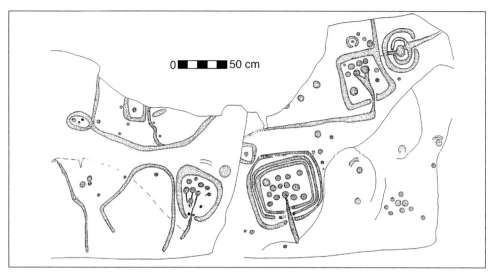

13 *Dod Law*

Another gapped square containing cups, two of which are linked to a duct that leads out of the enclosure and does a right-angled turn to the left, is the other prominent design. We are dealing here with a unique concept in design, although there are other rectangular and square components that are found locally at Amerside Law, Buttony and Fowberry.

Two hundred metres away, outside the Iron Age hillfort, are quite different motifs of the cup and ring type. The rock just described commands views across the Milfield plain, and in the opposite direction to the valley that breaks into the plain from the west.

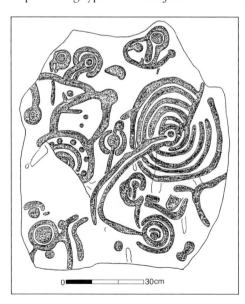

14 *High Auchenlarie*

High Auchenlarie, now at Kirkdale House (Galloway)

The provenance of this slab is not clear, but there are so many different design elements on it, that it is a good example to use here. Like the Dod Law rock described above, markings appear on two levels. A type of rosette in which a ring of cups lies between three concentric rings focused on a central cup has been cut through, and a different type of motif —large cup, ring and random grooves — fills the space.

The largest part of the surface is occupied by a central cup with six irregular rings around it, with two parallel grooves running out of the centre and a single groove running the other way. The double groove coming out of a centre is repeated in three other

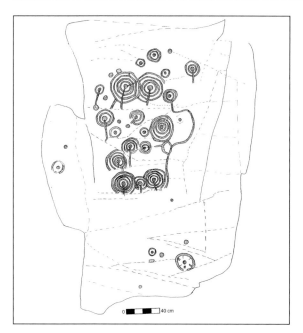

15 *Cairnbaan 2*

figures, and there is a complexity of grooves linking all the components together. It makes a striking visual impact, despite, or because of, the lack of precision!

Cairnbaan (Argyll) (NR 838 910)

This is one of two panels of rock art, each very different from the other, within 100 metres of each other.

The natural cracks in the slightly sloping surface create zones that have been respected by the motif-makers. At the bottom are four cups, one with a ring and another with a ring and six lines radiating from its centre like a star. In the next section are three series of concentric rings that abut each other. The centre, and smallest, has a cup, a ring from which a groove runs down the rock, and an outer ring that is cut into by the outer rings of the figures on either side. Both the outer figures have four rings around a cup, one without a groove and the other a very thin one running from the central cup.

Higher up the rock a central cup with four rings is linked to the lower panel by a long, curving groove. The rest of the figures include faint, perhaps roughed-out motifs, three being cups with single rings, and one a cup with two rings. The other rings around cups also have grooves running down the rock from the cups, but one figure has three rings and an arc, another has one ring and two arcs.

The highest part of the rock, separated by a natural horizontal groove, has two conjoined figures where each has a central cup and duct surrounded by four rings that are more angular than circular. One outer ring is incomplete. There are two motifs with central cup, duct, and two concentric circles, and cup and penannular, cup and two rings, three isolated cups and a faint cup, ring and long thin duct.

What is striking about this is that there are only five unattached cups on the whole panel, that many of the motifs stop at the horizontal cracks, and that so many cups attract

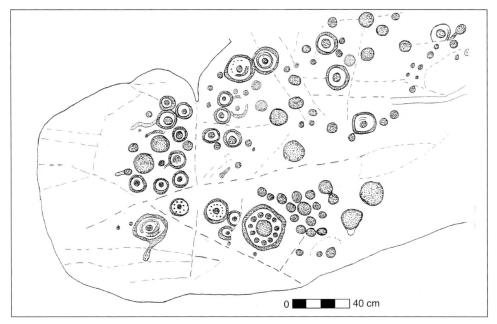

16 *Ormaig 1*

four rings around them. Some motifs stand clear, but the main ones run into each other.

Ormaig (Argyll) (NM 822 027)

The pattern on this part of a larger outcrop is dominated by cups of different sizes. On the lower slope of this near-horizontal sheet are three rosettes of different sizes: a central cup surrounded by a ring of cups, all enclosed in a single ring.

To the right of the largest rosette is what at first sight appears to be a random cluster of cups, but out of these it is possible to see another unringed rosette pattern of 7 small cups around a larger one.

Above this, and separated by a crack, is an apparently random choice of simple motifs that includes large and small cups, cups with single rings and double rings, and the beginnings of another rosette.

The motifs are spaced so that they stand apart from each other.

The Idol Stone (West Yorkshire) (SE 132 459)

This stone is a boulder on which cups have been arranged mostly in lines, giving a sense of order and design. Seven of the cups are enclosed by a rectangle with rounded corners.

'The Planets' (West Yorkshire) (SE 129 463)

Two thirds of the surface of this earthfast sandstone have been used in a design that partly encloses the marked part of the rock with long curvilinear grooves along its edge, and the inner grooves link single rings around cups. The effect is one of inter-connection and fluidity. At the centre of the design is a near-diamond shape with a pecked centre.

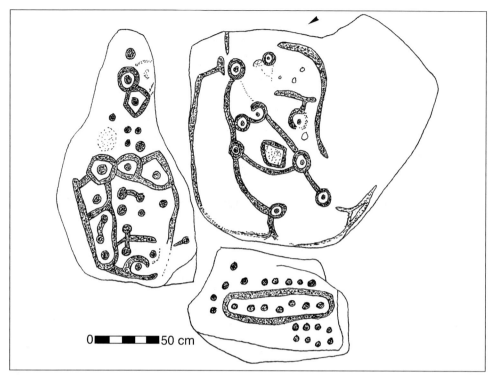

17 *Dobrudden, The Planets and The Idol Stone*

Dobrudden Caravan Park (West Yorkshire). Formerly (SE 137 401)

As this stone has been re-erected, it is not clear what its purpose was. It looks like a menhir. The surface has been zoned. Horizontally across the centre are three cups with irregular single rings that run into each other. This line is extended down the rock to include other enclosed and linked cups. At the apex there are four, possibly five, isolated cups and two cups with single rings.

Barningham (Co.Durham) (NY 046 085)

This large rectangular sandstone slab, brought in by ice, must have suggested from its surface and shape the design that eventually appeared on it. The RHS, only recently exposed, has pristine pick marks on it, and shows clearly the way in which the design was pecked into the rock-a central cup with an angular ring around it. The central part has many cups of different depths, and faint beginnings of grooves. The LHS uses the end curve of the rock to run a groove parallel to it, to bring it across the rock via a cup and ring, to form a rough square containing a large and two small cups. The motifs are spread fairly evenly over the surface.

The reader may see in these examples evidence of planning, and not a casual evolution, although it is possible that in some cases extra rings or other motifs might have been added.

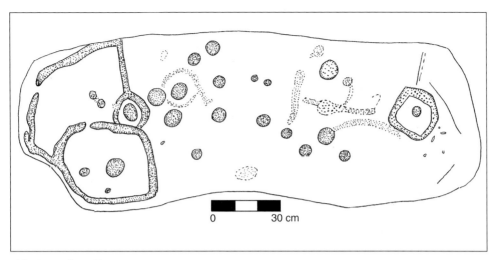

18 *Barningham 13*

The upper group at Achnabreck (Argyll) (NR 855 906)

This part of a more extensive outcrop, the largest with motifs in Britain, is zoned by natural cracks. There are multiple concentric circles around cups, radial grooves, scattered cups, cups enclosed by single rings and double rings. There are enclosures with multiple cups, a horned spiral, two sets of three linked spirals, and what appears to be a cup and three concentric rings overlying either a similar figure or one made up of arcs. There are three parallel grooves of the type seen at Ormaig.

The horned spiral can in no way be seen as earlier than any other motifs on the rock: on the contrary, it is one of the boldest and best-executed of all the motifs. It is not unusual for other motifs to be roughed-out, tentative, unfinished — not necessarily more eroded— and this too must be considered before assuming a big time gap between different types of motifs.

It is also interesting to note that not all the rock is decorated, and that there is a particularly crowded part in the middle section. The extension of this rock south has ringed cups that concentrate on the western edge (the highest part), with only an atypical ring on the east. The whole rock surface had been available for marking, but some parts were more favoured than others. Why?

Chatton Park Hill (Northumberland) (NU 075 290)

The position of this massive outcrop and the spectacular nature of its motifs make it the final example in this section. It also reminds us of how rich Northumberland is in its range of motifs and how well organised they are on the rocks.

The gentle downslope is towards the viewer. At the top of the rock there is a dramatic drop on the scarp to the valley, and from this site all the other major sites at Weetwood, Amerside Law and Old Bewick are visible. There are other extensions of this outcrop; some nearby are also marked, but there are large areas with nothing on.

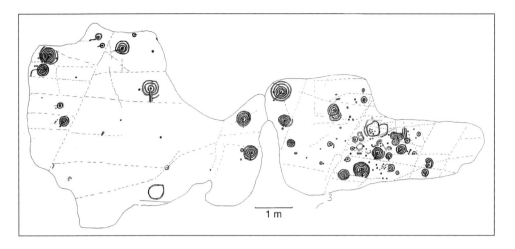

19 *Achnabreck, Upper Group.*

A long natural channel beginning in a basin winds its way down the rock. It has been slightly enlarged (a not-uncommon feature). There are domino cups arranged on one side, a small cup and arc, and a not very clear cup and ring motif. Where the channel ends are two faint figures, the upper being a cup at the centre of two angular rings with two parallel grooves running from them. Below this are two small cups enclosed by two angular grooves, the outer one incomplete.

To the right of the channel is a dominant motif of multiple rings of an unusual type. A central small cup is the beginning of a groove that is artificially directed towards the main channel. Two other grooves branch off to the right, one to the edge of the rock, and the shorter to become the duct of a cup and three penannulars. Between these grooves is a cup and five rings, and a faint cup and ring.

The dominant motif begins at the centre with a cup and three rings, bounded by an outer penannular that loops over a cup at the top. Two subsequent rings do the same, looping over the top of the extra cup and ring.

Between this figure and the channel are faint cups, grooves and rings, some attached to the outer circle; then there is a deeply picked cup with a diametric groove, a ring and two penannulars. Beside it is a possibly earlier rectangular figure, perhaps unfinished. A square lies at the outer RHS edge and at the top of the rock are a cup and ring and cup and two rings. Where the rock begins to fall away at the scarp, there are parallel linear grooves, cups and cups and rings. This use of an extensive rock surface with natural grooves already there to suggest flow and zoning has been used to create an effect that to modern observers is very satisfying.

It also has a great range of motifs that one can see on other rocks, but not arranged in this unique way. One may say that of all these panels, for every one is different.

The comments on the rock panels mean little without the pictures that go with them, so the reader will now be left to contemplate some others without any comments from the author.

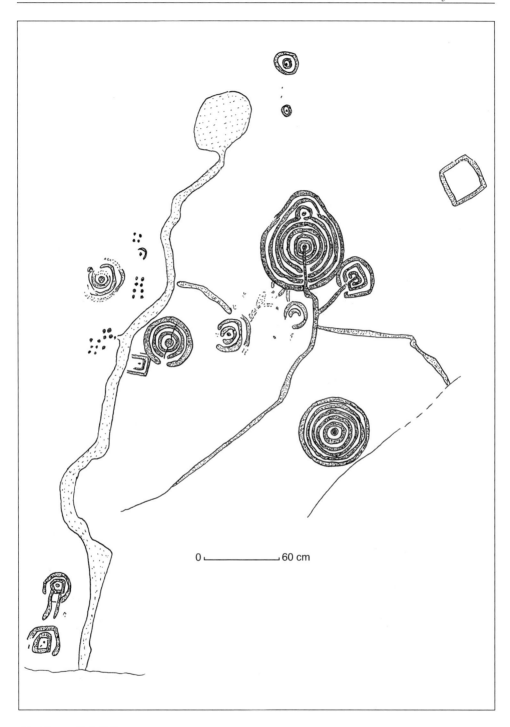

20 *Chatton Park Hill*

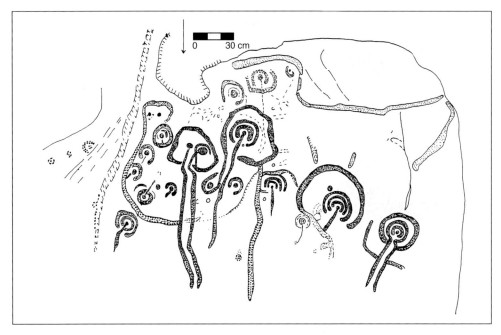

21 *Horton, Northumberland*

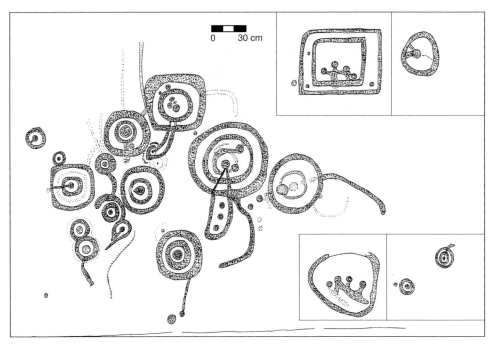

22 *Amerside, Northumberland*

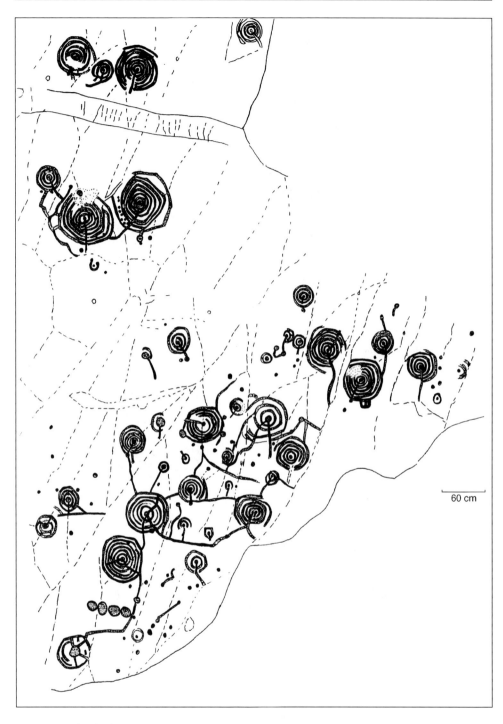

23 *Lower Achnabreck*

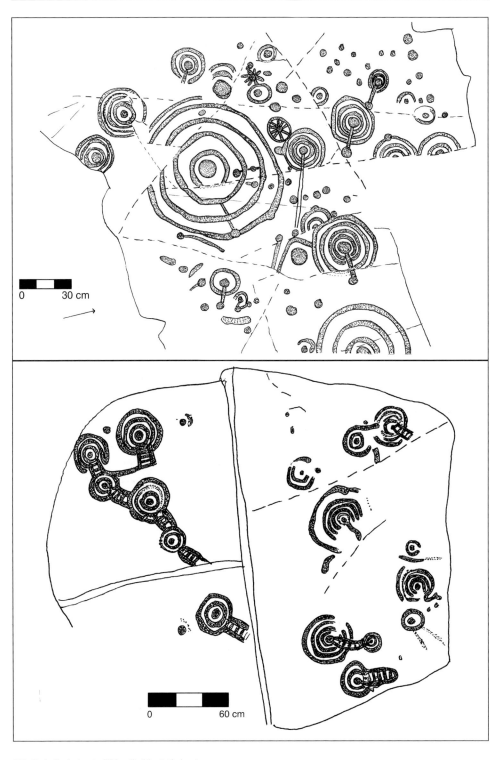

24 *Poltalloch (top); Ilkley 'ladders' (below)*

4 How the study of Rock Art began and developed

J.C.Langlands discovered some worn and defaced figures incised on a rude sandstone block, near to the great camp on Old Bewick Hill in north Northumberland. Though strange and old-world looking, these figures then presented an isolated fact, and he hesitated to connect them with by-past ages; for they might have been the recent work of an ingenious shepherd, while resting on a hill; but on finding, some years afterwards, another incised stone of a similar character on the same hill, he then formed the opinion, that these sculptures were very ancient. To him belongs the honour of the first discovery of these archaic sculptures.

Thus wrote George Tate, the Alnwick historian, of the discovery of the first rock art in the 1820s. He was to pursue the subject himself with great enthusiasm; the publication of his *Sculptured Rocks of Northumberland and the Eastern Borders* in 1865 became important. In 1830 Archibald Currie published the first brief regional survey of rock art, the cups and rings of Cairnbaan in *Description of the Antiquities, Etc., of North Knapdale*.

Perhaps one of the best-known nineteenth-century antiquarians was Rev. William Greenwell, Canon of Durham Cathedral, who in 1852 read a paper at the Archaeological Institute of Newcastle on the subject. Unfortunately the paper was lost and never published.

In 1853 George Tate read a paper to the Berwick Naturalists' Club. Mr. J. Collingwood Bruce was impressed with Mr. Tate's 'sagacity' and agreed that the carvings had 'a common origin, and indicate a symbolic meaning, representing some popular thought.' The Rev. Greenwell in 1863 took up the theme again, this time with the Tyneside Naturalists' Club, and told them that 'They differ from all other symbolised expressions with which we are acquainted, and seem peculiar to the Celtic tribes which once peopled all Western Europe.'

Attention moved to Scotland in the Lochilphead area of Argyll, and in 1864 notices of the discovery of 'incised' markings in Scotland and Ireland appeared in the Journal of the Archaeological institute.

In 1867 Sir James Simpson of Edinburgh published not only the Scottish sites, in *Archaic Sculpturings of Cups, Circles, &c.*, but also sites in England and other countries. His illustrations were lithographs by Mr. Richie.

Mr. George Tate at Bamburgh read a great landmark paper in 1864 to the Berwick Naturalists' Club. Of this the President remarked that the subject was 'in its infancy' and

'what we want, and what we have to wait long for, a key, which, like the famous Rosetta stone, will enable us to read and interpret these remarkable inscriptions, engraven so long ago upon the Northumbrian rocks. Whatever may be their import, now so mysterious, they cannot fail to prove, when their meaning is discovered, of very high interest.'

Mr Collingwood Bruce, who produced splendid lithographs with the help of the Duke of Northumberland, gathered together current research to make his own position clear. He felt that one tribe had made the marks, and that if one discovered many more in Europe it would be possible to trace the movements of these people. He found evidence of the *period* of the rock in areas 'abounding in remains of the kind usually styled Ancient British'— camps, burials and (rarely) standing stones.

Bruce found that there was no satisfactory answer to the *intention* behind them. He rejected the idea that they were maps of camps, warned readers of the Druidical sacrifice theory, and was not convinced that they were 'sun symbols'. He said that 'it is highly probable that these incised markings are, in some way or other, connected with the burial of the dead', and was supported in this belief by Canon Greenwell. 'If we connect the circular marked stones with interments, we advance a considerable way towards an explanation of their meaning; for this implies that they have a religious significancy.'

George Tate published *Sculptured Rocks of Northumberland and the Eastern Borders* in 1865. At the outset he declared himself more interested in facts than fancies, and said that 'such an extensive survey of the subject will of itself dissipate some of the crude notions which have been formed as to the meaning of the figures, and which have been founded on a limited knowledge of the facts bearing on the question'. He recorded 53 'sculptured stones' with about 350 'figures' on them. Among his conclusions he says the 'the sculptures of Argyllshire are the same age, and the work of the same people, as those in Northumberland'. He drew other parallels from Penrith, Pickering, Dorchester, Ireland and Derbyshire. In the 1880s Romily Allen compiled a list of cup marks in Scotland.

The interest in rock art research left Britain for a while, apart from chance finds, and blossomed in Europe. There an interest grew in the way the art was distributed, its age, and typology. The Abbé Henri Breuil gave an important Presidential address to the Prehistoric Society of East Anglia in 1934, and in 1957 O.G.S.Crawford published *The Eye Goddess*. At this time an emphasis was placed on seeing rock art as some sort of representation of humans. Breuil in his lecture looked at the relationship between tombs and open-air art, and did not see them as different.

The 1970s in Britain brought Ronald Morris' work to the fore, and that of the present author. Evan Haddingham produced his accessible study of rock art in 1974, *Ancient Carvings in Britain: A Mystery*. There has been considerable new data published, not only in books, but also in papers. Apart from the well-known journals, the new *Northern Archaeology* (The Bulletin of the Northumberland Archaeology Group) has become one of the most influential in producing new research quickly and well. Such work was largely ignored by professional archaeologists until the recent upsurge in interest.

Maarten van Hoek, living in Holland, has contributed much to the recording of sites here. Work by Colin Burgess, particularly important in looking at the issue of chronology,

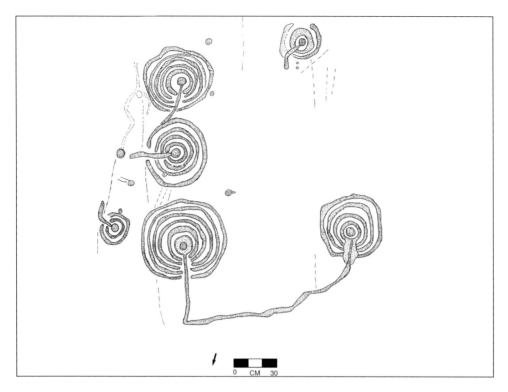

25 *Weetwood*

and the arrival on the scene of Richard Bradley, one of the brightest and most approachable of modern archaeologists, and research by a new generation, headed by Clive Waddington, have begun to place rock art as a vital part of our development, and not as a fringe activity left to enthusiastic amateurs. Shee Twohig in Cork has added great expertise in her wide-ranging investigations of megalithic art from Spain to Orkney. Recent work by Ian Hewitt (now at Bournemouth) and Paul Frodsham (Northumberland National Parks Archaeologist) and Tim Laurie is bringing interesting new thinking to the study. The work of those mentioned here, and others, is listed in the Bibliography. What is very gratifying is that we now have so many enthusiasts who discover new marked rocks and report them to us.

This interest has blossomed on a world scale, and in Britain it is interesting to see universities setting up specialised departments of rock art, and offering post-graduate qualifications in its study.

There are many reports being written, and comprehensive studies such as those of the Ilkley Archaeological Group are essential to expand the subject further. Only half the Yorkshire group study has been published so far, and it is vital that such research (in this case in recording over 300 marked rocks) should be published as soon as possible.

There is a downside to this interest, as a cursory look at some journals will show: the production of long-winded papers that have little of value to contribute, and a surge of quite absurd theories, which abstract symbolism seems bound to attract.

Symbolism: a search for meaning

Most researchers now accept that rock art was produced over 4,000-5,000 years ago, mainly by mobile peoples, at a time when settled agriculture was developing but when people were using upland, less fertile areas as a game preserve and a place to graze herded animals. We also accept that there was no language that we know handed down by these people that will answer our questions about them. We can only rely on the archaeological record, which is always very fragmentary.

In some parts of the world, art on the rocks can give a pictorial record of some human activities, such as hunting, gathering honey, ploughing and ritual, but in Britain rock art consists almost entirely of abstract symbols.

A function of symbolism, whether it appears as language or visual representation, is that it acts as a kind of shorthand; it condenses ideas into a compact statement that still contains levels of meaning. In the modern world we are at home with this process: at one level, for example, we recognise logos such as National Trust or National Park, we may recognise what the symbolism on washing machine instructions means, we are at home with traffic signs. The Christian cross, with all its variations, is familiar. The cloverleaf design of the Girl Guide badge incorporates a three-fold duty.

One does not necessarily have to know how a symbol originated in order to understand it. If we assume that cups and rings have been used for at least 1,000 years, it is unlikely that the origin of the symbol would have been so important to those who knew it compared with what it meant and why it was there. People could have gone on using the same symbols, perhaps modifying them, experimenting with them, accepting them without question.

The universal nature of these symbols has led some people to speculate that they have a common origin within the human neural system, by observing that the making of concentric circles and spirals, for example, is inherent, especially in young children. Others in our drug-obsessed culture have seen in primitive societies an origin of the symbols in drug-induced states of trance. Others do not think it necessary to attribute this to drugs, but to states of trance produced by dance or rhythmic chants and clapping. Observations of many third-world living cultures have been used to support this argument. This is all speculative, but it is understandable that we want to know, for example, why some Californian rock art looks like panels in Northumberland, or why there are strong similarities between Galician rock art and British. The early writers on rock art looked far afield — to places like Malta or India, for similar examples.

Producing theories about what they mean is not surprising because you can often see in them whatever you are looking for. Ronald Morris did a great service to archaeology when he investigated the large number of theories and put forward 'one hundred and four varieties' of explanations in his book *The Prehistoric Rock Art of Galloway and the Isle of Man* in 1979. He was a solicitor, used to weighing evidence, a scholar and discoverer of rock art, and his informative and amusing excursion resulted from his observations, reading, and contacts with many people working in this field. He looked at all the theories, and gave them marks out of ten!

He supported Professor Thom's arguments that some motifs were placed on standing stones that had important astronomical alignments. He noted their use and re-use in burials. One of his strongly-held beliefs was that their proximity to copper and gold sources was deliberate, but others see this as merely coincidental. He was strongly convinced of their religious and magical significance, but not at all moved by theories that they denote breasts, the Mother Goddess, eyes and phallic symbols, or that they were connected with fertility rites. He pointed out that there was no evidence to link them to sun worship, water divining, their use as mixing vessels, for casting bronze or colour, quantity measures, or the Freemasons' earliest symbol, the All-Seeing Eye.

Copies of worm casts, tree rings, and ripples made when stones are thrown into water were given very low marks. Druids don't come into it because they didn't exist then, and the idea that blood was poured into the grooves is not supported by any evidence. Their use as clocks was dismissed. Messages from outer space rated zero. He listed other theories such as bonfire ritual site markers, an aid to seed production, early pilgrimage marks, dye and transfer moulds, maps of the countryside, building plans, star maps and a tattooist's shop window.

Although he dismissed suggestions that the markings were placed where they were in the course of some sort of search for food, and gave the theory 2/10, we believe that there is a more convincing case here, and that they could also be boundary markers of sorts (1/10) and route markers. Could they be merely decoration? Doodles? Could they have been games? Do they represent parts of animals? Are they primitive lamp bases? Water images? Among the explanations that he dismissed completely were their use as secret treasure maps, plans of megalithic structures, for mazes, field ploughing plans, victor marks, early

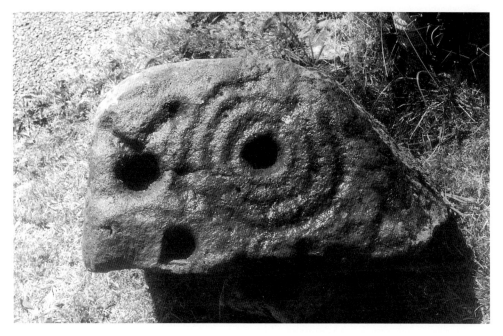

26 *Dean, Cumbria*

masons' marks, marks made by adders coiled up on the rocks, an early form of musical notation, a tuning device whereby wise men could alter the pitch of a rock's natural vibration by chipping it, a locked-up force, worship of the sea goddess, markers for healing wells, children's art, or just natural marks. The rest of his research brought in oath marks, knife-sharpening marks, early astronomers' night memoranda, and inclusive birth-growth-life-and-death symbol, healing magic, a mirror with its handle, and a womb symbol.

This breathless list of possibilities will no doubt grow, but the crucial point is that the acceptance of any theory is that it must be supported by evidence. It is different from simply having a 'gut reaction'.

Because contact with rock art can produce strong reactions, including a great sense of wonder, one must remember that poets, other writers and visual artists are going to respond to it in different, personal ways. This is to be expected and encouraged, but no theory of origin and use can be accepted unless it is backed up. It is possible that new discoveries may make this clearer. The study of rock art must be based on trying to understand how these motifs fit into the landscape: to move to the setting of each one, its relationship to others, and its association with an understandable context. That is the purpose of what now follows.

5 Art in the landscape

It is possible that motifs were made on skin, wood and cloth, but we see them on rock, which is more durable. The images, unlike some of those drawn in sand in modern Australia, were meant to last. They appear on outcrop and earthfasts in the landscape, but some are on 'portable' rocks (i.e. they can be moved).

From regional surveys we can imagine a landscape 4,000-5,000 years ago in areas that had rock art in an almost pristine wilderness. Some changes had been made: a clearing, a well-defined path, signs of a camp, or a burnt area where vegetation could regenerate. In marginal areas like these there is evidence that the earlier Mesolithic hunters and gatherers had chosen the same areas for their camps and blade-making, as did the motif-makers. This stands out particularly clearly in County Durham. Agriculture brought with it a more static society based on farms and land enclosures, but hunting and herding continued to play a big part in their economy.

We tend to separate secular from ritual activity in modern society; the distinction may not have applied to earlier societies. It is not surprising, therefore, to find that motifs may mark special places in the landscape relevant to hunting areas, and that the same motifs are put into graves and on standing stones. Their use reflects a different way of thinking about them.

In some ways decorated panels enhance the landscape. Unlike what was around them, they were organised, compact, spread across rocks specially chosen for the purpose, and an encounter with some of them would have been very impressive. However, leaves and other things would have covered some of them in a short time; for their use to be anything more than temporary, one has to assume that the surfaces were kept clean. Perhaps the paths to them were so well used that this became an automatic process. We don't know. Assuming that they could have been put there in a period that might amount to two thousand years it makes the process even more difficult to understand!

Exposure for long periods could erode some motifs and deepen others, especially those on a slight slope. Rocks, too, vary in hardness, and generally the softer sedimentary rocks were favoured for marking. This makes speculations about the currency of use almost impossible to determine at the moment.

Interest in motifs has not sufficiently taken into account the details of their setting. That many panels of rock art are at prominent viewpoints has been recognised; it is only recently through the work of Richard Bradley and his Reading students that an attempt has been made to place the settings within a coherent statistical framework.

What distances can be seen from marked rocks? In what directions? How close do you have to be before you can see the marked rocks? Is there a reason why some rocks were chosen for marking and not others? Studying this involves taking a sample of all outcrop rocks in the area and comparing them.

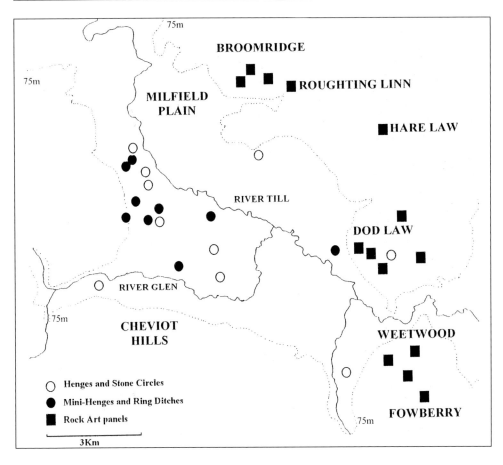

27 *The disposition of rock art around the Milfield Plain*

Are the sites of marked rocks inter-visible? Is there any rule that determines where different designs are sited? For example, are complex designs (with many concentric circles) in different places in the landscape from simple patterns (such as cups or single rings)? If so, as motifs are a means of communication, are they designed for different audiences?

This work has involved dividing a landscape into grids that include marked and unmarked rocks, measuring distances from rocks and the angle of sight, and making sense of the results. It was done on many sites in different regions in Britain, taking into account information already available. An interesting part of the research that I observed was that students were set down in a limited area of known rock art to see if they could predict where the markings might be. They were able to do so quite accurately.

Although all regions where there is rock art must be seen as different, Richard Bradley has put forward a number of common factors. Where there are monuments, the rock art leads to them in a carefully-constructed way, with the complex motifs at the highest parts. Simple motifs tend to be lower down on the margins, where local people went about their daily business; he thinks the complex motifs are therefore addressed to people coming

from some distance to the monument sites. His landscape surveys show that the complex motifs are often at 'entrances' in the natural terrain, reached by a sequence of others. He sees 'thresholds', which may have conspicuous rocks or rock outcrops overlooking the river valleys, at places where valleys run into an area of ritual This proposition can be tested on a regional basis; the survey that now follows looks at some regions briefly, and others in more depth.

North Northumberland (Beckensall 1991, Bradley 1997, Waddington 1998)

All known rock art panels have been recorded, and many of the panels have been known for nearly 200 years. Reading University has surveyed some areas. Open-air rock art in Northumberland has a wide distribution. In the Wooler area, where the River Till flows towards the Tweed along a flat plain consisting of sediments laid down by a large glacial lake, the plain is reached through gaps in the sandstone scarps to the south and east. The River Glen flows in from the west past the Cheviots, which are composed of igneous rocks. The Till begins its life as the River Breamish, rising in the Cheviots, flowing down the Ingram valley, north past sandstone ridges on either side, which include major rock art sites at Hunterheugh (Beanley Moor), Old Bewick, Amerside Law Moor, and Weetwood and Fowberry on the opposite bank. The river skirts Chatton Park Hill, and at Horton and Buttony makes a right-angled bend to break through the sandstone scarp at Weetwood Bridge, before flowing north past Gled Law and Dod Law towards Milfield and Ford. The plain is of crucial importance, because recently it has been shown to contain Saxon buildings, henges, cemeteries, linear ditches and pit alignments of the prehistoric period. The major rock art sites line the valleys that lead to gaps in the scarps. The sites of panels of rock art are visible from each other; the panels themselves are not, and could have been obscured even from a short distance away by trees.

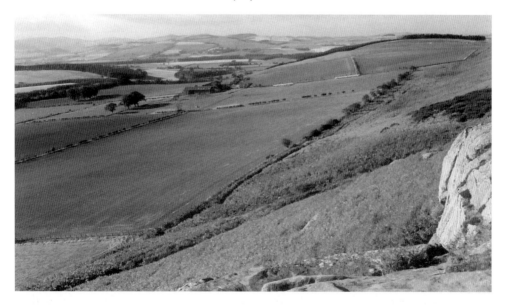

28 *Broomridge, west from Goatscrag Hill*

Broomridge

One of the 'entrances' to the Milfield plain is along the valley of the Broomridgedean Burn. It has cut into the sandstone, and is flanked by a steep sandstone scarp known as Broomridge, or Hunters Moor, which has panels of rock art, four figures of deer, early Bronze Age/late Neolithic burials under a rock overhang on Goatscrag Hill, evidence of destroyed burial cairns at the other end, and the largest outcrop of marked rock in England, at Roughting Linn.

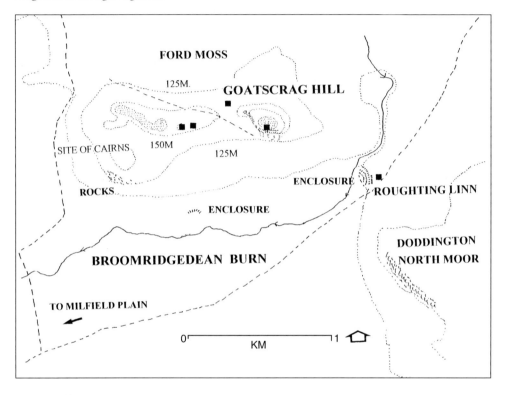

29 *Map of Broomridge*

The ridge has its own distinctive natural focal point in outcrops of sandstone that are eroded into dramatic shapes visible for many kilometres; they lie below that part of the ridge from which burial cairns were cleared away for recent agriculture. The survival rate of rock has been affected by the use of some outcrops for the quarrying of millstones, some of which, in various stages of removal, are still visible. Surface traces in the thin soils have been disturbed by rig and furrow ploughing. The ridge has marked outcrops that overlook the Broomridgedean Burn valley, with its access to the Milfield plain via a sunken lane; the other side has views of the North Sea and Ford Moss.

From west to east, there are three panels of rock art on outcrop. The first, (NT 9736 3718), now covered over, faces away from the scarp edge; it consists of a central cup with three irregular rings, a concentric arc, and a long curvilinear groove that surrounds most of this.

The next rock (NT 9719 3778) has many different types of motifs on a large outcrop (where there are later millstone quarries). One figure has a central cup with seven concentric rings that on close examination are seen not quite to meet. There are three other motifs of the cup and ring type on the same patch of rock. Farther west are incomplete concentric rings, a rosette, cup clusters with two cups joined and one with a sharp duct leading out (all with well-defined pick marks). There are other single scattered cups and some natural ones.

Farther east, and away from the scarp edge on a raised natural rock platform, partly eaten away by quarrying, is a slab of rock (NT 9703 3708) with the design arranged to point towards the south valley. It was one of the first decorated surfaces to be recognised and recorded in the nineteenth century. As the illustration shows, its decoration is based upon variations of cup and ring motifs. There is a diametric groove, arcs, cups and rings, motifs joined together by grooves; at the north end are large rings.

Goatscrag Hill rises above the rest of the ridge; on one edge (NT 976 371) are sets of two cups joined together by a curved groove, like horseshoes. Underneath the rock overhang were cremation burials in pots buried below the present floor level. Four figures of deer are pecked into the vertical iron-stained wall of the rock overhang. Three are static; one has its legs bent in movement. They appear to be prehistoric, but are not definitely so. The crag drops away to the stream, which meets a second stream; together, they have cut through the sandstone to form a promontory. The Broomridgedean Burn tumbles over the edge of this as a waterfall called Roughting Linn, which means that here the water bellows like a bull into the pond. This promontory has massive, multiple earth and stone walls separated by ditches, enclosing the promontory in an arc. It has never been excavated, so we cannot assume anything more than that it is prehistoric.

Beyond this by only a few metres is a large whaleback of sandstone (NT 983 367), uncovered by William Greenwell in the mid-nineteenth century. Half of it on the west has been quarried away, and a large slice has been cut out of it crosswise, but the rest has such a variety of motifs that it is justifiably one of the finest rock art panels in the world. Richard Bradley drew attention to its similarity in appearance to a long barrow or chambered tomb, and pointed out that the deep, ringed motifs run around the edge like the decoration on Irish passage grave kerbs. The more delicate, plant-like motifs are arranged towards the centre of the rock, above the others.

This natural outcrop occupies an important place in the landscape at the threshold between the route to the Milfield Plain and access to the coastal plain of the North Sea. Recent clearing at Hare Law Crags (NU 013 335-012 335) in a small wood has added more marked rocks to those already recorded. This appears to be part of a route from Roughting Linn to the high ground overlooking another threshold to the Milfield plain, this time near the village of Doddington. Between Roughting Linn and the sea, there are other examples of rock art, but they are portables.

Roughting Linn, for all its importance, is a prime example of bad management. No helpful finger post, however discreet, enables the visitor to locate it, and many frustrated people end up at the farm. There is a notice board that should be in a museum, and nothing to show in sunless conditions what is on the rock. Trees are growing out of the rock in places. It remains, however, a beautiful place.

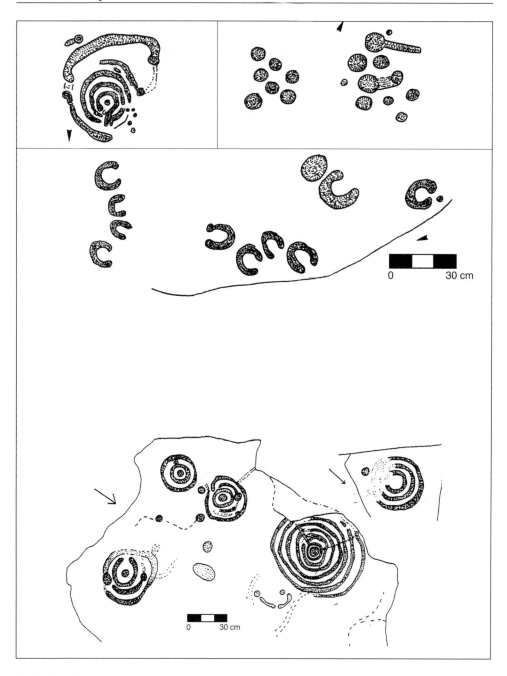

30 *Rock motifs on Broomridge*

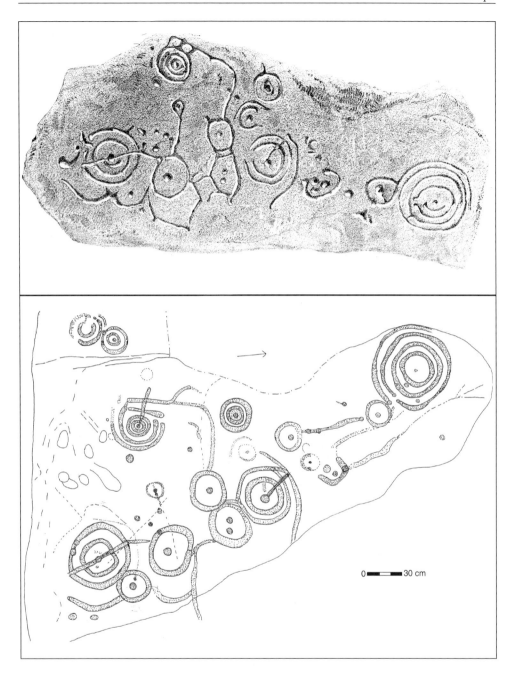

31 *Broomridge rock art recorded in 1850 and by the author*

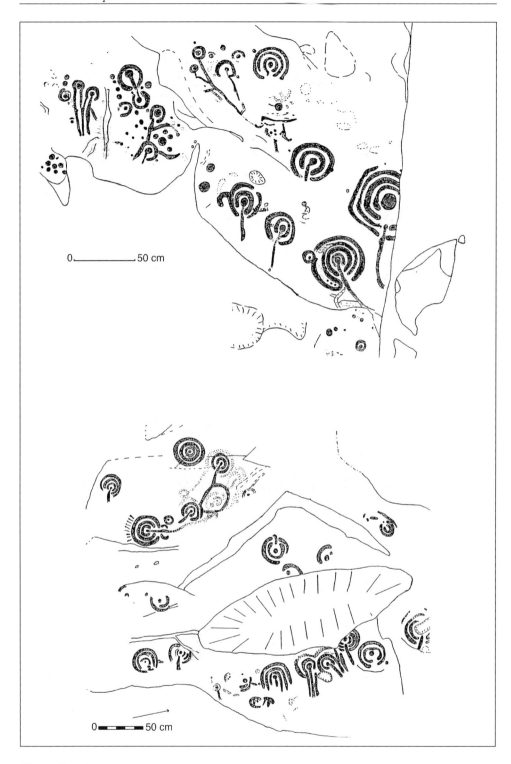

32 *Roughting Linn east*

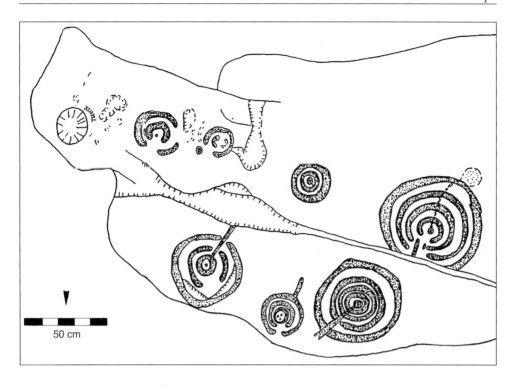

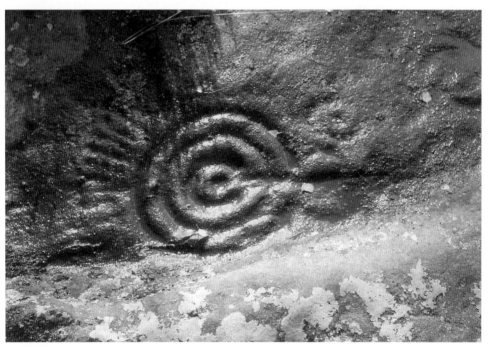

33 *Roughting Linn North, and a photograph of a unique figure, drawn on p.44*

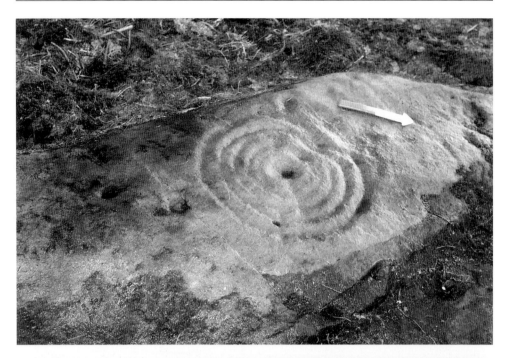

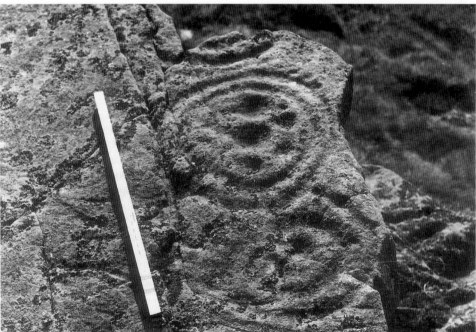

34 *Hare Law Crags*

Millstone Burn/Snook Bank (Beckensall 1992, Bradley 1997)

This second area of Northumberland is chosen because it marks the gap and communication route between low-lying, level ground to the south and hills to the north. The burn is so named because millstones have been quarried in the area, and *Snook Bank* is the ridge where the beasts were shackled. The Roman road, the Devil's Causeway, follows the same valley on its route from Hadrian's Wall north. Other cup and ring marks in the area follow a NE-SW course towards Alnwick and Rothbury on high ground that includes a cup and ring marked outcrop at Lemmington Wood (NU 1294 1080) side by side with runes. There is a rock shelter at Corby Crags (NU 1279 0962) with an enlarged food vessel under the overhang and a cup, channel and basin above it, and cups and rings on a vertical rock surface at Caller Crag. Southwest, via cairnfields and other features, the sandstone scarp reaches the Coquet at Rothbury, where there are major rock art sites on either side of the river.

On the Millstone Burn side, west, the marked rocks (NU 1189 0521-1142 0528) are outcrop and earthfast boulders with views across the valley south, and the highest on the ridge top look towards the Cheviots. The Snook Bank sites (NU 1293 0520-126 056), to which we have added in our recording very recently, lie on top of steep outcrops that overlook a plain to the south, and others are hidden in cleared ground with rough pasture that contains cairns and marshy hollows. Most of the rock art is on exposed outcrop or in thin soil that supports some heather, grass and bent, and is not productive except for grazing.

The area with this large sample of marked rocks was examined in Richard Bradley's survey; he noted that the most distant views extended in two directions along the axis of the valley. The motifs on these rocks do not include the largest systems of concentric circles; there is a great variety of motifs, some unique to this area.

In April 1999 another panel of cups and single rings was found at Wellhope (NU 115 061) beside a public path running through a wood, parallel to the Millstone Burn valley northwards. It links the Snook bank sites to the Caller Crag rocks (NU 1150 0695), which are spectacular outcrops of sandstone that have whitened with time. We are led up to the top via some natural terraces to a small cave. At the back of this high outcrop are motifs, mainly cups on a vertical face, and easily missed, but the natural outcrops form an outstanding place in the landscape, like those on Broomridge. There is a small cairnfield to the south.

35 *Millstone Burn and Snook Bank sites from the south*

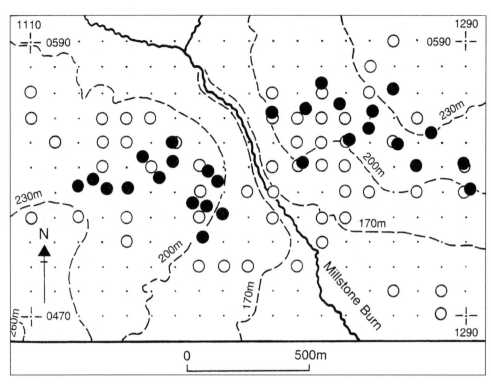

36a *Richard Bradley's map of rock art on Millstone Burn (closed symbols) and control samples (open circles) recorded during field work*

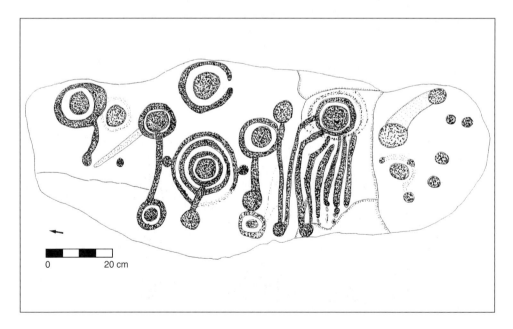

36b *A recently-recorded panel on Snook Bank*

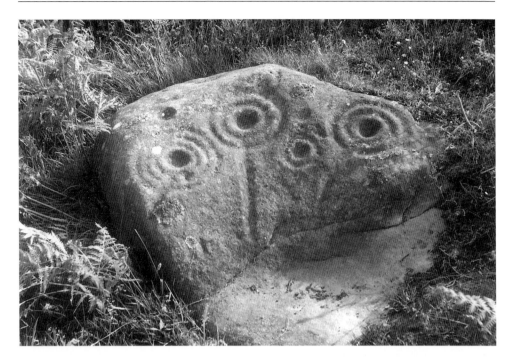

37a *Millstone Burn*

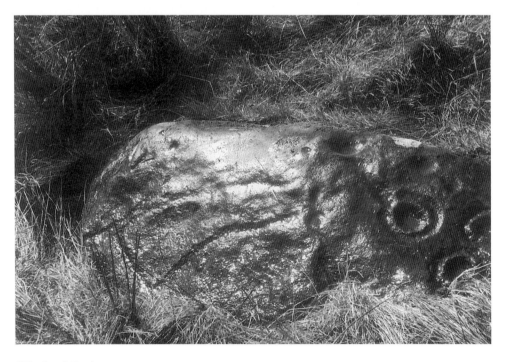

37b *Snook Bank*

Lordenshaw (NZ 0512 9912-0060 0045) (Beckensall 1992, Bradley 1997)

It is only recently that this well-visited area has revealed that some of its stone piles are tri-radial cairns, possibly of the type excavated at Turf Knowe, Ingram, in the Cheviots. One cairn with two radial walls surviving has two exposed cupped stones at the junction of the walls (NZ 0525 9905).

An outstanding ridge of sandstone is dominated by a large enclosure, usually referred to as a hillfort that continued to be used as a settlement in Romano-British times. Within the fort are faint cup marks; on the slopes leading away from the ridge are varied motifs that include very large cups, one at the head of a long, wide serpentine channel. Also on the whitened outcrops on the eastern side are long grooves linked in some cases to cups, cups and rings, basins, and clusters of midget cups. The ridge leads down to the junction of the Whitton Burn with the River Coquet, including cairns and more marked rocks, ending at the valley bottom with large cups on outcrop.

To the west, the art nearest the hillfort begins with a large outcrop (NZ 052 991) much of which has been quarried away, but with some fine motifs, overlooking the Coquet valley to the Cheviots, and looking up to the Simonside Hills. Below, further west on a parallel outcrop is another set of motifs including the famous 'Horseshoe Rock' (NZ 0502 9918) on the edge of a cairn.

The relationship between cairns and motifs will be discussed later. This ridge is a very important ritual site where the rock art has very extensive views of the landscape below and all around it.

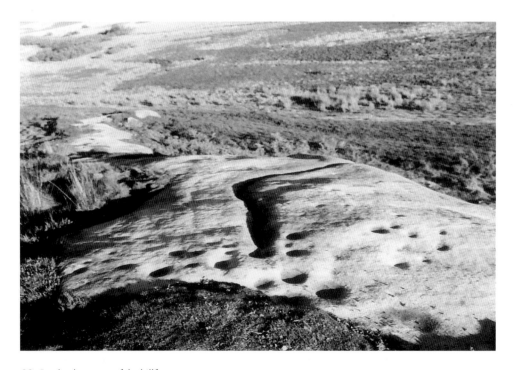

38 *Lordenshaw, east of the hillfort*

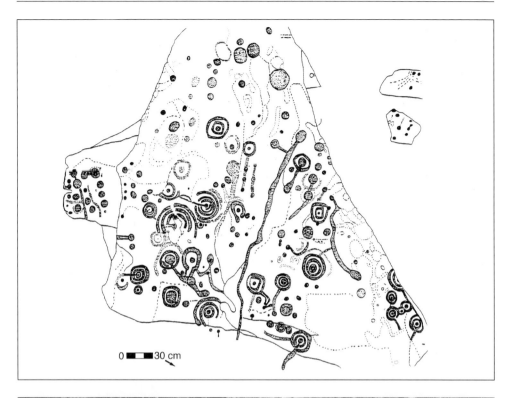

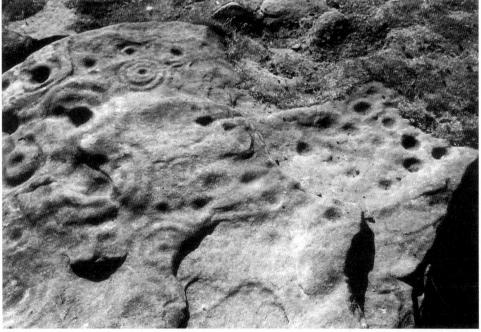

39 *A large decorated outcrop at west Lordenshaw. The drawing is accompanied by a photograph of part of the rock.*

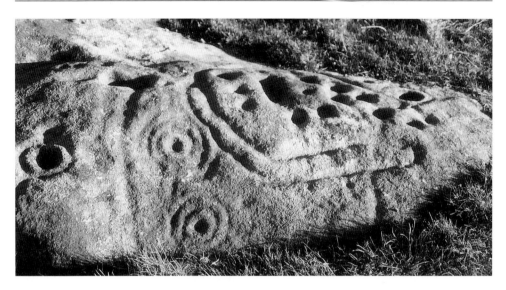

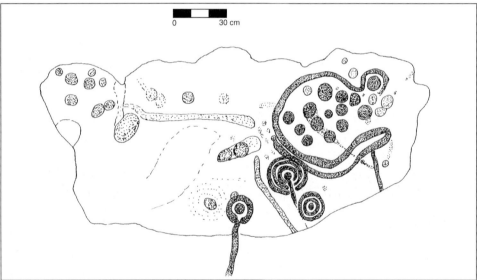

40 *The Lordenshaw 'Horseshoe' rock, a decorated kerb of a cairn*

Monuments

The relationship of rock art to monuments will be considered in a wider context later. Meanwhile it may be noted that there are many examples in Northumberland of motifs occurring in cists, on the cobbles that cairns are made of, and on the rocks on which cairns stand. The currency of the motifs lasts into the early Bronze Age, and they are used in a different way from open-air rock motifs. Some rock shelters also have motifs, and simple cup marks appear on standing stones. Spirals occur in one cremation pit. A cup-marked cobble has been found in a henge pit (Harding, A, 1981). Interesting though these discoveries are, they appear in only a very small proportion of monuments such as cairns.

County Durham, Swaledale and Wensleydale (Beckensall and Laurie 1998)

Not long ago, this area was relatively unknown, until the author and Tim Laurie published a complete survey in 1998. Now it is one of the most important areas. It has neither the large multiple concentric circles of Northumberland and Argyll, nor extensive outcrops suitable for this, yet it has a great range of motifs and a fascinating distribution pattern.

The areas favoured by Mesolithic people, when hunter-gatherers left slight traces in the landscape of their flint and chert chippings during their incursions from more permanent sites on the coast, coincide in some cases with the same areas favoured by Neolithic pastoralists and hunters at a time when arable farming was being established in the more fertile areas such as the river valleys and terraces. Rock art overlooks lowland sites; the motifs survive because the thin moorland soils are not attractive to anything more than mineral exploitation, rough pasture, grouse rearing and army ranges.

The markings are not found at intermediate heights at any distance from the rivers. One may assume that before they were made the people using the land would have plentiful game to hunt for food and skins, and fish, especially migratory salmon. There might have been little alteration to the pristine wilderness.

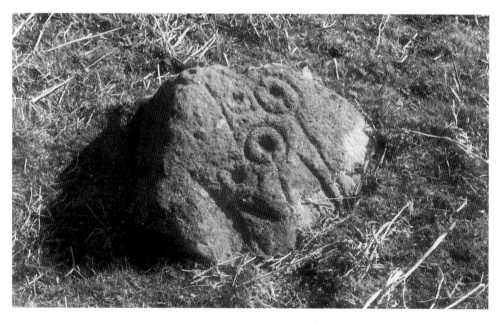

41 *Barningham north west*

Much of the marked rock had been moved there originally by ice sheets, in the form of small flat earthfasts and boulders. In Teesdale, most of the marked rocks occur in open clusters or groups of individual sites above 250m OD on the highest slopes that form the southern edge of the Tees valley. The sites are listed as High Hagg, Feldom and Gayles Moor, Barningham Moor, Cotherstone Moor and above Deepdale. Most recently-found are in a line east of Eggleston, a bleak area that has produced some surprises, including a

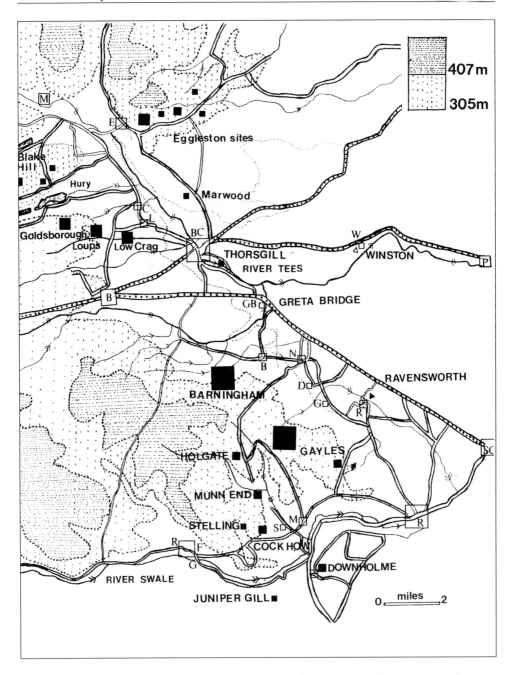

42 *Main rock art sites in County Durham and Swaledale. The sketch map shows the access roads to the sites, high ground and rivers. Villages and small towns are initialled. Solid squares show the areas of rock art. Small triangles indicate portables*

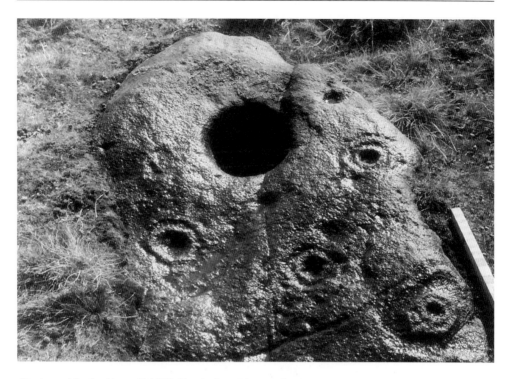

43 *An earthfast boulder on Eel Hill, Barningham Moor, south*

rare beaker burial in a cist, and cairns and enclosures. Others occur above 300m OD at Bracken Heads, Blake Hill, Howgill and Marwood along with some burnt mounds.

In Swaledale the markings are confined to rough pasture and heather moor just below or above 300m OD, in the vicinity of Marske Beck, a principal north bank tributary of the Swale. The distribution is patchy, but it does provide a link between the developing and increasingly successful farming communities of the late Neolithic, Bronze Age and Iron Age. Swaledale and Wensleydale begin to fill in the archaeological record when the first pastoralists arrived with henges, round barrows and cursus monuments in the Vale of Mowbray and in the Vale of Eden.

An abundance of rocks suitable for marking, the altitude and remoteness of the areas makes it likely that these areas always had a preponderance of such sites. There is rock art at a lower elevation that shows that it may have had a wider distribution; all the evidence here is from portable rocks, some from burial contexts.

Other burial associations are on the high moors, in cairns. The only other firm context is on Ellerton Moor at Juniper Gill, where a cupped standing stone marks a pass or saddle between Swaledale and lower Wensleydale. The most important site is a recent excavation at Fulforth Farm, Witton Gilbert, near Durham city, where there is a double-sided purpose-made cist cover and two pristine marked rocks in the cist. This, and an account of all other burial contexts, will be dealt with in detail in the section on Monuments. Examples of open-air rock art follow:

Barningham Moor

Close to Barnard Castle, Barningham Moor extends from the unenclosed east-west road to Stang Foot from Barningham, south to the How Tallon ridge. The moor is a mixture of enclosed pasture in the west, and open grouse moor elsewhere.

Below the southern high ridge a number of springs rise, and flow north to join the Tees eventually. Others rise in Haythwaite Allotment and flow in the same direction. This Allotment encloses rough pasture in a stone wall, and includes Scale Knoll, a lateral moraine ridge formed by the Stainmore Glacier, which was also responsible for scattering local fell sandstone slabs and some granite boulders, the latter not having any motifs. Shale, sandstone and limestone outcrops are covered by this glacial material. The strata outcrop to form a steep scarp edge below How Tallon and Eel Hill, and have been heavily quarried.

The moor gives very wide views from almost every spot northward over the valleys. Nearly 100 rocks have motifs, many with simple cups; the more elaborate lie in the vicinity of springs and streams rising from Osmonds Gill and Eel Hill. They cluster near Osmonds Gill, Washbeck Green and Scale Knoll.

Cups alone can produce interesting designs without being enclosed by rings. We see them linked together like strings of beads, or in zigzag and other patterns, joined in pairs, clustered in large numbers. In some cases they are so large that they become basins. The smallest cups form three lines of three.

The ringed motifs do not exceed four rings, one fine example being on a flat slab in Osmonds Gill.

Some ringed figures appear on boulders and slabs that have been placed vertically and horizontally, some being part of enclosures that may post-date them. The most elaborate enclosures are to the east below How Tallon, with stone foundations, facing north. The use of some of these is for dwellings, but the stone-dump enclosure constructions are for herding. Apart from the enclosure context, marked stones are also found in and on cairns. The large, excavated cairn called How Tallon, where pottery and other artefacts date it to c. 2000 BC, contained marked cobbles. Other cairns remain unexcavated, with decorated slabs and small boulders embedded in their surfaces; they will be considered in more detail as monuments.

There is a small seven-stone circle above Osmonds Gill, near to a cairn with a decorated boulder; their presence and another cairn and unique panel of rock art on Eel Hill help to emphasise that Osmonds Gill is a special place in the landscape. The junction of Osmonds Gill and Cross Gill, both formed by ice, has produced a spring source of great character. A line of stones across it suggests that it would have been ideal for herding. The place has a powerful feel to it, shut in and deep; it is marked and overlooked by decorated rocks. Water that begins underground, that can be heard before it is seen, flows to the site of a burnt mound towards the north.

Tim Laurie has investigated the burnt mound phenomenon of which 74 have been recognised in Wensleydale, Swaledale and Teesdale. He concludes that they were not associated with permanent occupation, but as 'picnic saunas, alfresco dilettante-group-feasting-places with wild boar on the menu, and saunas where flagellants apply birch branches after hot baths in steaming tents'. Some excavated in Northumberland have

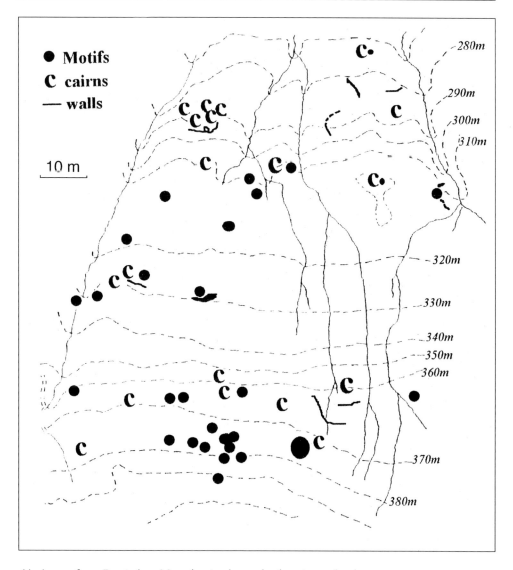

44 *A map of west Barningham Moor, showing decorated rocks, cairns and enclosures*

given early Bronze Age dates. Since *Prehistoric Rock Art of County Durham* was published, more rock art has been found further west, on Scargill Moor.

Gayles Moor

Gayles Moor has about 80 marked rocks in an open linear group extending east-west on an elevated terrace of gently sloping moorland about 2000m long and 1000m wide. All rocks are above 350m. OD, their southern boundary being the ridge of the Feldom and Folly Plantations, which leads east to other, minor sites.

Marked rocks focus on Hill 99, a prominent large tumulus-like mound that is probably of glacial origin, though its use as a burial mound is possible. There are scatters of earthfast

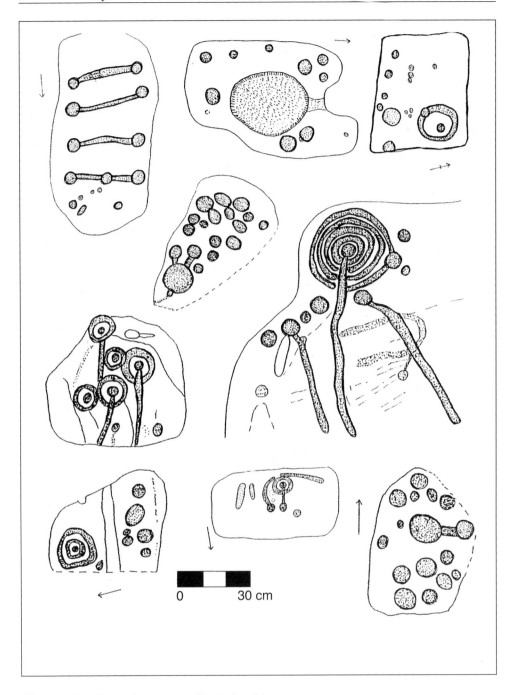

45 *A selection of decorated rocks on west Barningham Moor*

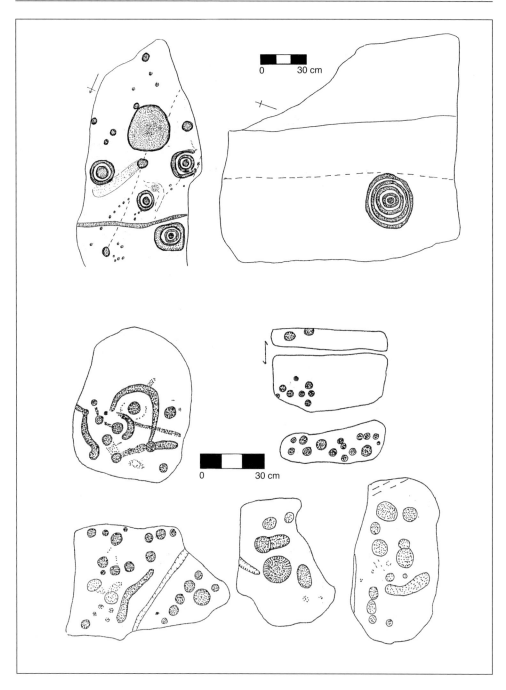

46 *Marked rocks at Eel Hill and in the valley of Osmond's Gill (above); Bottom Decorated stones in cairns, north Barningham Moor (below)*

slabs and boulders, many half-buried in heather and marsh grass. Today it is used by the army and for rough grazing. The map shows that there is a concentration of motifs more elaborate than cups in the centre of the area. Rings are absent from the western part. The rock surfaces can only be seen close-up, and most have very wide views north towards the valley. One is set in a small stream valley and marks the spring source with cups linked by grooves, a pictorial suggestion. A slab of rock in Folly Plantation has a design that was cut through in prehistoric times and another added on the removed surface. This practice is unusual, but is repeated in Northumberland.

There are some fine designs in the area. The only keyhole type of motif in the whole region is found on partially quarried outcrop near the huge mound. There are other mounds, including a ring cairn, and a cluster of cairns at the western extremity of the area. It is difficult to relate motifs to cairns, as no excavation has taken place. What remains to be said is that so many small rocks, boulders and earthfasts have been decorated, and the logic of their general distribution seems to be that any available rock was used, that it is spread out in a line across the landscape, with wide views to the north. Unlike Northumberland and Argyll, there are few elaborate panels leading to large ceremonial or ritual sites, but the presence of cairns in the same area as the rock art suggests a connection.

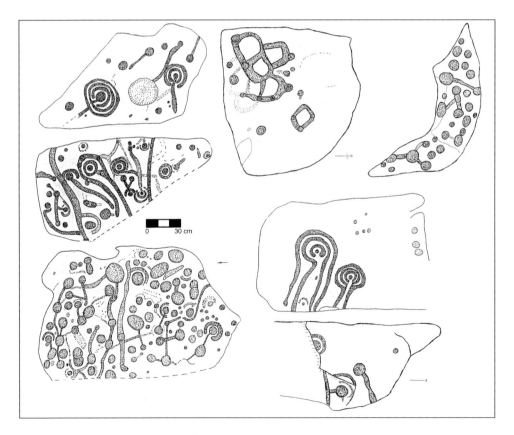

47 *A selection of decorated rocks on Gayles Moor*

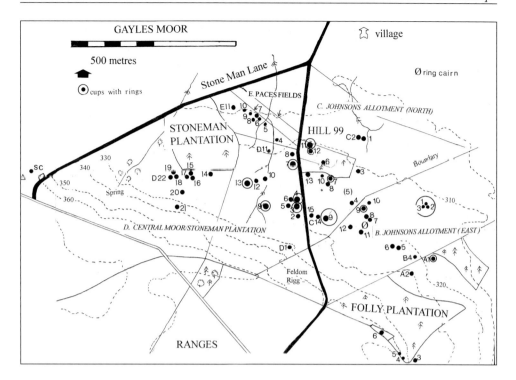

48 *The location of marked rocks on Gayles Moor*

Cotherstone Moor

This includes sites on the eastern edge of Goldsborough, West and East Loups, and three rocks on the Pennine Way.

Although the sandstone massif of Goldsborough is a prominent place in the landscape, visible for many kilometres around, these outcrops are not marked. The gritty sandstone on the slope to the east is where markings, mostly rings with simple cups, are found before the gently-sloping land plunges into a steep valley.

West Loups (NY 967 171) is a ruined farm, dating from the sixteenth century, built within an ancient circular enclosure (unexcavated) in a shallow valley, with its widest view to the east. Around the farm, on the ridge to the north where a well-embanked drove road runs on a ridge, are panels of fairly simple motifs, at viewpoints and at two springs. On the ridge to the north are more marked rocks with a view to the north, and to the south are three rocks by the Pennine Way leading into the valley with the farm. One has four cups in a ring, and another has an unusually pecked surface prepared for the three cups and single rings arranged in a line.

There are no monuments nearby and nothing with which to associate the marked rocks. Only their positions in the landscape link them to all the other sites that we have been considering.

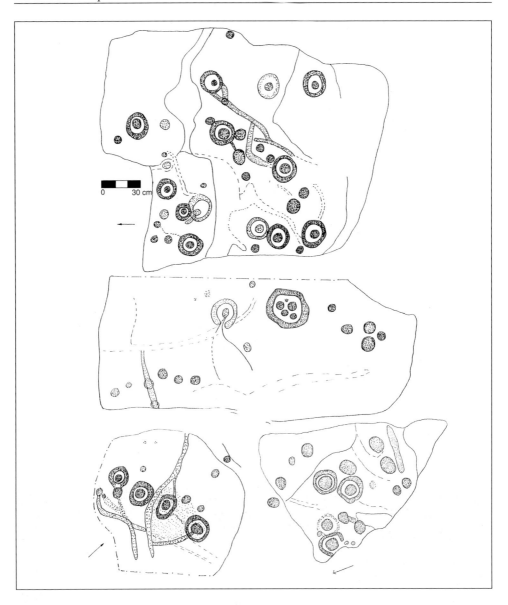

49 *Goldsborough and Loups: a selection of marked rocks*

Blake Hill to Eggleston

North of the above sites is the Baldersdale valley, with a line of marked rocks facing south. The rocks, mainly cup marked, occupy high places on the ridge, but at Howgill there is an interesting difference. Two flat rocks, Millstone Grit, lie in pasture that is very wet; this is the source of streams. The rocks have only recently been found; they were almost invisible. On the ridge to the north are other marked rocks overlooking this area. Cairns, enclosures and burnt mounds have just been recorded there.

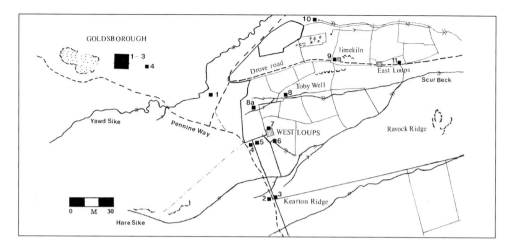

50 *The Goldsborough and Loups sites*

East of Eggleston is another line of recently-discovered marked rocks that stretch from Stobgreen Plantation and Bracken Heads through Barnard Castle Allotment to Langleydale Common. Cupmarks predominate, but the search for these often leads to other finds, including cairns, enclosures and a small settlement at Bracken Heads at a site that overlooks what might be a dried-up lake, and beyond that a spectacular view of Teesdale. The land here is again marginal, with thin, poor soils only useful today for rough grazing and grouse-rearing. The most easterly rock, a block of sandstone, the surface of which is covered with cups and grooves, overlooks recently-discovered enclosures and some small cairns, one of which had a cist revealed by rabbits. On excavation, this had a beaker burial, one of only five in Teesdale. The search goes on.

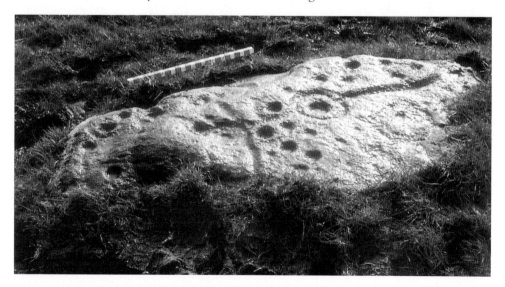

51 *Howgill, a flat boulder lying at a spring source*

63

North and east Yorkshire, and Cleveland (Spratt 1982)

The work of Dr D.A.Spratt (1982) has made the following summary possible. In prehistoric times the high sandstone areas of the Northeast Yorkshire Moors were being destroyed with the advance of pastoral and arable farming, and settlements were eventually concentrated on rich lowland, particularly in the limestone areas. No doubt these richer areas were always favoured; prime agricultural sites have been so heavily farmed that evidence of previous agriculture and communities has been ploughed out, whereas today the moorlands can preserve prehistoric monuments such as burial cairns, cairnfields and enclosures. In recent times, though, there has been encroachment on marginal land in many parts of northern Britain, with destruction of the prehistoric past. This region has cups and cups and rings, many associated with burial mounds, and some associated with enclosures. With very few exceptions, the marked rocks are found in regions on the periphery of the hills, the most favoured settlement areas. The high moorlands, although having a spread of burials and cairns (many from field clearances), do not seem to be places where people lived permanently, nor was there much funerary activity there. One exception is the appearance of cup and ring stones in a small cairn on Near Moor, near Whorlton (SE 474 988). The piles of stones, lynchets, hollow ways and elaborate systems of field walls (needed as stockades and to keep animals off the crops) are the work of farmers who practised mixed farming and eventually ruined soil fertility. There are cup and ring stones at Near Moor where a large round barrow is incorporated in the wall, a similar feature noted on Barningham Moor, Co. Durham.

The pushing of pastures into the hill forests for seasonal mixed farming, to supplement whatever other farming was going on in richer areas, ruined the thin soil. In this area where there were no central places of ceremony, like stone circles, barrows mark the areas where segmented tribes held sway.

The map shows how sites with decorated rocks lie at the edges of the high moorland, coinciding with finds of Beakers and Food Vessels, and most have been found as a result of the excavation of barrows.

This brief survey will treat the appearance of rock art in the landscape and in cairns in the same section.

In the landscape the most prolific site is at Fylingdales, where Graeme Chappell continues to add to and relocate sites found by Stuart Feather. Only a few appear on OS maps. The area has many cairns, but the motifs are found generally on low outcrops, mostly obscured by heather because they are so low. Thirty such rocks have been recorded on Brow Moor and Howdale Moor.

There are two main clusters, followed by more dispersed marked rocks:
1. Five rocks overlook the Slape Stone Beck from the east, and another lies on the west bank of the burn. An unusual feature of the motifs is the 'comb' — a line from which other parallel lines seem to hang. One rock (NZ 9592 0148) lies on a large ridge-shaped boulder with a cup, four cups with single rings, each with an arrangement of channels and ducts and two 'comb' motifs, one of which is cut by a later cup and ring. Pick marks are visible. The others have two cups, 15 cups and two irregular-shaped

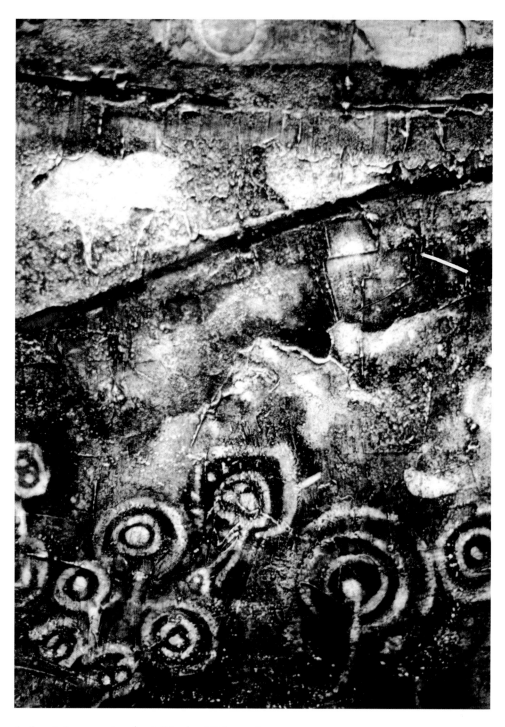

1 *An artist's response to rock art.* (Gordon Highmoor)

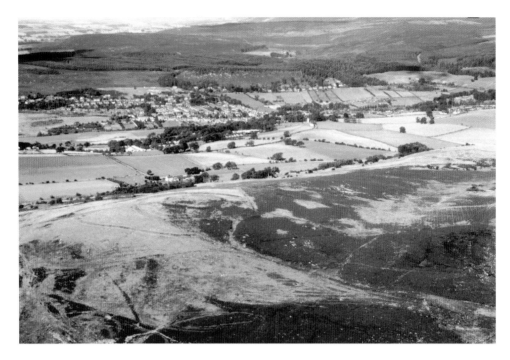

2 *At Lordenshaw, Northumberland, a hill fort is flanked by ridges that have cairns and rock art*

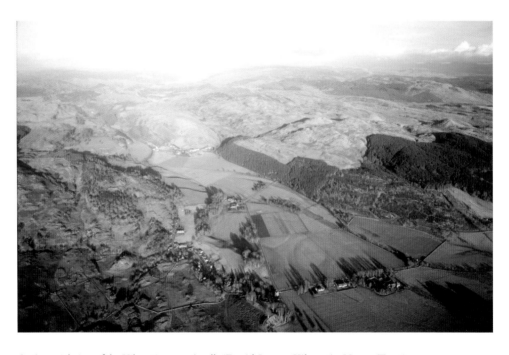

3 *An aerial view of the Kilmartin area, Argyll.* (David Lyons, Kilmartin House Trust)

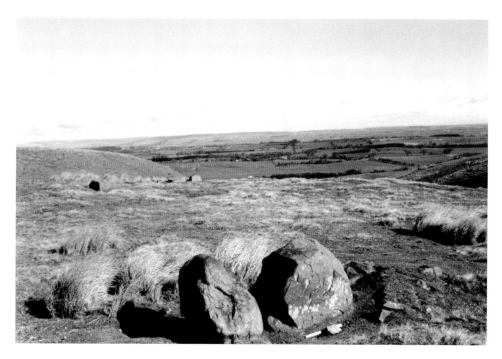

4 *Barningham Moor, County Durham. A marked boulder is part of a prehistoric enclosure, looking north to Teesdale*

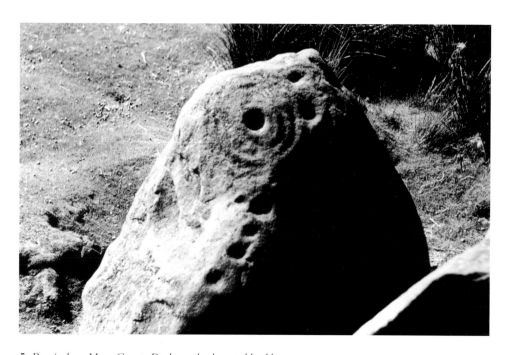

5 *Barningham Moor, County Durham: the decorated boulder*

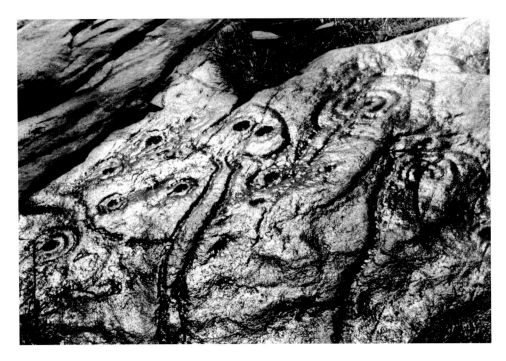

6 *West Horton, north Northumberland*

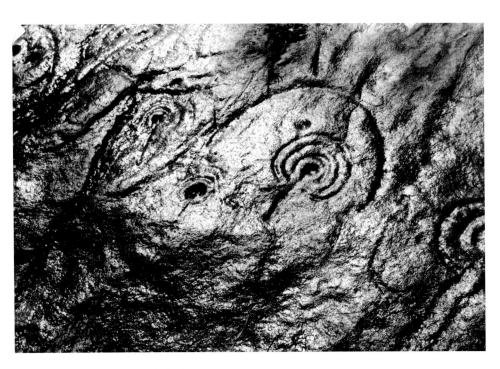

7 *West Horton, north Northumberland*

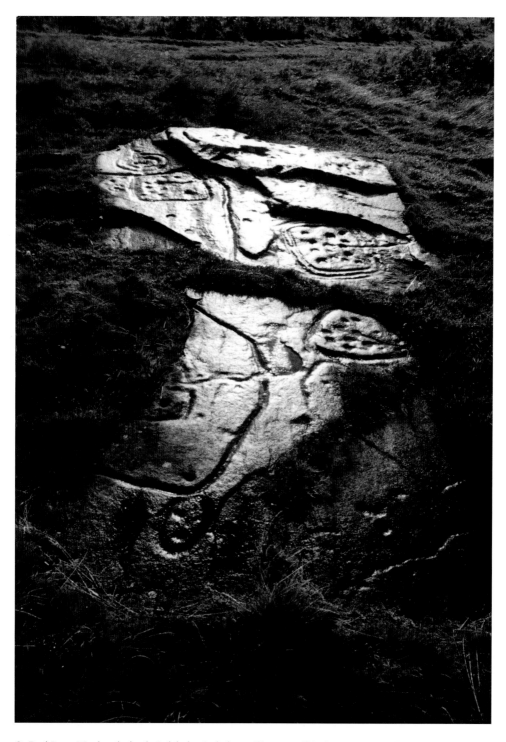

8 *Dod Law, Northumberland. A slab that includes rectilinear motifs in its composition.* (Ian Hewitt)

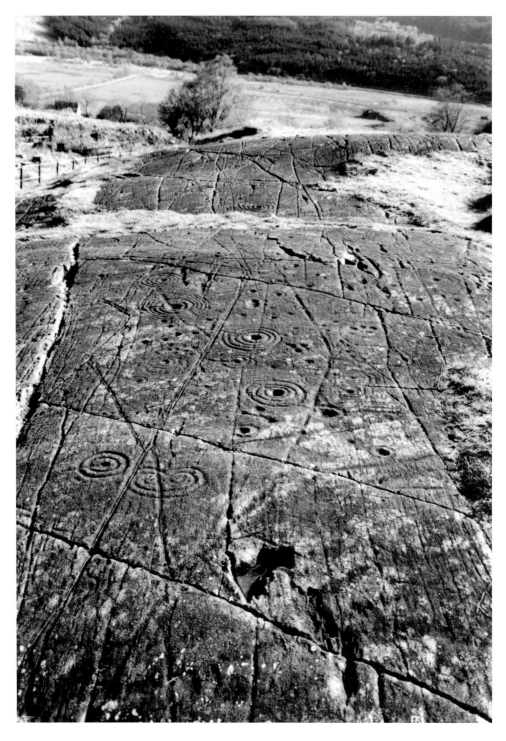

9 *At upper Achnabreck, Argyll, this is part of the largest expanse of decorated outcrop rock in Britain. The view extends south to the sea*

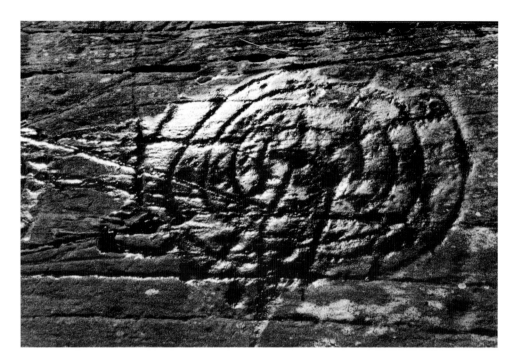

10 *The upper rock at Achnabreck*

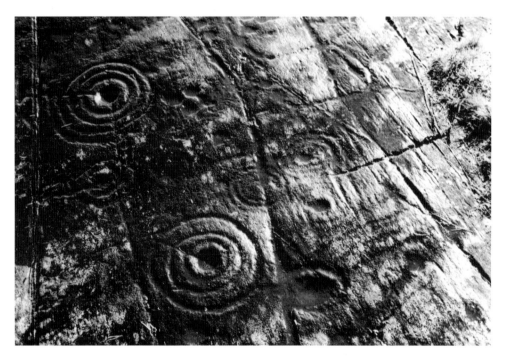

11 *Motifs at upper Achnabreck include triple spirals and parallel grooves*

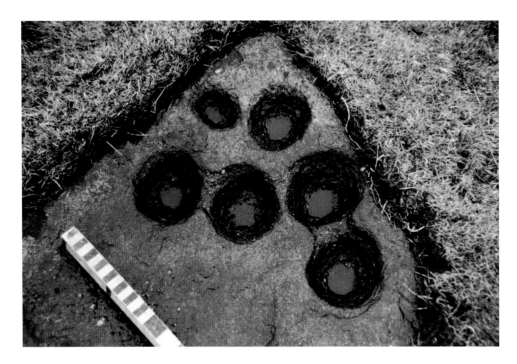

12 *Deep cups, some linked, at Eggleston, Co. Durham*

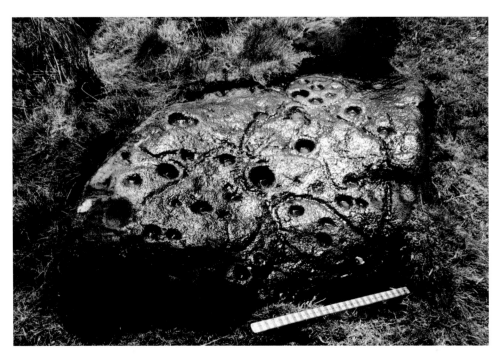

13 *Gayles Moor, Richmondshire*

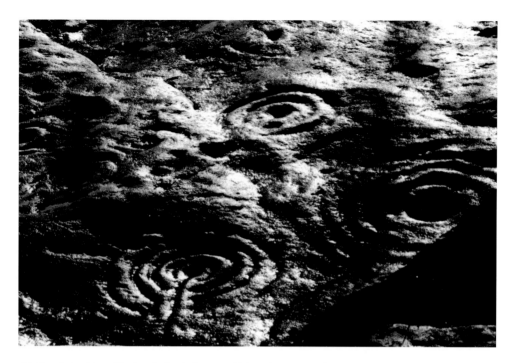

14 *Roughting Linn, Northumberland. Some motifs have been quarried away*

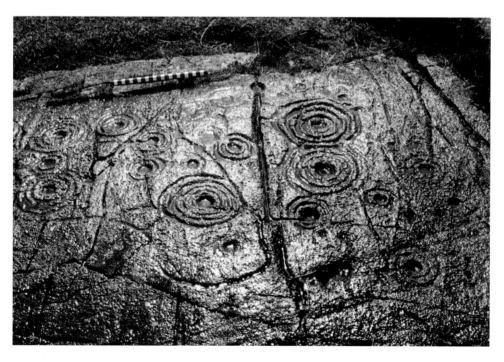

15 *Cairnbaan 2, Argyll*

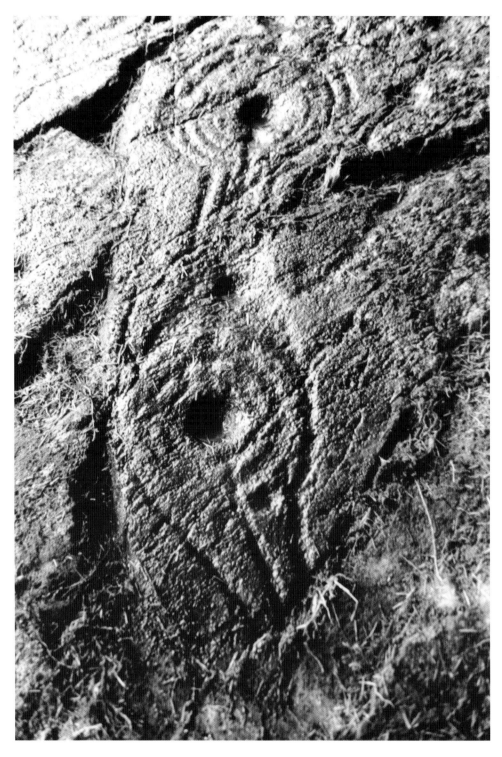

16 *Variations on a theme: unusual motifs at Ormaig, Argyll*

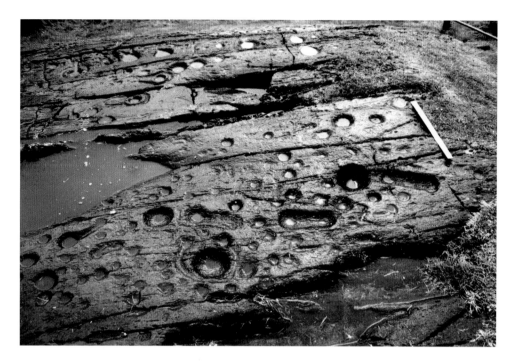

17 *Kilmichael Glassary, Argyll*

18 *Spirals and other motifs on a cliff at Morwick, Warkworth*

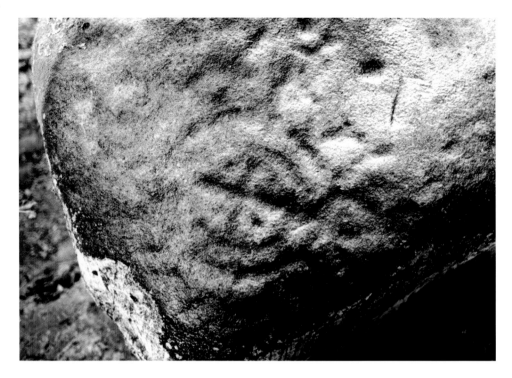

19 *Rowtor Rocks, Derbyshire.* (Ian Hewitt)

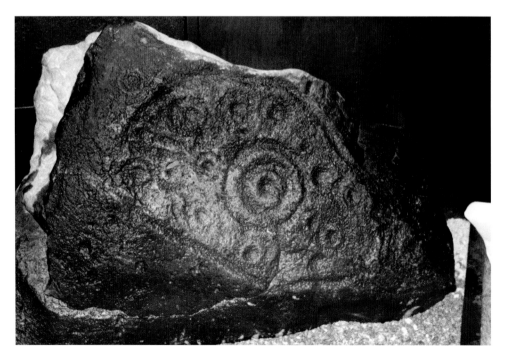

20 *The Honeypots Farm stone at Tullie House Museum, Carlisle*

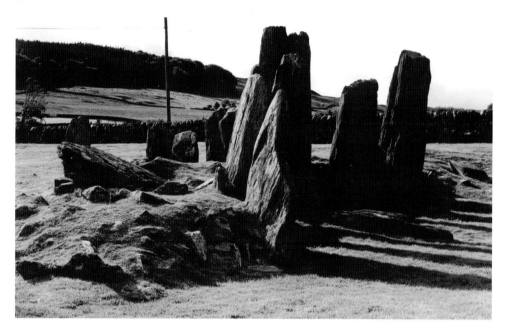

21 *Cairnholy Cairn, Galloway: a Neolithic long barrow*

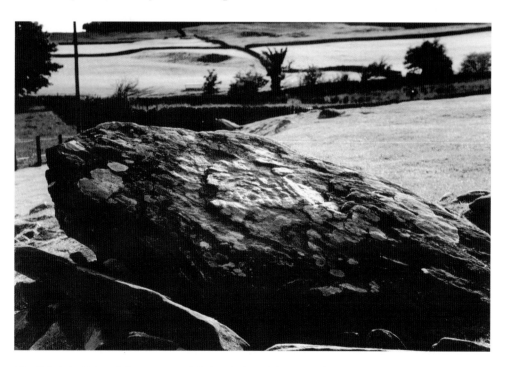

22 *Cairnholy Cairn, Galloway: an eroded, disturbed marked cist cover lying beside the cairn*

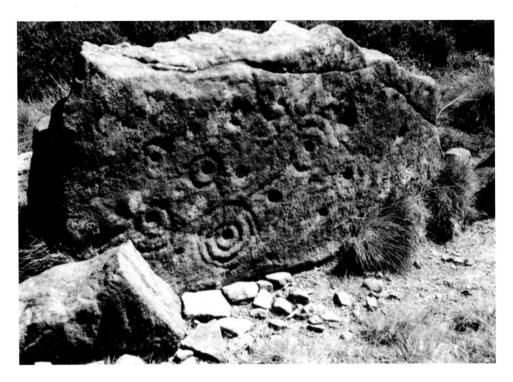

23 *An upright slab on Barningham Moor*

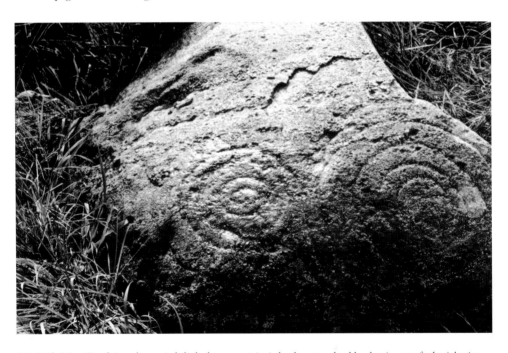

24 *Little Meg, Cumbria, where spirals linked to concentric circles decorate a boulder that is part of a burial cairn*

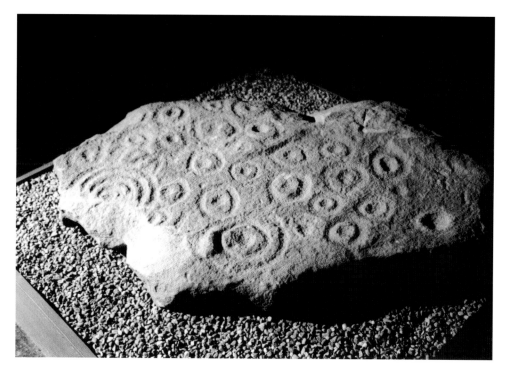

25 *The Fulforth Farm cist cover, now in the Fulling Mill Museum, Durham*

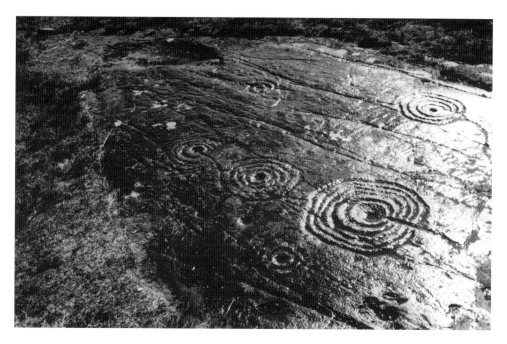

26 *An outstanding decorated flat outcrop at Weetwood, Northumberland, where the English Heritage Pilot Project field survey began in 1999*

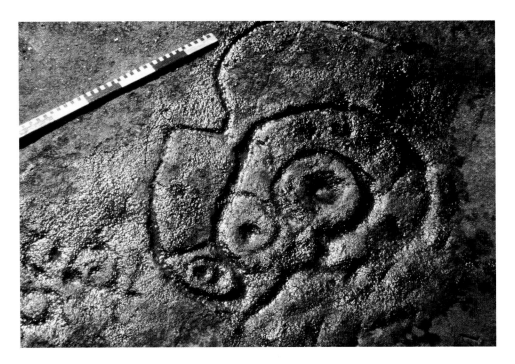

27 *An elaborate motif on Hangingstone Quarry, Rombald's Moor*

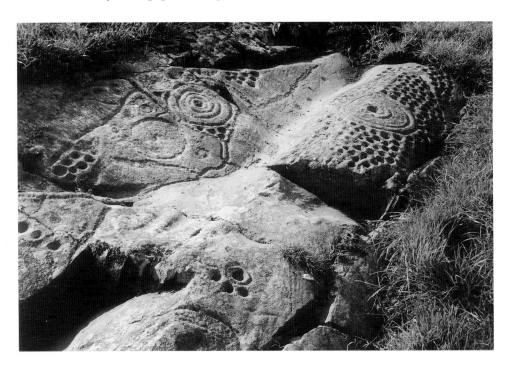

28 *An extensive decorated outcrop at High Banks, Galloway. Other parts are covered over.* (Jan Brouwer)

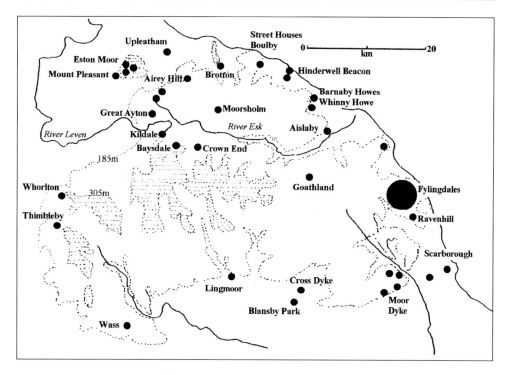

52 *The main sites of North and East Yorkshire and Cleveland*

depressions, a single cup, two cups and four faint cups; 20 cups of which two have single rings, two larger cups/basins, and an arrangement of grooves, with light pick marks. All these rocks lie in heather on common land.

2. The second cluster lies north of a path and at the NE end of a row of grouse butts, on a slope (NZ 964 013 – 764 030). A low flat rock has a cup and two concentric rings, cup, and traces of three eroded cups, and some pick marks. Another has a cup and two rings and a cup and three rings, divided by a channel midway across the rock. (NZ 965 012). The third has seven cups and linked channels on a flat slab, and the fourth has a cup and ring with connecting grooves, but this rock can no longer be found.

3. A continuation of this group north west has three other marked flat rocks, one with a cup and ring, two faint grooves and pick marks. The second has 15 cups, some enclosed by a groove. The third has two deep cups, and irregular depression, and three eroded cups. The group arcs around a burial cairn. To the south east there are three more rocks in a line close together in heather (NZ 9674 0105). One has 14 cups and another has 16, some with surrounding grooves.

4. On <u>Brow Moor</u>, north of Robin Hood's Butts (burial cairns) is a low flat rock (NZ 9622 0147) with a cup and three rings and traces of a fourth. South of this is a flat rock (NZ 9624 0152) with a cup and ring and two faint grooves.

5. On <u>Howdale Moor</u> are two marked rocks. One (NZ 9561 0123) is a large, low rock with 30 cups, two cups and rings, a comb motif, a basin, and a rectangular pecked area.

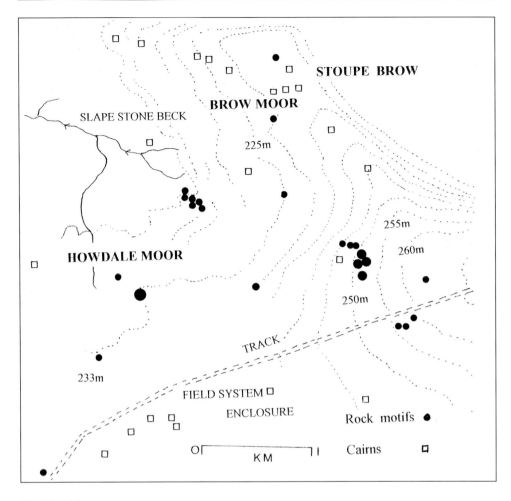

53 *Fylingdales*

6. South of the grouse butts is a large ridge-shaped boulder with two faint rings, four
 cups, and traces of five other cups (NZ 959 009).

There are other possibilities, but some recorded previously are not to be found.

Other outcrop markings appear at <u>Eston Hills</u> (NZ 564 174), <u>Aislaby</u> (NZ 658 091),
<u>Baysdale</u> (NZ 623 068) and <u>Allan Tofts</u> (NZ 828 030).

Most of the other marked rocks were found during the excavation of barrows. Most
prolific was the <u>Hinderwell Beacon</u> (NZ 794 178), with 150 marked cobbles. This mound
was enclosed by a stone circle about 9.1m (30ft) in diameter with a 1.2m (4ft) thick wall.
It contained seven cremations, two with Food Vessels. A third vessel stood by the side of
an urn with calcified bones. 150 stones had one, two, three or four cups, one having an
incised cross and another a V-shape.

Other barrows contained cup stones in the mound: several at <u>Boulby</u> (NZ 745 190),
24 cups and one cup and ring at <u>How Hill</u>, Brotton, (NZ 695 189), one at <u>Street Houses</u>

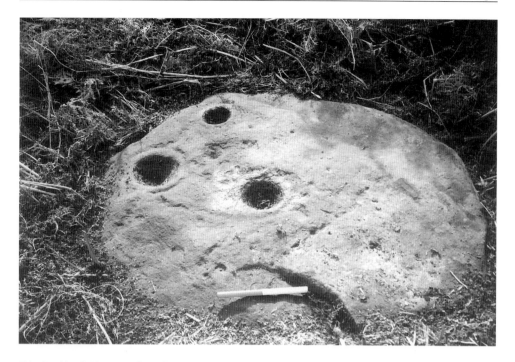

54 *Goathland (Graeme Chappell)*

(NZ 736 196), and at <u>Eston Hills</u> (NZ 574 184). Some barrow kerbstones are marked: 19 cups and three grooves at <u>Upleatham</u> (NZ 624 202); six cups at <u>Airey Hill</u> (NZ 644 167). Cups were found on barrow kerbs at <u>Barnby Howes</u> (NZ 830 131) and 30 at <u>Moorsholm</u> (NZ 691 120). Canon Greenwell reported many cup stones in three excavated barrows on <u>Wass Moor.</u>

A cup and ring with a Beaker came from <u>Mount Pleasant</u> (NZ 558 165), cup stones with a Food Vessel from <u>Whinney Howe</u> (NZ 833 145), one with a handled Beaker from <u>Guisborough</u>. Six cupped stones were associated with an axe-hammer at <u>Ling Moor</u> (SE 713 883), others with Food Vessels and urns at <u>Hutton Buscel</u> (SE 959 872), and with Beaker and urn sherds at <u>Blansby Park</u> (SE 814 865).

Thus there is an unusually high incidence of rock art in a monumental context in the region, and other marked rocks come from drystone walls, dykes, a hillfort ditch and the floor of an Iron Age hut.

In 1988 Blaise Vyner published his excavation of the 'Wossit' at Street Houses (Vyner 1988). This was a Neolithic ritual site where its palisaded trenches and central pit were backfilled with sandstone rubble, including cupped stones, found only in the upper deposits. In this layer were two cremations in collared urns. He concluded that the unusual enclosure site (thus the term 'Wossit') was Neolithic, during which time activity was short-lived, but after that activity continued until the middle Bronze Age. He noted that the cupped stones were absent from the slumped levels of the Neolithic cairn at Street House. His conclusions were: 'The deposition of rubble over the lines of the back-filled

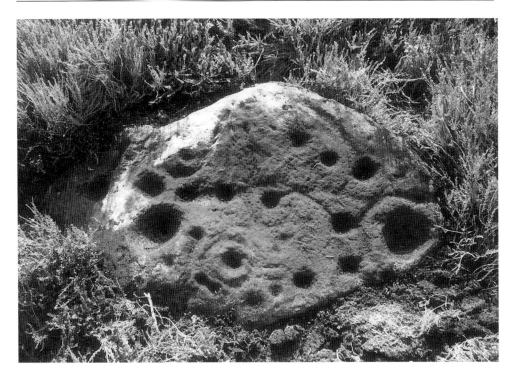

55 *Fylingdales (Graeme Chappell)*

trenches and the central pit, together with the incorporated cup-marked stones and two cremations in collared urns, can be seen as an event separated by some centuries from the main use of the same site.'

West and north Yorkshire (Ilkley Archaeological Group 1986 and forthcoming)

In this region 297 marked rocks were originally recorded and published by the Ilkley Archaeology Group in 1986, in an excellent book. The same group has since recorded a comparable number in other areas from Nidderdale in the north to the main bulk of the rock art in west Yorkshire: Washburndale, Wharfedale, and Airedale. As in Northumberland, pioneering work dates to the last century; in more recent times the work of Eric Cowling, Arthur Raistrick, Stuart Feather and Stephen Jackson has motivated the Ilkley group to go further and publish their results.

The most recent and as yet unpublished work is to the credit of Dr Keith Boughey, Anne Haigh and Edward Vickerman, with major contributions to fieldwork from Warwick Pierson and Annette Vautier. Bill Godfrey had an important part in the production of the initial volume. Without their preparedness to share their unpublished work, I could not have attempted an overview of this area. All the sites have been surveyed by Tom Gledhill and Ros Nicol for West Yorkshire Archaeology Services, appointed by English Heritage.

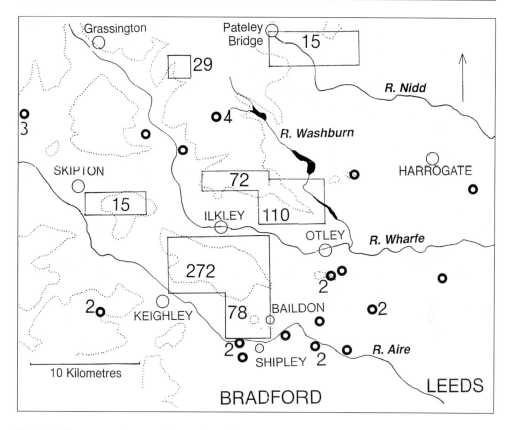

56 *A distribution map of sites with the number of decorated rocks* (Dr. K. Boughey)

637 marked rocks are now known in the whole region. 600, or 94% of all the rocks listed, lie in these watersheds: north Aire (191), north Wharfe (152), south Wharfe (192), and south Washburn (65). Almost all the marked rocks lie in the broad band of the Millstone Grit series to the east of the Pennines' anticline. The moor tops generally slope from west to east; hard bands form the edges of shallow terraces in the hillsides. There is a widespread scatter of varying gritstones and sandstones, some formed by landslip and others moved by ice. Markings are found on these bedrocks, boulders and erratics.

The absence of marked rocks below 300m OD may be due to agriculture and quarrying, although there are some in the pastures below Addingham Moorside, Rivock Edge, Morton Moor, Baildon Moor and Burley Moor. There are several recorded at low levels in the Aire valley, now destroyed or lost. As many as 411 out of the whole region's sites lie within 250m OD – 360m OD, 64% of the sites.

The patterns on the rocks show regional variations. Cups, as in the rest of Britain, are the most common symbol, and linear and curved grooves form designs, with striking results, although there is no widespread use of the multiple concentric circles that we see further north. Many of the rocks are at extensive viewpoints, not usually at the highest points, on gently-sloping ground.

Rombalds Moor

The area, of gritstone, is now moorland with heather, bracken, peat and bog. To the north is a scarp above Addingham, Ilkley and Burley, and about half the marked rocks lie along the scarp, above and below it, with extensive viewpoints north-east and north-west over the Wharfe valley.

Above the scarp is a series of plateaux on the north east, the most important, containing Green Crag Slack and Woofa Bank, has over a third (96 out of 271) of all the rock art on the moor.

On Green Crag Slack is a prominent 'enclosure' wall. An excavated area had walling that was not at all prominent until it was dug, and had not previously been identified as such. Both 'enclosures' have associated marked rocks, although these are only a few of the total number on the slack.

Although excavations at Green Crag Slack have produced some vital pottery and other artefacts, the association with supposed enclosure walling should not lead to generalisations. One conspicuous wall, marked on OS maps, has two marked rocks in the walling, one under it, and several close to the walling both inside and outside the enclosure. The walling that was excavated by Bill Godfrey and Gavin Edwards has no marked rocks in the walling, but there were three within the enclosed area. Perhaps the term 'enclosure' is misleading, as the walls appear to be deliberately incomplete. The account of the excavation was published in 1988 (CBA Forum Group 4)

The flint artefacts are of high quality, and the raw material came from the North Sea coast. These finds are associated with Grooved Ware pottery, often found in special ritual contexts elsewhere. Carbon dating from one of these concentrations gives a Late Neolithic date

To the south west is another concentration, at Rivock Edge, on another plateau, from which the land slopes to the River Aire. The land has been reforested, but about 30 marked surfaces are known. Forestation means that several are now impossible to see or even to relocate.

Although the outcrops form the scarps, there are some boulders and other earthfasts brought down by glaciers. Some of their mostly-horizontal surfaces are decorated. The boulders vary in size, with some large ones decorated at Rivock Edge. The shape of the rocks has in some cases determined the kind of decoration pecked on the surfaces. As in other parts of the country, natural features have been incorporated or enhanced to become part of the design.

Recognised settlement sites may not have come to light on Rombalds Moor, but there is a significant number and concentration of flints, from the Mesolithic, Neolithic and early Bronze Age from wide parts of the moor, particularly along its northern margins and terraces. One collector alone (Robin Hardisty) has 8000 flints from the local moors, mostly from Rombalds Moor.

Some of the best known rocks on Rombalds Moor are on or below the north west edge, away from the more prominent clusters. These include: Addingham Moorside (SE 078 472), the flat top of which is covered with cups, grooves, rings and basins. There are 44 cups, and nine cups and rings. The Piper Crag stone (SE 084 470) has cups, rings and grooves on smooth gritstone. The Badger Stone (SE 110 460) rises like a triangle with a

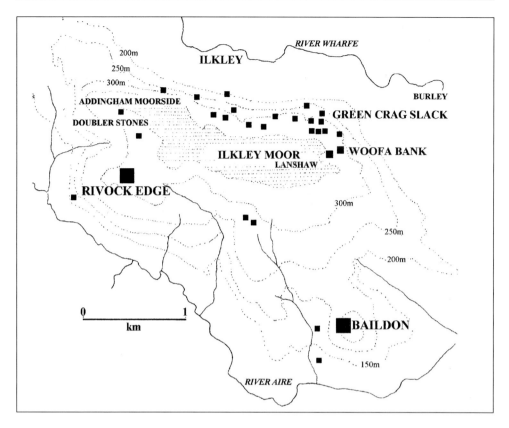

57 *Rombalds Moor: Main sites*

rounded top from the grass, and its coarse grit has a marked SW face, some on the east, and a cup on the NE face. The design is complex and crowded to the west, where cups and enclosing grooves are interlinked with grooves. To the east on the same face is a serpentine groove that is like the beginnings of a swastika, a rare design that on the Swastika Stone (SE 095 469) is regarded as Iron Age or later. The Barmishaw stone (SE 111 464) is flat topped, fairly smooth grit with worn cups and grooves and the famous 'ladder' motif which is confined to this area in Britain. The Panorama stone (originally at SE 103 470), removed in 1890 to a railed enclosure at St.Mary's church, Ilkley, has more examples of this ladder motif and sets of multiple rings that are sadly being eroded away.

On the north east of the moor are some well-known marked rocks, examples of which are illustrated here.

On the edge of Hangingstone Ridge (SE 128 467), an expanse of bedrock, are many cups, cups and rings and grooves. There is a strong individuality at work in arranging the motifs into panels. Quarrying may have removed many others. With a lower profile, Backstone Beck (SE 127 462) is horizontal, almost flush with the peat and bracken, and the slab has about 57 cups, four long grooves, a cup and ring, and cups linked by grooves or partly surrounded by grooves.

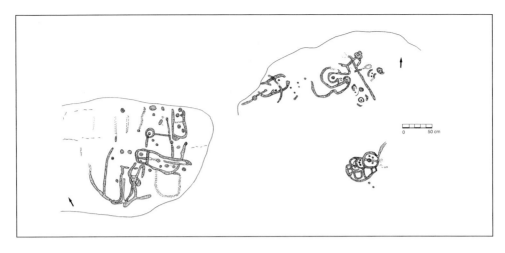

58 *Hanging Stone Ridge (right) and Rivock Edge (left)*

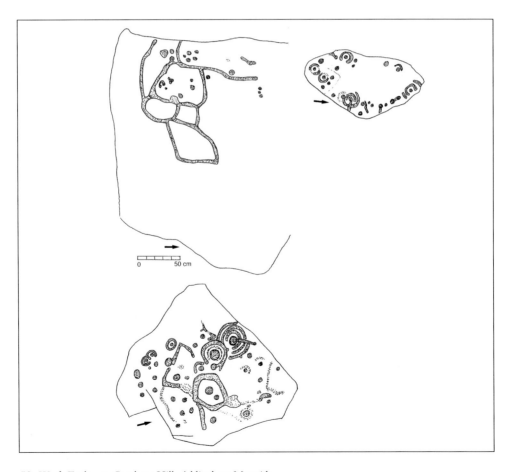

59 *Woofa Enclosure, Stanbury Hill, Addingham Moorside*

The siting of the rock art is not confined to good viewpoints. Most upland sites have extensive views, if there are no trees. The smaller marked rocks and decorations often lie well back from any scarp. The absence of settlement sites suggests that the area was used for pastoral and hunting activities. No marked rocks are known near the stone circles or the really large cairns, which occupy different areas. The three recognised cairnfields on Rombalds Moor are Stead Crag, Woofa Bank, with the smallest on Hawksworth Moor in the SE sector looking over Airedale from the north. All these include marked rocks.

Skipton Moor
Horse Close Hill, which consists of grit and shales, rises to 373m OD. The Skipton area has 15 marked rocks, nine of which are on this hill and two at Snay Gill on lower ground immediately below. Horse Close Hill overlooks the valley of the Aire, at a level of c.180m OD.

Baildon Moor
Baildon Hill, at 282m OD, overlooks to the northwest a major art cluster on Low Plain, a high plateau at c.250m OD. Further marked rocks lie on the west slopes and on Brackenhall Green, a lower terrace above Loadpit Beck, a tributary of the River Aire. Mining for coal with bell pits and attempts at agriculture have disturbed the prehistoric landscape of the Low Plain.

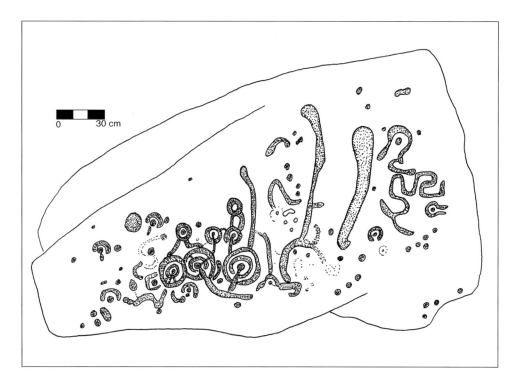

0 30 cm

60 *The Badger Stone*

On the lower of two north-facing plateaux (Low Plain) close to Dobrudden Farm there are 37 of the 44 Baildon Moor marked rocks, 28 of them lying roughly in two lines, and they have two or three badly disturbed barrows among them and old enclosure walling. In the valley to the west, at 170m OD, are other marked rocks, on flat land beside streams, with the remains of a ring cairn and an enclosure of unknown date.

There have been other rocks reported in the past that cannot now be found; it is possible that the distribution pattern of rock motifs also reflects disturbance and destruction.

The researchers in the whole area of Baildon Moor point out that the majority of marked rocks 'are small, of fine grit, with horizontal or near horizontal surfaces, low in the ground, hidden by the grass, and close together.'

The River Wharfe watershed

This region is a mix of published and new sites, and the 'old' or southern ones include the whole of the northern side of Rombalds Moor south of the Wharfe together with the 'new' areas north of the Wharfe. The former, those that figure in the earlier published survey, now number 192 sites, the north has 149, making a total of 341. Marked rocks are found

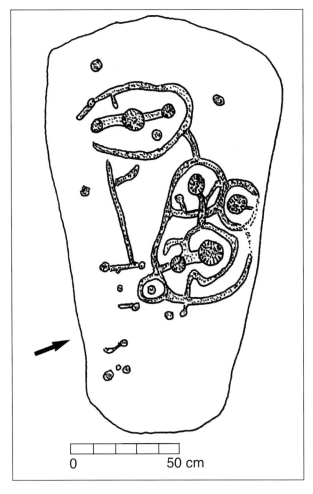

0 50 cm

61 *Dobrudden (SE 1376 3988)*

in the greatest numbers on the sides of the moderate uplands that border the middle sections of the river valleys. Whereas the survey of Rombalds Moor covered less than 150sq. Km, the study of the concentration around mid-Wharfedale and smaller groups in adjacent regions covers 2500sq.km. The marked rocks are in a band 8 km. long and 1 km wide on Middleton, Askwith, Snowden and Weston Moors.

A major site is at <u>Skyreholme</u>, where 33 gritstone boulders and other earthfasts have simple cups, some grooves, and a few rings. Some cups are linked by grooves. The rocks lie at c.350m OD.

<u>Langbar Moor, Middleton Moor and Middleton Moor Enclosure</u> form a major site, with marked rocks below 300m OD on rough gritstone. Some rocks have only a few cups, others multiple cups, and grooves. 18 of the 70 rocks have rings (i.e. 25% of the total), two of which have triple rings and one, exceptionally for the region, has five rings. <u>Askwith Moor</u> lies further east, and has 26 sites with cup marked outcrops, earthfasts and boulders (some having been moved), with the decoration formed of simple cups, grooves, and the occasional ring. Some of the cups are of doubtful origin. The locations are between 230-290m OD.

<u>Weston Moor</u>, with 15 sites, lies to the SE, where four out of 15 rocks have rings, one of which, the prominent <u>Greystone Rock</u>, is a large isolated boulder with angled grooves, cups, and two cups with three rings. In the same area are cairns and field clearance heaps. <u>Snowden Carr</u>, with 49 sites, between 220m-260m OD, is perhaps best known for 'The Tree of Life Rock' (SE 1779 5123) and 'The Death's Head Rock' (SE 1797 5116), which lie close to each other and among other marked rocks. These rocks are not 'complex' in the sense used of multiple concentric circles of other areas, but the more limited symbolism of cups and grooves is put to equally good use. The illustration shows how a central stem and its offshoot-grooves incorporate cups to form a plant-like effect. The other has four cups linked and enclosed by grooves, unconvincingly suggesting a skull to some people. There is a settlement and cairns in the same area. Among the many marked rocks are cups, curving and linear grooves, and mostly single rings. A recent discovery in this area is of a large sloping rock at SE 1806 5125, now covered over, that has about 40 cups, some large, many with single rings and curving grooves, forming a complex design. It lies SE of Snowden Crags, east of the crags in steep pasture where it has an extensive outlook. Close by is a rock with cups and rings, and grooves, and another with 20 cups, two very large, and one with three rings.

Closer to the river, eastward from Snowden Carr, are 6 marked rocks at <u>Ellers Wood</u>. (one at SE 1895 5099). These rocks do not have an extensive outlook, for they are almost at the bottom of a narrow river valley, which may have been even more densely wooded in Prehistoric times than it is now.

Thus we have a series of clusters of marked rocks on the moorland stretching north above Wharfedale from the Washburn on the east to Langbar Moor and Middleton Moor on the west. Fieldwork continues to find new rocks in this marginal land. Modern settlements tend to concentrate on the major river valleys. The survey shows again that a pastoral-hunter economy is likely to have been the most successful in the high moorland, taking into account changes in climate and vegetation.

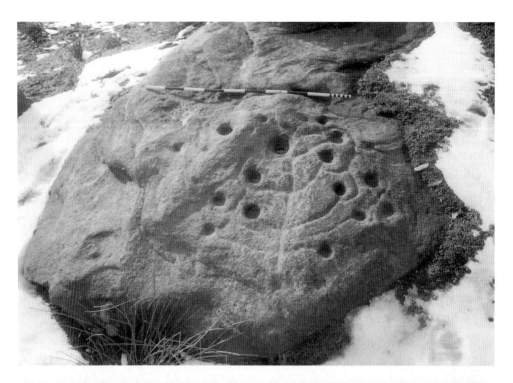

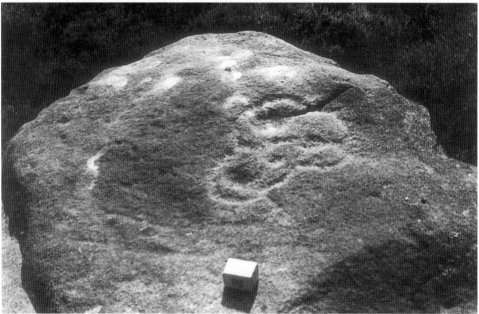

62 *a.The Tree of Life* (E.Vickerman);.*b.The Death's Head Rock*

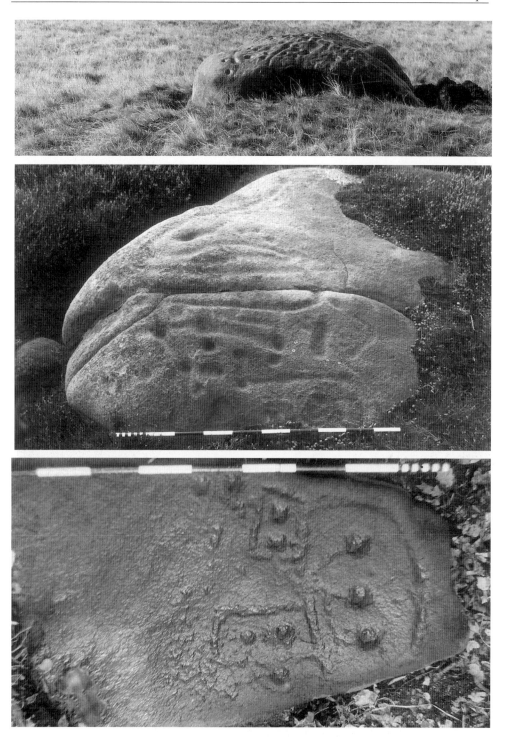

63 *a.Pike Bent Rock; b.Burnhill Kiln Allotment (Skyreholme); c.Ellers Wood (Washburn)* (E. Vickerman)

Nidderdale

The Nidderdale region has 16 marked rocks, from Brimham in the far north (SE 2039 6478) to sites east of Pateley Bridge, where the decorated rocks are largely on scattered erratic boulders, some with up to 80 cups, rings and complex grooves. The sites have a view over the River Nidd; the Brimham Rocks site overlooks the valley from the foot of a spectacular outcrop of eroded rocks that form an impressive natural focus in the landscape, rather like the sandstone scarps in Northumberland. The motifs on the rocks in this region include a rosette at Riva Hill (SE 2205 6393), and are not at the top of the hills where they would have the best outlook. Those at Guisecliffe are below the steeper slopes.

The importance of having the many new sites documented cannot be over-stressed, and one hopes that this may be done with a publication of a quality equal to that produced in 1986 by the Ilkley Archaeology Group.

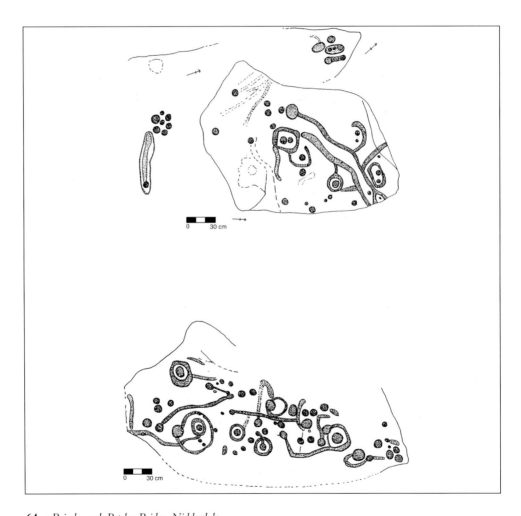

64 *a.Brimham; b.Pateley Bridge, Nidderdale*

The Peak District (Barnatt and Reeder 1982)

The most southerly concentration of rock art is in Derbyshire, with one marked rock over the border in Staffordshire. The distribution on either side of the River Derwent shows more associations to the east with cairns and a stone circle, although at Gardom's Edge the motifs are on outcrop rock.

Overall, the area is not comparable with the regions already examined in numbers of motifs, but there are some very interesting characteristics. Much of the recorded rock art has been moved to museums or another place in the landscape, and some lost.

West of the Derwent
West of the Derwent Gardom's Edge 1-2 (SK 2730 7301) is outcrop with motifs, some of which have been covered over for preservation. One is a complex design including two touching oval grooves containing cups, and a large cup with two rings. The site is east of a hillfort. Site 2 (SK 2752 7328) had two rocks, now at Sheffield Museum, one with a single cup and the other a boulder with a flattened circle containing 13 cups.

To the north on Ramsley Moor there is a cluster of ritual monuments, including a barrow with three marked stones, two with single cups, and one with two cups.

A ring cairn, known as Barbrook II, sometimes referred to as a stone circle, (SK 2775 7582) lies 300m from the cairn; on a stone now in Sheffield Museum there are four cups on the edge of one face of a small triangular slab.

Ian and Irene Hewitt pieced together two flat slabs of stone that had been lying apart, that formed a decorated cist slab, the design forming a chevron pattern. It now lies to the NNW of that cist. In Sheffield Museum are nine cups surrounding a central one on the flat base of a stone; the curved top has four lines of cups, 15 in all.

Barbrook 1 (SK 279 756) refers to a stone circle 50m ENE of the marked cairn which has a cup and ring now in the museum.

There are other small cairns in this area.

At Birchin Edge (SK 2871 7255) a barrow was found in 1957 that had 12 cups on a stone that was part of a cist. Stone Law (SK 290 716) had two stones from a barrow, both lost, with a single cup and three cups. Park Gate stone circle (SK 2804 6851) has two cups on the tallest stone in the circle.

East of the Derwent
The Eyam area has a further group of monuments, the Stanage barrow (SK 2154 7865), two sites on Eyam Moor (SK 2243 7932 and 2291 7901) and Wet Withens stone circle (SK 2255 7900), which have cups. On a rock protruding from the disturbed Stanage Barrow are 6 cups on the upper surface, 8 cups on the west side, and four on the south side.

South of these are two sites at Ball Cross (SK 228 691) and Calton Pasture (SK 2338 6855). The Ball Cross rocks were found at Bur Tor hill fort, which they pre-date, and are at Sheffield Museum. One has 8 concentric rings on a broken boulder, one has a single cup, and another has 12 cups inside a flattened ring. A fourth has a cup and single ring, a fifth has 7 cups on a triangular stone and a cup and duct; one has three cups arranged in a rough circle.

At <u>Calton Pasture</u>, found near to a barrow, is a very interesting design of a cup in two concentric rings with a duct coming from the cup, with four motifs arranged around it: a cup linked to a cup and ring, and a cup and ring linked to another cup and ring. This is now located at the Derbyshire Museum Service.

South sites

South of where the Bradford, Lathkill and Wye join the Derwent are three more sites.
<u>Bleakley Dike</u> (SK 2157 6340) has a rock found in a stream, now in Sheffield Museum. It is a boulder with 20 cups pecked evenly over the surface.

<u>Rowtor Rocks</u> (SK 2355 6215) form an outcrop of Millstone Grit, on which are some very interesting designs. Some are illustrated, but in addition there are single cups, and cups with single eroded rings. The serpentine groove is unique in this area. The design on the north side of the outcrop 5m. down a steep slope centres on a rare cross within two concentric rings, with four cups in the segments thus formed. Around the circumference are 10 ovoids, arranged like the petals of a flower. There are isolated cups and two cups with single rings.

<u>Robin Hood's Stride</u> (SK 2247 6225) is an outcrop block with a ring on top.

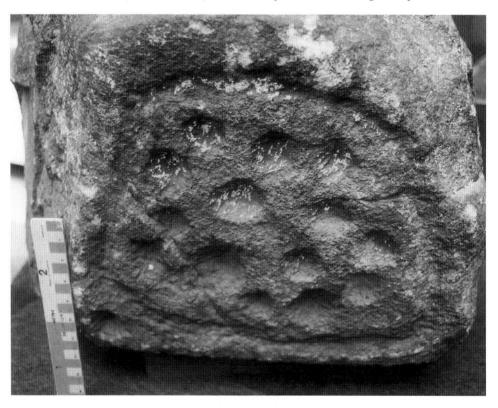

65 *Gardom's Edge (now in Sheffield Museum).* (I.Hewitt)

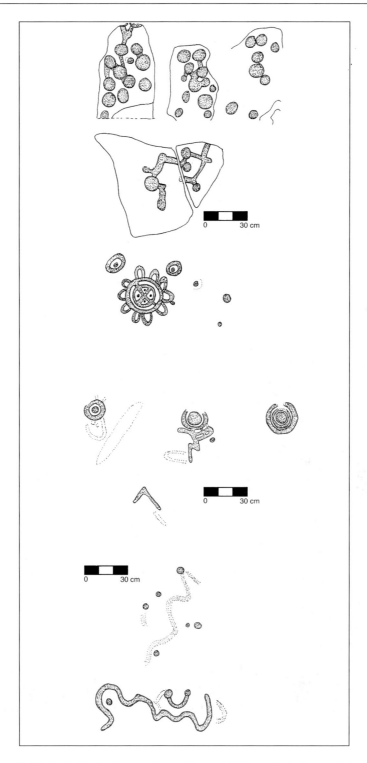

66 *The Peak District: Stanage Barrow, Barbrook II Stone Circle, Rowtor Rocks*

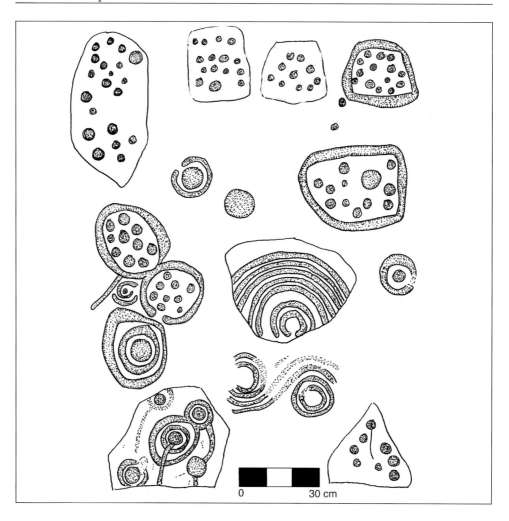

67 *Peak: Bleakley Dyke, Barbrook II stone circle (two rocks), Gardom's Edge, Burr Tor (and below), Calton Pasture, Ball Cross*

Other sites

As there is only a limited amount of rock art in this part of the world, the following complete the picture, and may indicate where more may be found:

Brund, Staffs. (c. SK 100 615): a single cup on a rock fragment from a barrow.

Elkstone (SK 050 585): a single cup from a barrow.

Burbage Rocks (SK 2678 8156): 6 cups on scarred outcrop.

No attempt has been made in this survey to look at motifs in the landscape and on barrows and stone circles separately. There is a strong coincidence of rock art with monuments, and the siting of both is at prominent places. No rock art has yet been found in the valleys, and it is sited to overlook lower ground.

The south-west of England, and Wales

Rock art in these areas is not prolific and not well known. Most of the rocks come from burial cairns. References to them are scattered, and I am grateful to Irene and Ian Hewitt for their thorough investigation of the references and sites (Pers. comm.). It is not possible to name every site, and what follows is a selection.

There are no sheets of decorated outcrop. Given the large area, it is not surprising that the form, method, medium and context vary considerably.

In Cornwall the West Penwith Survey (Russell, 1971)) lists many cup marked stones and pebbles in various locations such as walls, hedges and gardens.

At Stithians Reservoir (SW 716 355) ten cupped stones came from a stony field close to the edge of a marshy valley bottom. The field is now under water. There are 1-20 cups on the rocks, some appearing to be in a circular, arc-shaped or straight-line arrangement. They are all in an undated context.

In the Dartmoor National Park there are three locations: Holmingbeam (SX 559 651), where a granite boulder built into a wall has 14 small cups and ovals; Dunstone (SX 716 758), which is a granite boulder with at least 13 shallow cups: and Brisworthy (SX 559 651), where cupped granite boulders have been built into trackside walls (Greeves 1981:27).

Others have turned up in more helpful contexts.

Cornwall

There are 14 locations of marked rocks in Cornwall in a monumental context. Elsewhere in Britain some marked rocks are incorporated into cists and into the material from which barrows are constructed, and in these examples, the same applies.

The Scillonian Chamber Tomb of Tregiffian, (SW 430 244) has an entrance-flanking stone with single and connected cups of a Neolithic period.

A large cupped slab has been recovered from a barrow at Tregulland (SX 200 867) (Ashbee 1958; 189), built into the inner kerb, marked on both faces. In the same cairn ring 'were numbers of cup-marked slate slabs, while surmounting the cairn-ring, in approximately the centre of the walling, was a cup-marked block of coarse sandstone'. Elsewhere, Ashbee says, 'Cup-marked stones, found among the stone rubble infilling the disturbance, hint at a stone-built, -covered, or-lined grave.' From what he called 'the final envelope' within the central area of the ring cairn, he found 'an elaborately cup-marked and channelled rectangular slab'. The Food Vessel at this level defined the burial as early Bronze Age. All the marked rocks in the cairn could have been reused material, but their presence in the central burial area gives them a special significance. Many of the barrow stones are cupped.

Hendraburnick, Davistowe (SW 132 881) has cup stones on the capstone of a long-barrow chamber.

On Treligga Common, two excavated barrows of the cemetery had rocks with motifs. In Barrow 2 (SX 0450 8599) there was a mound of slate and some quartz over a rock-cut cist burial pit covered with a corbelled roof. The central cist had a large capstone over charcoal and cremations, and at the edge of the cist was a cup marked rock. Other cupped

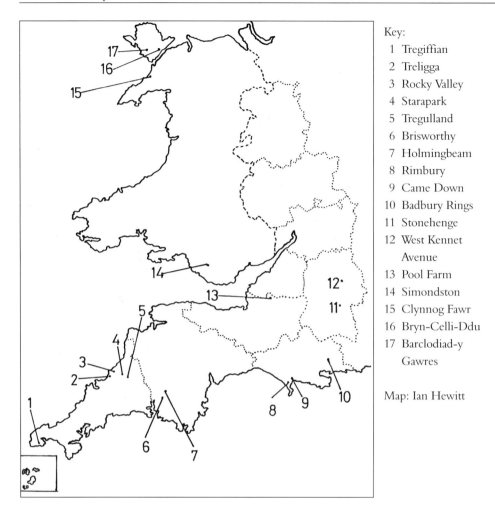

Key:
1 Tregiffian
2 Treligga
3 Rocky Valley
4 Starapark
5 Tregulland
6 Brisworthy
7 Holmingbeam
8 Rimbury
9 Came Down
10 Badbury Rings
11 Stonehenge
12 West Kennet
 Avenue
13 Pool Farm
14 Simondston
15 Clynnog Fawr
16 Bryn-Celli-Ddu
17 Barclodiad-y
 Gawres

Map: Ian Hewitt

68 *Map of sites in the south-west of England, and Wales*

stones were mentioned; outside the kerb wall was a stone with three cups, another with one, and a large blue slate slab with a cup mark. Although this cairn was small, it was apparently constructed with rituals that involved a mortuary house, charcoal, burning and cupped stones.

Barrow 7 (SX 0431 8515) was narrow-ditched, with an inner walled mound covering a central funeral deposit. A small cist and inverted pot were found under the surviving part of the mound. Two cupped slabs were found, one *in situ* beneath the inner wall, a slate slab with three cups, and a small cobble with a single cup, out of context.

The Starapark Barrow (Trudgian 1976, 49) (SX 133 863), made of earth, was ploughed, and three marked stones were removed. One has a fine meandering groove associated with cups on a slate slab, located outside James Smith School, Camelford. Two other stones were cupped; one that is also outside the school has a large oval, a large cup and five smaller ones.

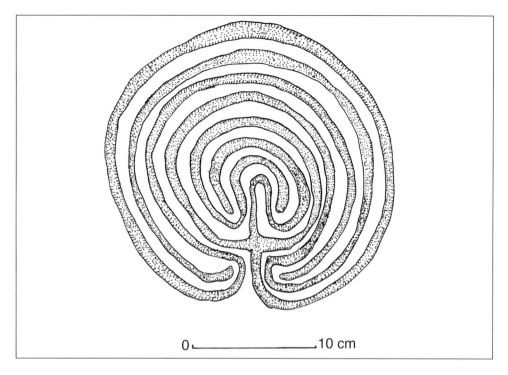

0 ⌞_____⌟10 cm

69 *A labyrinth at Rocky Valley*

Tichbarrow (SX 146 881) is an area that includes Starapark, Tregulland and several other barrows. 31 marked or worked stones were reported in an undisturbed Bronze Age layer. All except three were of local schist. Many had cups on two faces. One stone was bigger than, and different from, the rest in that it had three 'true cup-marks (not pit-marked).' Some stones were perforated, notched and artificially rounded, and lay outside the kerb of this round barrow.

The Penhale Barrow, Nancekuke (SX 676 4620) was a ditched barrow, made of a mound of turf. A holed and cupped small stone was found among the layer of stones on the old ground surface.

The Lousey Barrow, St.Juliot (SX 134 932) had two shallow, pecked cups in a sandstone pebble at the bottom of the barrow ditch.

The Three Brothers of Grugith (SW 761 198), near Helston, are three boulders defining a space of average cist size, and the 'capstone' is recorded as having nine cups, but this is questionable.

Castallack Menhir (SW 454 254) has small cups in a horizontal line.

Apart from the Starapark slab, all these finds have only simple cups, but the Tintagel labyrinths at Rocky Valley (SX 073 893) are on vertical outcrop. They are very well made; they are not in a 'cup and ring' tradition. There is no context to help date them. They closely resemble the miz mazes of the chalklands.

Dorset

The <u>Badbury</u> barrow contained a sandstone block with two pecked daggers with hilts, two flat axes with expanding edges and five cups. This decorated part, in the British Museum, was broken off a half-ton slab that was thought to be the cist cover. The interments were with Food Vessels, and there were cremations in Early/Middle Bronze Age Urns. Flat axes used as motifs occur at Stonehenge and at Kilmartin, Argyll.

The <u>Came Down Barrow</u> (SY 685 859) (Warne,C, 1886) is a large barrow that contained two flat stones from 'the summit of the cairns', with 'a series of concentric circles incised upon them…unequalled in Dorset'. They are still in the cairn.

Somerset

<u>The Pool Farm cist cover</u> (ST 5375 5417) is on display at Bristol City Museum. A large bowl barrow, unditched, and made of earth, covered a large cist with its floor on the original ground surface. The cist was made of different kinds of stones, and contained cremated bone. After the excavation in 1931 the mound was removed, but the cist was left until it was re-examined in 1956. The discovery of motifs at Stonehenge may have led to a more thorough search, and the fine-grained sandstone was found to have nine cups, six footmarks and an uncertain motif. The cups are deeper than the footmarks, and occupy the centre of the slab.

This is a unique design on a cist cover, very rare elsewhere, but the motif of feet appears at the <u>Calderstones</u>, Merseyside and the <u>Cochno stone</u>, southern Scotland.

The <u>Culbone Standing Stone</u> (SS 832 474), part of a stone row, has been re-erected. It has a ring cut by one projecting radial of a cross. Elsewhere these crosses fit into a prehistoric context, though rare, as in Derbyshire, for example.

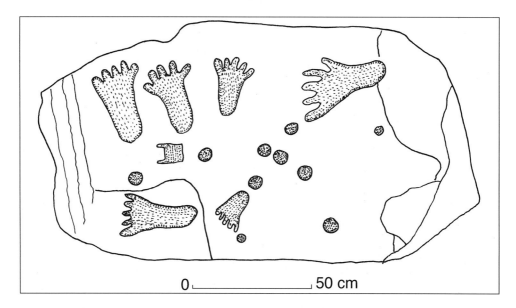

70 *Pool Farm cist cover*

Wales

At the <u>Simondston cairn,</u> Bridgend, there was a cupped slab in a cist containing two Food Vessels. The <u>Crick Barrow</u> had two large cup marked stones in the kerb. At <u>Trefael</u> a large slab has its surface covered with cup marks, and was thought to be a cist capstone. At <u>Trellyfiant,</u> a stone chamber that had been part of a barrow had shallow cups on the capstone's upper surface.

The Chambered tomb of <u>Barclodiad y Gawres</u>, Anglesey, is described elsewhere in the text. A second tomb, with a complex development there is called <u>Bryn-Celli-Ddu</u> (SH 5077 7020), which has a standing stone inside the tomb with a complex maze or zigzag pattern. <u>Llanbedre </u>church (SH 584 269) has a six-turn spiral, probably the best in Wales. At <u>Clynnog Fawr</u> in north Wales are four large stones supporting a capstone that has cups on its surface, some joined by grooves.

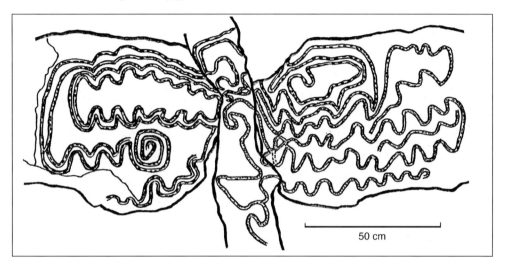

50 cm

71 *Bryn-Celli-Ddu*

Galloway (Morris 1979, Bradley 1997, Van Hoek 1995)

Galloway has one of the highest concentrations of rock art in Britain, but has very little of it in monuments. The distribution of rocks with motifs does not occupy the whole of the coastline, but is restricted to a 40km band along the coast that extends 15 km inland.

The map shows how the art clusters around peninsulas that are the estuaries of major rivers. The coast is fertile; it is used today mainly for pasture, and in the past may have been fringed by marshland. The coast is easily accessible from the hinterland.

The proximity of the sea to many of the marked rocks has made it obvious why so many have extensive sea views. Those who see history as invasions or movement of settlers into the area from elsewhere point to the location of suitable landing places along this coast for such incursions, but it could just as easily work the other way: local people fished or launched their own explorations from here.

72 *Map of sites in Galloway. The size of the filled circles denotes the concentration of marked rocks*

Away from the coast around Cairnholy the land becomes steeper and opens up into large tracts of moorland. In other parts, away from the sea, the land is broken up into basins, divided by rock outcrops and dykes, and there are small pools and lakes. Most rock art is in shallow valleys on or around the coast. Whereas megalithic structures such as the two Cairnholy cairns are close to the sea, round cairns favour isolated hills.

Richard Bradley's survey reveals that simpler motifs appear close to the sea, with wide views across the river valleys that run to the shore, concentrated in areas favoured by modern farms, with direct access to the sea.

Some sites do not have 'wide views'; there must be reasons other than that for their siting. We have seen in other parts of Britain that although most rock art is sited at the best viewpoints, some can mark an important water source, for example, or a limited area where there may be a watering hole. The High Banks site was close to a source of water. Torrs and Blairbuy are also near to water sources.

Richard Bradley sees the simpler art being in areas that are best suited to all-year round occupation, but the more complex art is less consistently placed, some on higher ground. That the latter overlooks the coast may be dependent on what rock was available for marking.

'The simpler carvings appear to be mainly in settlement areas, whilst some of the complex rock art is located on higher ground' leads Richard Bradley to the suggestion, also based upon work in other regions, that the 'message' in rock art was for different audiences. He suggests that the placing of motifs could have something to do with the search for food, or for ritual, but he warns that there is too much supposition in this.

The Reading University survey area looked at unmarked as well as marked rocks to see if there was a special reason for choosing one rock surface rather than another. The survey was not concerned with finding more rock art, but with the logic of its distribution. The initial recording of motifs on a regional scale was done by Ronald Morris, followed by Maarten Van Hoek, who added considerably to the data.

Van Hoek distinguishes five major linear groups, each centred on a 'landing' place:

1 Knock to Balcraig (Monreith Bay) 2 Eggerness-Claunch (Garlieston Bay)
3 Mossyard-Cauldside (Fleet Bay) 4 Senwick-Clauchandolly (Brighouse Bay)
5 Balmae-Bombie (Balmae Ha'en).

He observed that three of the linear groups 'seemed to be focussed on the highest hill in the area, encircling it, and having a concentration behind the hill'. He notes the way the rock art abruptly ends in all groups.

Over 400 marked rocks have been recorded in Galloway, although some may no longer be found. Prominent among them are cup and ring motifs, and there are more spirals in the landscape than anywhere else in Britain. The latter do not have the variety of motifs of a site like Morwick (N.), but are impressively well spread

A selection of sites follows. The rocks are mostly greywacke, metamorphic slate, soft enough to peck designs with a hard stone pick. These pick marks are visible in many of the motifs. The vast majority are on outcrop, on about 300 panels. About 100 outcrop panels have cups only. This is easily accounted for; the most accessible rock is used, and the picture contrasts with County Durham, for example, where there is little outcrop but scattered glacially carried slabs. Half the sites are at 10-70m OD, and 36% are at 90-120m OD. The hill-country sites are generally on the lower slopes.

With such a wealth of sites to choose from to illustrate the rock art, a selection has been made that takes into account their accessibility or special nature. All have been documented, but are sketched rather than drawn accurately (e.g. there is no width to grooves, and the relationships of motifs within a panel are not clear).

A general characteristic of the landscape is that it is undulating, with extensive outcrop ridges and small hillocks. There is an abundance of open views, mainly because the decorated rocks are close to the sea, overlooking it. There is some boggy ground. In hilly country some of the streams cut deeply. There is some modern arable, much pasture, and rough land characterised by gorse and bracken. Some important sites are in danger areas, used as military ranges. With these general observations as background, each area of rock art has to be seen in its specific setting; designs, although sharing similar symbols, must be examined to see if there are individual characteristics. For example, spirals are relatively plentiful and concentrated, some areas have unique decorations, and others have rare motifs such as 'keyholes' and 'rosettes'.

It is convenient to subdivide the coastal area into peninsulas: The Machars of Galloway, Gatehouse-Creetown, and the two peninsulas that frame Kirkudbright Bay. These areas have most of the rock art. Reference will be made to limited sites; the rest are all well documented. Grid references are given for only one rock in a regional cluster.

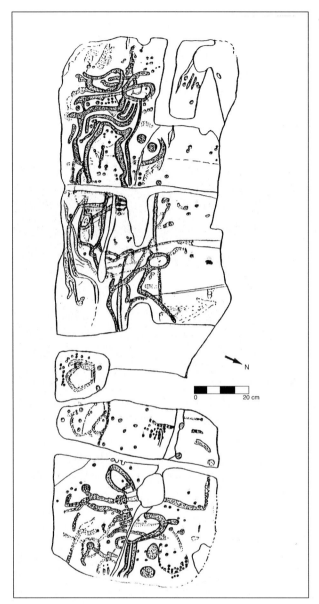

73 *Eggerness deer*

The Machars

The main sites are <u>Glasserton Mains</u> (NX 405 373) which has many cups and concentric rings, gapped and ungapped. <u>Knock</u> (NX 364 401) has some unusual motifs, including spirals and a serpentine groove, an incised grid, and an interesting use of enclosing grooves.

<u>Blairbuy</u> (NX 371 414) has linked spirals, cups and multiple rings. One figure of cup, duct and five rings has five parallel grooves at a tangent to the outer circle.

<u>Balcraig</u> (NX 377 443) includes fenced-in outcrops with some spectacular multiple cups and rings around a central cup. Almost all are ungapped, and one has nine rings.

<u>Drumtrodden</u> (NX 362 447) is accessible, fenced off, and protected. There are sheets of greywacke in three areas, and scattered on them are many motifs based on cups and rings. Many follow the lines of outcrop, and there are many multiple concentric circles.

One of the most interesting (NX 3627 4471) has six cups with 5-6 rings all linked together in line with a groove. Included as an integral part of the design are two spirals, one right-handed and one left-handed. The part that has been exposed is eroded, the rest fresh. The three areas at Drumtrodden have 21 panels of varying size and use of the surface.

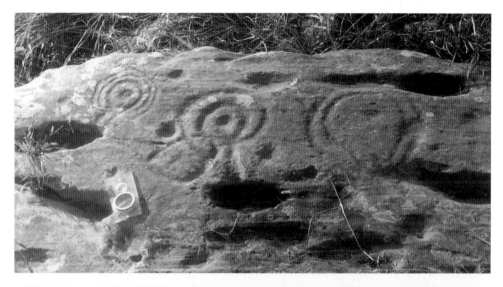

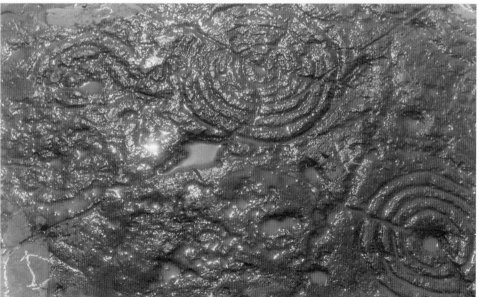

74 *Broughton Mains 1 and 2* (2 is by R.W.B.M)

Eggerness (NX 486 472) overlooks Garlieston Bay, and is now famous for two kinds of motifs found there: spirals and animals. The most spectacular, a long slab of rock with deer motifs, now covered over, is more likely to be Iron Age than early Prehistoric, but it has two large cup marks on it. It is closest to the sea, and the deer are to be viewed with the sea as a background. The animal imagery is also present to the north, as part of a cluster of outcrops that have spirals, midget cups and other motifs on 7 panels. There are three S-shaped spirals out of sixteen, among them and a cross in a ring. The animals may be deer or horses, and three are running. The Penkiln sites, apart from two small spirals, concentrate on cups and rings with a scatter of cups, cups with single rings, some gapped, grooves, and a very interesting variation exposed by Margaret Morris (NX 478 485). Culscalden (NX 471 484) and North Balfern (NX 433 508) have three panels.

Broughton Mains (NX 458 456) is inland, with two outstandingly interesting sites. The first is a small ridge that stands clear of a field; the second is now covered. The latter has multiple cups and rings, mostly linked, and scattered cups and rosettes.

Claunch (NX 427 481) and Culnoag (NX 417 469) are in a similar inland area, on outcrop ridges in pasture and arable. There are multiple concentric rings around cups, and two sets of ten and seven parallel grooves. This parallel groove feature may also be seen at Blairbuy, for example and at Ormaig (Argyll).

Gatehouse-Creetown

Some stones from this area of extensive outcrop have been moved.

Still *in situ* is a marked cist cover at Cairnholy Cairn; this will be discussed elsewhere.

Among the sites are Upper Newton (NX 550 555) and Laggan Mullan (NX 561 552), the latter with motifs that are simple in that they consist of mainly of cups and cups with single rings. Cauldside Burn (NX 528 573) includes a right-hand spiral of six convolutions. Cairnharrow (NX 540 568) has five concentric rings, central cup and two radial

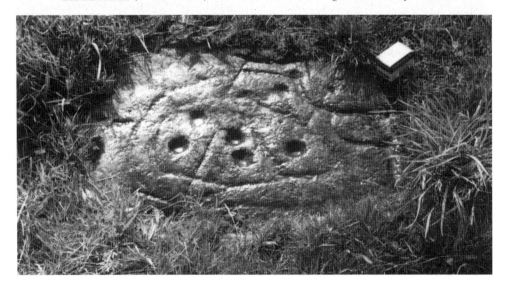

75 *Torrs*

grooves and satellite cups and rings. Mossyard (NX 547 520) has a number of motifs on fractured outcrop that includes cups and rings, one figure having two grooves running from the inner ring, and another of the keyhole type.

Cairnholy (NX 515 546) has a large outcrop standing well above the ground with cup clusters, some in a domino pattern, and cups and rings, gapped and ungapped. Other rocks in the same area have similar markings.

Kirkmuir (NX 513 540) motifs form a line on low outcrops on the west slope of the valley, including cups with single rings or penannulars, some with ducts.

Kirkudbright

There are two main areas of rock art accessible from Kirkudbright: to the west of the bay, and the very prolific area to the east, beginning at the coast and stretching northeast.

The western area, the Borgue area, has low rolling land with patches of outcrop, generally running NE-SW. Tongue Croft (NX 6033 4833), found by R.Morris, has a cup and six concentric rings, cup and four rings, and cup and three rings. Senwick (NX 6473 4668) has four panels with cups, cup and rings and an S-spiral.

Clauchandolly (NX 642 471 - 648 468) has 11 rocks with multiple concentric circles, arcs of cups, and some eroded figures. The existence of such motifs was recognised in 1969.

The Balmae-Torrs area is next, a similarly hilly country with outcrop rock, especially on low slopes. Visiting it is complicated because it is a military training area.

The rock art of Balmae (c. NX 686 446) does not include multiple concentric rings in its 15 rocks, but some of the figures include cups with single or penannular rings, cup clusters. and some irregular-shaped grooves around cups. Some sites have been lost since they were recorded.

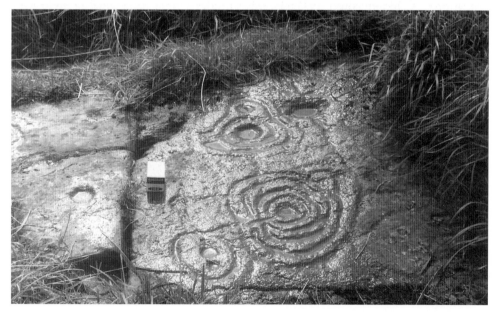

76 *Townhead*

<u>Torrs</u> (1 is at NX 680 458) includes small and large outcrops, with a variety of motifs. '<u>The Prince of Wales' Feathers'</u> is so named because it has three sets of cups centred on four concentric rings, the central figure with a duct from its cup that aims at the grooves from the outer rings of the other two figures that join below it. Another well-known design, close by, is of cups enclosed by, or among, oval-shaped grooves. Another outstanding design is at NX 697 452, where a partially exposed outcrop has heavy clusters of cups as the principal motif, and some grooves. Another large outcrop knoll close by has a small cup with nine concentric circles.

Knockshinie (NX 684 455) has three marked outcrops. It is 1.25km. inland on the moor, with sea views. One outcrop of two has a row of 6 cups, two with ring and penannular, all linked by a linear groove; on the same surface is another series of irregular grooves around a cup that seems characteristic of this area.

Townhead has five groups of rock art (Howwell-Dunrod, The Grange, Blackhead - Townhead, and Milton). They are all-important areas of rock art, with diversity of manipulation of the basic symbols. As most of the concentration of the Townhead area is in one field on the lower slopes of a hill, this will serve as illustration. There are multiple concentric circles. Scatters of cups are not very many, but the arrangement of cups inside circles is unusual. For example, some circles of cups are enclosed by a ring, either complete or broken. There is a figure of three incomplete concentric ovals containing 13 cups. One rock (NX 696 470) found by Ronald Morris (who also found many after the publication of the other sites) in 1973 has a very complex pattern of cups and grooves including an occulus, oval with two cups connected to irregular rings centred on three cups. Maarten Van Hoek's sketches and accounts of all these make fascinating reading and viewing, for he has revealed other rocks such as rock 4 in his survey, a large outcrop in four parts covered with circular patterns of cups inside one to four rings, some with 'keyhole-type' grooves leading out of them, large cups, cups joined by a linear groove like a string of beads, and a rosette. Some of these are unique in Britain. On rock 6 (NX 6994 4713) is an outcrop completely covered with the most complicated pattern of grooves seen in Britain. He lists 17 sites within this area.

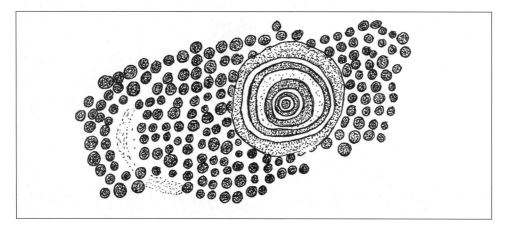

77 *High Banks*

A sub-area at <u>Milton</u>, a small valley between two hills, continues the spread of marked rocks in 23 listed sites. The first is at NW 704 462, now lost; those still visible include many cups, concentric rings, and one complex arrangement of grooves (at NX 7003 4698). <u>High Grange</u> has two outcrops (NX 6999 4749) found by Elles and Maarten Van Hoek, which include linked cups, cups and rings and connecting grooves.

<u>High Banks</u> (NX 7090 4895) lies on the edge of a dried-out water hole. It is one of the most striking in Britain in terms of design, based on cups and rings. The deep, symmetrical cups spread around concentric circles on the curved top of a bolster of rock are particularly impressive, and on another panel the cups form an arc around the circumference of a cup at the centre of five concentric circles. There is an unusual feature, where the interior of a ring is pecked to form stippling.

The extensive outcrop was first reported in 1886; some of it is now turf-covered, following excavation between 1964-78. It is a great pity that no artefacts have been recorded in this area; interesting though the motifs might be, there is nothing to which we can relate them.

The last series of sites in this area is centred on Newlaw Hill, on the north slope.

<u>Newlaw Hill</u> (NX 733 488) is a large outcrop of rock in rough ground, boggy in places. A scatter of cups here is similar to that at High Banks, with up to five rings around central cups, mostly with ducts. One outcrop has its motifs linked together by grooves.

78 *High Banks* (R.W.B.M.)

Bombie (NX 725 497) is a major site, with stretches of exposed rock, some of the bolster-type outcrop. The most common feature is the creation of multiple concentric rings, up to eight in number, around cups. Most have ducts, one has a diametric groove, and another has two radials. Some motifs are spaced out between cracks that divide the rocks into natural panels. Kaledon Naddair and his group have made a contribution to the recording of these sites, and to others.

Other sites include Culdoach (NX 708 525), a steep ridge in rough grass, with linked cups and single rings and ducts, and multiple rings around cups with ducts that are joined in a complex way.

Central and southern Scotland (Morris, R. 1979)

Southern Galloway lies south of parts of Northumberland. Elsewhere there is little rock art immediately north of the Anglo-Scottish border. One panel is illustrated here, found in a garden at Jedburgh and now at the Art Gallery and Museum, Kelvingrove. It has an interesting design, but illustrates a practice that is no longer followed — the indelible painting of grooves.

79 *Jedburgh*

One of the most outstanding sites in Britain is at Ballochmyle, Ayrshire (NS 512 254), a red cliff overlooking a tributary of the River Ayr, with over 150 motifs that were discovered in 1986. The motifs are varied, with a predominance of cups and cups and rings. There are three animals, probably deer, radiates from a central cup inside a ring, and other motifs that are difficult to identify. One or two examples are superimposed. Some of the rock face has been quarried.

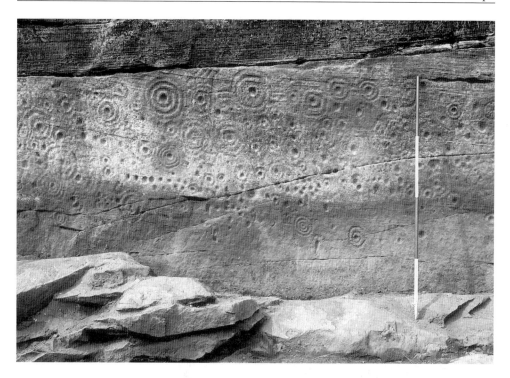

80 *Ballochmyle* (R.W.B.M)

Southeast of Ayr is <u>Beoch</u> (NS 522 809), where a slab in a cist in a stone circle has five sets of concentric rings with no cups.

North along the coast is <u>Blackshaw</u> (NS 231 483) where a large gritstone outcrop has 300 cups, cups and rings and three spirals.

Other sites in Ayr include a decorated boulder, a now-missing decorated slab with cups and rings and spirals from <u>Coilsfield</u> (NS 466 262).

North and south of a line roughly between Glasgow and Edinburgh are sites that are mostly on smooth, near-horizontal sedimentary rocks. There is a preponderance of cups; many of the cups and mainly gapped rings have a radial groove or grooves from the central cup or inner ring. There are a few rings without cups and some spirals. Other marked rocks are large boulders, portables, and some are cist slabs.

In the area around <u>Glasgow</u> there are many interesting sites and individual stones, examples of which follow.

<u>Auchnacraig</u> (NS 502 736), with views over the Clyde estuary, has outcrop sheets with cups, some partially ringed.

<u>Kelvingrove Museum</u> has three flat boulders from <u>Bowling</u> with cups and cups and rings linked by many grooves.

The most important site is at <u>Greenland</u> (NS 434 746), well reported by Mackie and Davis (Mackie, E and Davis, A 1989) which has some dramatic figures, including two cups with nine rings that flow into each other, very carefully executed. There are other groups of multiple concentric circles and a rosette.

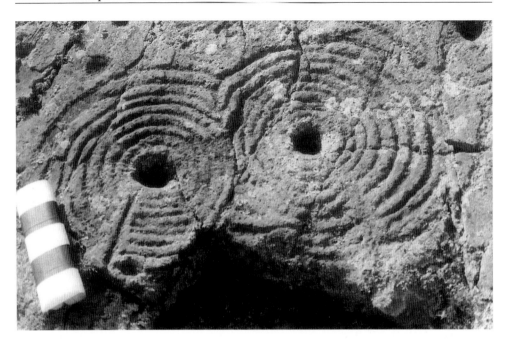

81 *Greenland* (R.W.B.M)

Another important site is at <u>Whitehill</u>, where the <u>Cochno Stone</u> (No.1, NS 504 738) is one of 17 outcrops with motifs. It lies 3.5Km north of Clydebank, inland, with sea views. The outcrop sheet had to be covered to preserve it from vandalism, so I have not seen it. The drawing is from Ronald Morris' archive, a sketch made from different sources.

Near <u>Stirling</u> there is a large spread of marked rocks around the farm at <u>Castleton</u> (one at NS 858 884), including many multiple concentric circles on greywacke outcrop, some of which is raised above the ground.

Other notable examples are at <u>Duncroisk</u> (NN 532 358), near Killin, where many hilly outcrops have cups, cups and rings, and a rare cross-ring motif.

To the east in the Lothian region there are many rocks still in situ, such as the <u>Bonnington Mains- Tormain Hill</u> outcrop (NT129 696) that includes a design of a cross formed by linking three cups. Other stones, reputed to be parts of cists, have been lost, although sketches have survived. The spirals on the cliff face at <u>Hawthornden</u> (NT280 632) are similarly positioned to those at Morwick, Northumberland.

At <u>Traprain Law</u> (NT 581 747) some quarried rocks had casts made of them. There are incised cups and multiple rings and linear forms with grids and chevron patterns. Only the cups are made by pecking.

<u>The Royal Museums of Scotland</u>, Edinburgh, has an important collection of marked rocks, both original and casts, from Borders, Central, Dumfries and Galloway, Fife, Grampian, Lothian, Strathclyde, Tayside and Orkney. For many people, such a collection under one roof has great advantages either as a starting point for the study of rock art or as a follow-up to field visits.

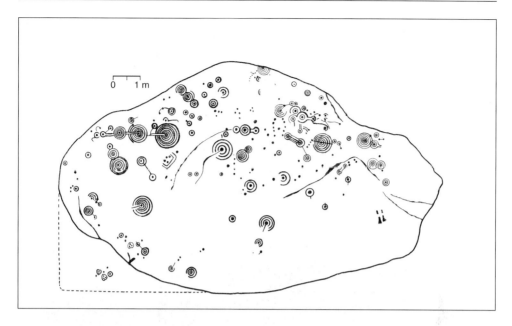

82 *The Cochno Stone* (R.W.B.M)

83 *Duncroisk* (R.W.B.M)

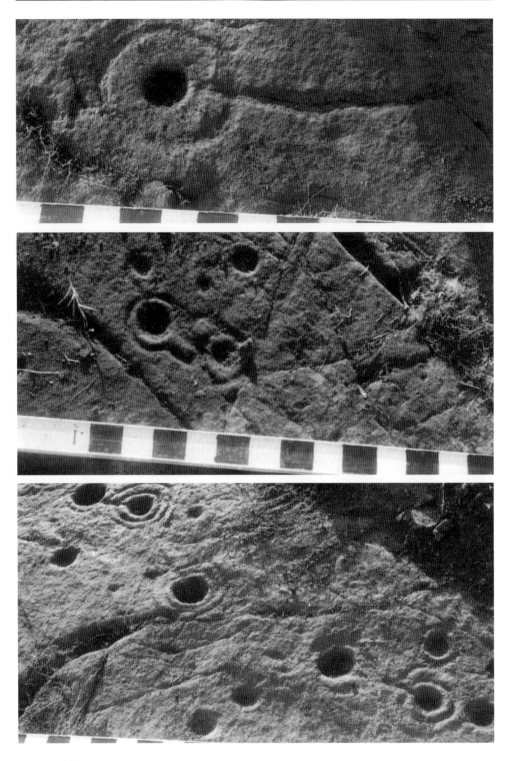

84 *Whitehill* (R.W.B.M)

Argyll (RCHMS 1988, Bradley 1997, Morris 1977)

Argyll has concentrations of rock art ranging from simple to complex motifs. South Argyll has most of its motifs on boulders, whereas the Kilmartin area, mid-Argyll, has more on outcrops.

Kilmartin is quite remarkable, not only for the quality of its rock art, for its burials and ritual monuments, but also for the way in which motifs are placed in the landscape. The area is an important through-route from the sea, and this ease of land-based access probably accounts for the area's economic importance and for its status as a ritual centre. Until quite recently low land was covered with peat, and it preserved the monuments that peat-cutters exposed.

The rock motifs occupy a significant place in the landscape, marking the sites that give access to this large plain. In many ways it is like the situation in north Northumberland already outlined in this chapter.

The outcrop rocks are not prominent features; they are near-horizontal and can only be seen close by. High above and around the plain, they form a base for a rich variety of motifs. To go from one site to another means walking above and around the plain, which is, like the entrances to it, what the decorated wide viewpoints overlook.

The outcrops are sedimentary sandstone, shale, and limestone that have been meta-morphosed by heat and pressure caused by earth movements. They have turned into quartzite, schist and marble. Ice sheets moved SW, leaving boulder clay and raised beaches. It is possible that about 5,000 years ago, the period of the cups and rings, the climate was warmer and drier before deterioration set in and peat began to form. There have been 200 years of peat digging to expose the monuments that we see today.

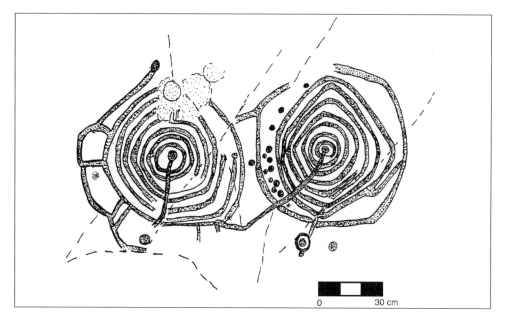

0 30 cm

85 *Achnabreck*

86 *Argyll: the distribution of Rock Art, and some named sites.*

It is difficult to find how people earned their living there except by farming, pastoralism and hunting; there is little evidence of where they used to live, although the terraces on either side of the plain seem to be likely candidates. Perhaps the impressive monuments have distracted attention from more modest traces of activities in the past. These margins of the near-flat valley are where the rock art is. The rocks themselves must have protruded from the soil or had a very thin vegetation cover. The area that has the major monuments is surrounded by clusters of rock art, generally at a higher level, where there are also occasional standing stones and cairns.

Kilmartin itself is a very good centre for exploring this area, for it has an information centre and restaurant that provide the visitor with facts and sustenance to explore the area. To the north is <u>Creagantairbh</u> (NM 843012 and 844012), east of the Kilmartin road to Oban, where a rock sheet is partly exposed, marked by a prominent erratic boulder. On it there are over 130 cups and 12 cups and single rings. Although the rock art here is mostly fairly simple, there is at the north end an oval with a cup, and a series of small enclosures that are very unusual, with a long groove leading along the rock to its northern extremity. The site marks a threshold into the Kilmartin area. The outcrop points the way down the valley to Kilmartin, and is on one of the routeways from Lochilphead and Loch Crinan north east to Loch Awe.

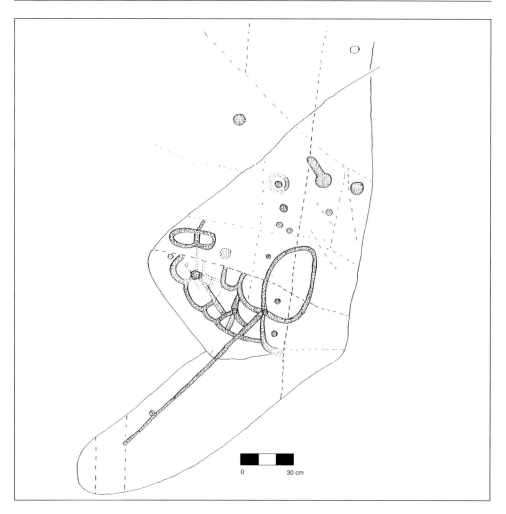

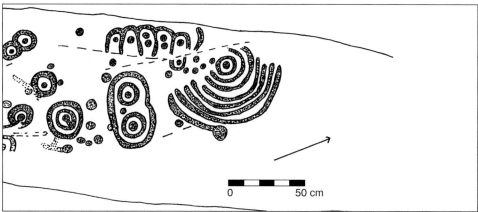

87 *a.Creagantairbh; the north extremity; b.Glasvaar*

Other valleys lead to the Moine Mhor, and the unique art at <u>Glasvaar</u> (NM 8801), which overlooks later sunken trackways and small stone alignments, and an extensive valley, suggests a good reason for putting it there — another threshold, another access point. The six groups of symbols must have acted as a marker, a message, to people travelling those high ridges. What exactly that message is, we don't know. A decorated boulder in the farm wall (NM 884014) may have come from a cairn. Its decoration respects the shape of the rock.

On the opposite side of the Kilmartin valley lie <u>Ormaig</u> (NM 822027) and <u>Ardifuir</u> (NR 7896, 7997), some distance apart, both overlooking the sea. Ormaig has a concentration of cups and rosettes, interlinked figures, and parallel grooves on one part of its surface; it is a viewpoint over a steep stream valley and to the coast. The forest planted there is beginning to cover some of the motifs; they may disappear unless it is controlled. That raises the issue of how much could have been seen from it in prehistoric times if the area had been woodland.

Ardifuir, in a glen with an impressive dun, has simpler motifs; the decorated rocks dominate the view to the sea in a kind of warm armchair depression in the land. These sites have no notice boards, and tourist access is available but not pushed. Such access is left to other sites, notably Achnabreck.

<u>Achnabreck</u> (NR 55906, 857906, 856905), is the largest decorated outcrop in Britain. Until recently it was in the middle of a wood, which has now been cut down so that not only the motifs are visible but the valleys leading to Lochilphead and to the modern Crinan Canal. This is a crucial site for access to the Moine Mhor and sea. Were there trees when these motifs were chipped into the rock? If so, this might not work as a viewpoint. Were there distinctive well-worn paths leading to it? Was it a routeway? If there were no trees, then the rock outcrop itself might be seen from afar. The variety of motifs, the way in which they are spaced, linked, the way in which they use natural cracks and surface irregularities and put out grooves to follow the downward slopes is very impressive. The position of the sun, the wetness or dryness of the rock has much to do with how we view it today.

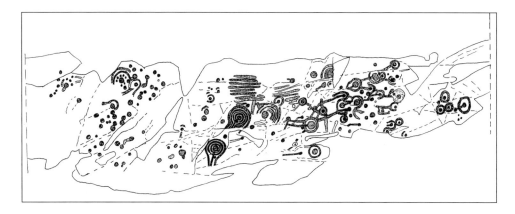

88 *Ormaig 2*

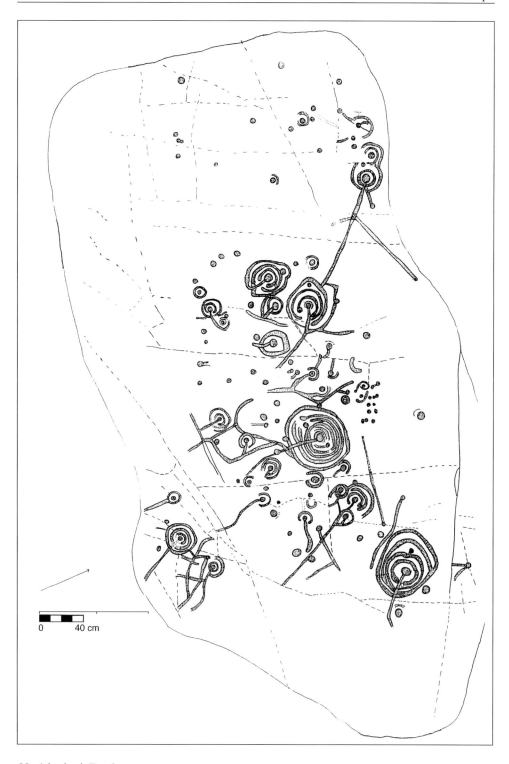

89 *Achnabreck East 2*

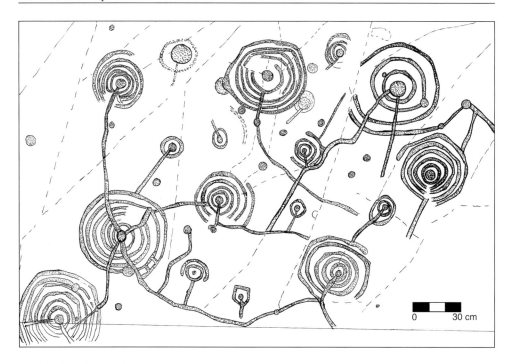

90 *Achnabreck lower rock*

The highest part of the outcrop has attracted speculation; some see in the making of the motifs different hands at work and different periods, as suggested by the superimposition of a few figures and by the presence of a horned spiral (the latter being as well-executed and preserved as well as any other motif on the rock). There are many varieties of designs, suggesting that different people made them; whether there was a big time gap is not clear. The sheer size of some of the concentric rings, their spacing, the way some of them incorporate cups not just into their centres but into the spaces between rings, gives a distinct quality to the use of symbol in design.

Parts of the rock ridge are separated by grass. The most easterly is one where the edges of the rock as it is exposed today are not marked. The third patch, reported by Ronald Morris, is now difficult to find; it has only a few faded motifs.

If one moves from this splendid outcrop to the carpark and road, the valley that opens up to the west follows the Crinan Canal to the sea. Two ridges overlook this, the more southerly being the site of a cairn burial that contained rock art and the other at <u>Cairnbaan</u> having two outcrop panels of rock art within 100m of each other (NR 839910, 838910). They pose interesting questions about their relationship, for they are have very different kinds of motifs. The low ground here around one rock is quite sodden, and may be at a spring source. The other slopes more, and the area around it is usually dry.

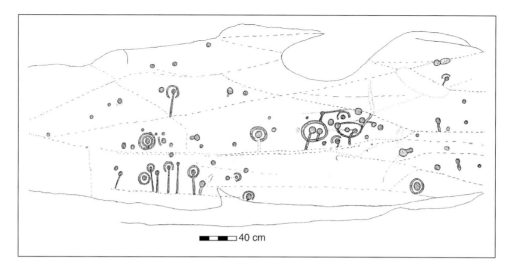

91 *Cairnbaan 1*

The outcrop sheet <u>Ballygowan</u> (NR 816977) lies high above the valley, the decoration framed like a picture with unmarked edges.

92 *Ballygowan: view from the rock*

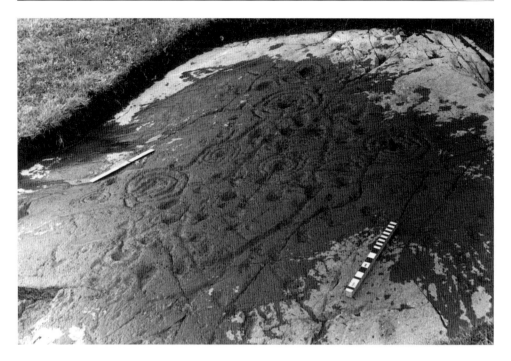

93 *Ballygowan*

Near to the ruins of Poltalloch House, the outcrop sheet of <u>Poltalloch</u> (NR 812973, 815968) is almost overgrown with mosses and lichen since the RCAHMS survey over 10 years ago. The gently sloping outcrop has very widely-spaced concentric rings, some with cups between them, and radiates from a central cup with and without an enclosing ring (star shapes). Today the outcrop leads to wet pasture, with extensive views south towards the sea outlet. Some decoration has been cut off, and other marked rocks were blown up when a path was constructed.

Around the Mhor the decorated outcrops follow the high ground overlooking the valley. At <u>Nether Largie North</u> there is a small group of cups, however, lower down at the base of the rock outcrop, close to and west of the cairn.

Close to the road south of Kilmartin on the east side of the valley is <u>Baluachraig</u> (NR 831969), with rather simpler motifs than some of the others. There are cups in lines, scattered cups, and cups at the centre of 1-4 ungapped rings. Again, there are extensive views across the valley from this gently-sloping outcrop, which lies close to standing stones, large cairn, kerbed cairn and a small henge that form a ritual complex on a terrace.

The last representative rock chosen is at <u>Kilmichael Glassary</u> (NR 857934, 858935), which lies in another entrance into the Kilmartin valley. It is an untidy site, lying above the valley among houses, with a metal fence protecting some of the markings. The emphasis is on

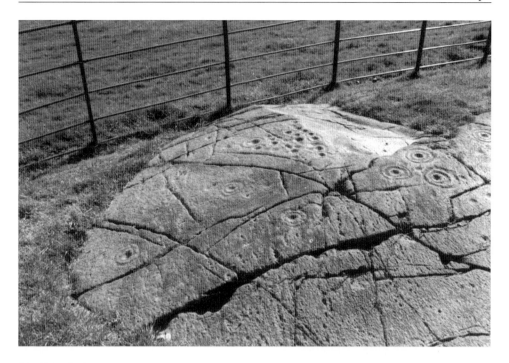

94a *Baluachraig*

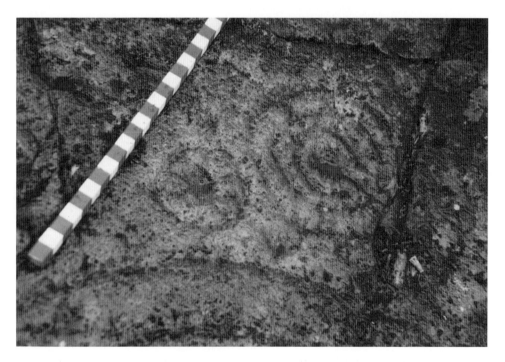

94b *Poltalloch: detail*

cups, many of them deep and linked to others by short grooves. They are arranged to follow the crack lines in the rock, and near the lowest slope some have long thin ducts coming from cups, and there are curvilinear grooves that enclose groups of motifs. All have weathered well.

NNE from it is a different kind of arrangement: a cup and duct with four penannulars, another cup with three rings, and other cups and single or double rings. Some small enclosures are attached to the largest figure, making use of natural cracks. This part of the outcrop is unfenced, and lies in some very untidy ground outside a house fence. It is likely that other motifs are waiting to be discovered along this ridge, and an excavation could also be used to consolidate what is already there and display it to advantage.

Kilmartin (NR 836 989), with its commanding view over the valley and its monuments, has always appeared to be a very important site on a terrace, now covered with modern buildings, so it came as no surprise when Paul and Barbara Brown recorded a cupped boulder on the hillslope behind the village, with a view down the valley. This is illustrated here.

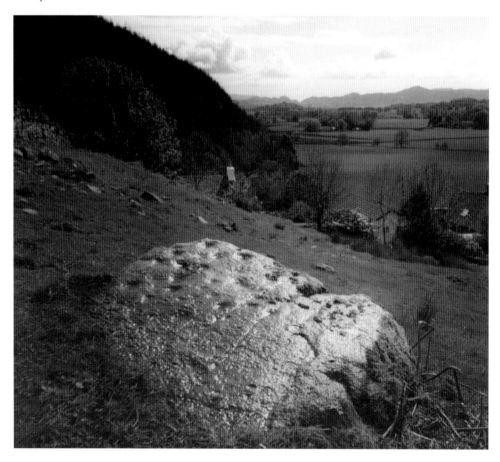

95 *Above Kilmartin* (Paul Brown)

Monuments

Monuments in the Kilmartin valley will be given detailed consideration later, but a note is necessary at this stage to relate them to rock art.

Burials and standing stones, including the Temple Wood stone circle, have long been recognised as having a variety of motifs. The recent excavation of the Temple Wood circles shows that the site has a time scale of up to 2,000 years, and the presence at other sites of simple cup marks, complex spirals, and flat pitted axes reinforces the use of motifs over a long period. Unlike rock art in the landscape, that in burials was not meant to be seen, and marks a difference in perception of how it should be used. As in other areas, it was earth-oriented rather than arranged to look up at the sky.

The cist cover on view inside the <u>The Nether Largie North cairn</u> (NR 830 984) takes its place here in the survey because its earliest use may have been as a standing stone. There are two distinct motifs: cups, which are made with a very fine stone pick, and axes of a metal type, some pecked with a blunt pick and others chiselled with a metal tool.

The illustration shows the relationship between cups and axes, and the LHS, possibly the base where the standing stone was slotted into the ground, is smoothed. This contrasts with the rest of the block, which has clear clusters of small pick marks. At some stage the block was broken at the RHS top corner and a cup mark pecked onto the surface. The stone may then have been removed from its socket, the axe heads added when the slab became a cist cover. Some of the axes are unfinished and faint. An end slab with a large and small axe was built into the cist; all the decorated surfaces faced inwards.

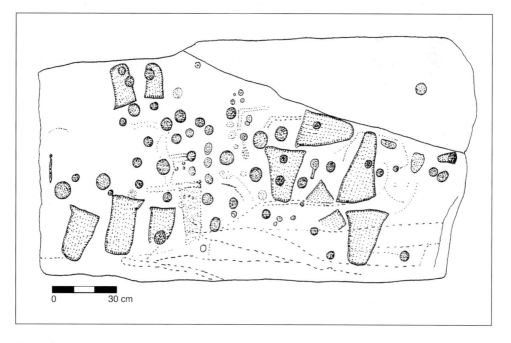

0 30 cm

96 *Nether Largie cist cover*

Tayside (Bradley 1997, Stewart 1958)
Tayside includes Perth, Kinross, Angus and Dundee.

Rock art in Strath Tay occupies a limited area of 20km from the confluence of the Tay to the River Tummel at the eastern end of Loch Tay. Further down the valley there is good agricultural land, but no rock art. Most of the art is in the main valley, with an offshoot in a side valley towards the east end of the loch. What distinguishes this valley is a number of monuments including round barrows, stone and timber settings and stone circles. They mostly occupy the river terraces. Cup marks are found mainly on the major terraces. The cups and rings, the more complex motifs, are on higher ground, and from there they overlook the valley from part way up the slope or from positions that overlook shallow basins on the upper edge of the valley. Today they are higher than modern cultivation, on marginal land. At Remony and Urlar, above gorges that have waterfalls are the only places on high ground that includes stone circles.

Margaret Stewart produced the first survey of sites (Stewart, M 1958-9 SAS 92), a general field survey of Strath Tay in the Second Millenium BC. She assumed that migrations inland were either from the Atlantic or North Sea coasts. She warned that 'It is not always profitable to look for the reason why prehistoric migratory movements made use of a particular route because the reason, if it exists, may not be capable of expression in terms of modern society.' She noted that 'South Tay and its immediate environs carry one of the most remarkable concentrations of cup markings in Scotland.' She distinguished sites that have cup marks only from the cups and rings, and recorded that the more complex designs occurred over 500ft OD. Where cups and rings occur at lower levels, she noted that they were outnumbered by cup marks, and that whereas the complex motifs are mostly on outcrops, cups appear on free-standing boulders.

She singled out two boulders with unusual gapped circles on the hillside east of Tombhuie Cottage (NN 794 447) above the main group of marked rocks at Braes of Taymouth (NN 792 488) to consider whether they might be similar to designs at Knowth in Ireland, but such a link is very tenuous.

In considering other prehistoric sites and artefacts she noted that 'in south Tay there is no coincidence between the distribution of food vessels and that of cup and ring markings,' and favoured the idea of a route from the east followed by the builders of chambered tombs. 'East of Strath Tay cup and ring markings are sporadic and there are none of the calibre of Balmachnaughton (NN773 436), Urlar (NN 841 466) or the Braes of Cultallich (NN881 490). Westward they are found at a number of sites along the north shore of Loch Tay and there are superb examples in Glen Lochay west of Killin.'

Richard Bradley, whose work has built on that of Margaret Stewart, comments that 'much of the valley is very fertile and is used for cereal growing. In fact it is the one extensive area of arable land where prehistoric rock art is found in northern Britain'. He examined worked stone there, and found that the higher up the slope, the less intense and prolonged was its use. From this he concluded that the simple cup-marked stones were in the most settled areas. The density of worked stone was least where the more complex rock art was found, so the assumption is that this was outside the outer limits of prehistoric activity.

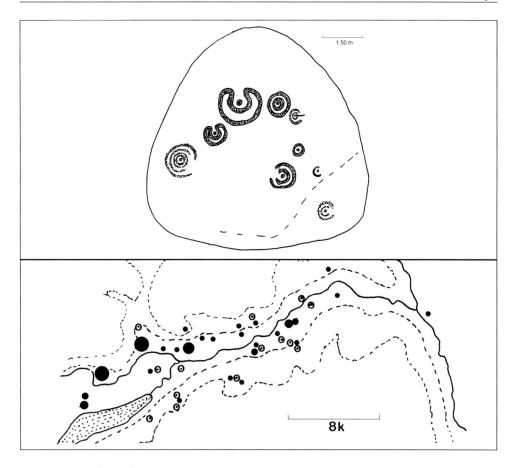

97 *Tayside. Motifs on a boulder at Braes of Taymouth; Dr Stewart's plot of the distribution of Rock Art in Strath Tay. Filled circles: cup marks. Open circles: cups and rings. Contours at 200m and 400m.*

He found that 39 cupped rocks lay at 200m and below, and 39 over 200m. Cups and rings were on only five rocks at 200m and below, and 21 over 200m.

John Sherriff (Sherriff, J R. 1995) has given an account of all the marked rocks in <u>Angus</u>. The earliest discoveries were in three souterrains (curved underground storehouses), two were possibly in a cist and a cairn, and one was on a standing stone. Since about 1868 the number has grown. Until the 1980s discoveries were chance finds, but now there has been more systematic search, and there is potential for further discoveries.

Here 47 sites have been identified, half of the rocks having cups only. The distribution is centralised, with a particular concentration of the most elaborately marked stones east of Forfar. There is a scatter along the coast and on the north edge of Strathmore.

Sheriff's conclusion is: 'The significance of rock carvings in Angus is that, over most of the district, they provide a complement to other forms of evidence for a Neolithic presence, but that in those areas where other indicators are either absent or rare, they constitute a major source of evidence.'

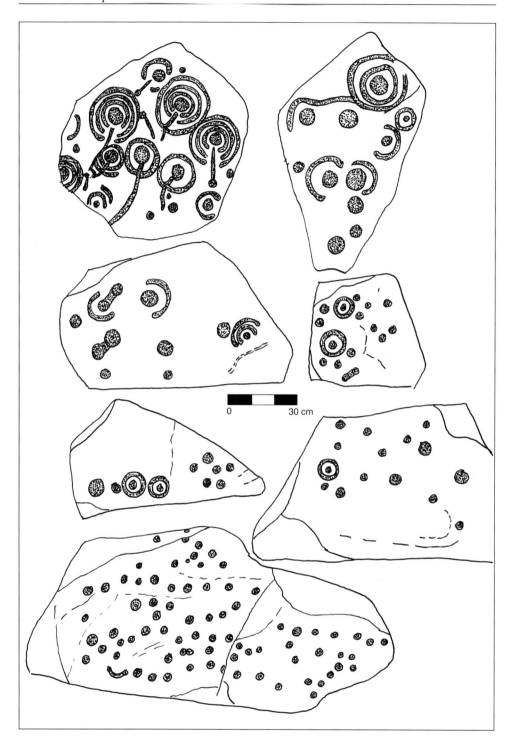

98 *Angus: early discoveries of marked rocks at Welton, Reswalie and Caterthun, based on drawings made by T.R.Allen in 1882.*

Highland and Grampian regions, and Orkney

There are some scattered sites along the north coast, mostly with cups only, and the rest are near the east coast, mostly along the Murray Firth. The marked rocks at the Balnuaran of Clava are perhaps the most significant, and are described in the section on Monuments. Cup marks on recumbent stone circles and two cup marked stones in the Dalladies barrow are also important.

Orkney

Orkney has an unusually heavy concentration of prehistoric monuments, and their importance includes 11 decorated slabs. The most impressive of these is a superbly made block from <u>Westray</u> (HY 438 490), found during quarrying behind the bay of <u>Pierowall</u>. Apparently a chambered tomb built by Grooved-ware users in the later Neolithic had been demolished in the same period and they built a flint-working platform on it. The marked stone would have come from a tomb some 18m (59ft) in diameter, possibly as a lintel, and the type of decoration allows it to fit comfortably into the Irish Passage Grave tradition. Two other decorated stones came from the quarry spoil, with pecked linked spirals.

The largest stone, now in the Tankerness House Museum, Kirkwall, is superbly displayed, and the lighting shows the techniques of pecking and smoothing to advantage. Sir J.Y.Simpson, one of the early pioneers of rock art study, includes drawings of three marked slabs in his *Ancient Sculpturings* (1867) from Orkney (plate XIX). There is a stone with a series of double circles and double volutes from <u>Eday</u>, a stone from <u>Pickaquoy</u>, with concentric circles round a central cup, and a volute cut on the end of an elongated stone from <u>Frith</u>.

A potsherd from <u>Skara Brae</u> (HY 231 187), one of the best preserved Neolithic villages anywhere, includes spirals and lozenge motifs, now made famous by modern jewellers. There is a much lower-key type of decoration in Orkney that is mostly incised rather than picked, and this takes the form of parallel lines, triangular or lozenge shapes and chevrons. Some of it is in tombs, such as <u>Maes How</u> (HY 318 127), and the <u>Holm of Papa Westray tomb </u>(HY 509 518). Some of it is in houses. At Skara Brae some was found in the midden, and the rest on the structural stones of the houses: on passage walls and inside two of the houses.

At the <u>Barnhouse</u> settlement (HY 239 285), excavated recently near the Stones of Stenness, parallel lines, chevrons and hatchings were scratched on stone, and more structured designs were found on a slab at the <u>Ness of Brodgar,</u> consisting of eight parallel tubes filled with oblique parallel lines, chevrons, lozenges and hatchings.

The latter stone partially covered two cists, and may have been reused.

The recent discovery, or new awareness, of such incised motifs shows that Neolithic art was not confined to curvilinear designs.

Orkney promises much from modern archaeology in the future, and it is useful to be aware that similar types of art may have been commonplace on materials that have not survived like stone.

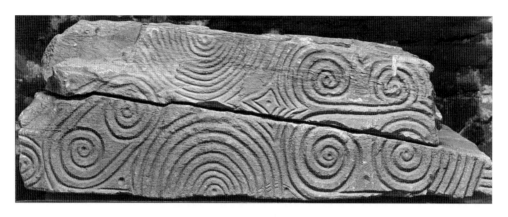

99 *Orkney: a very fine slab from Westray, now at Kirkwall's Tankerness House Museum.*

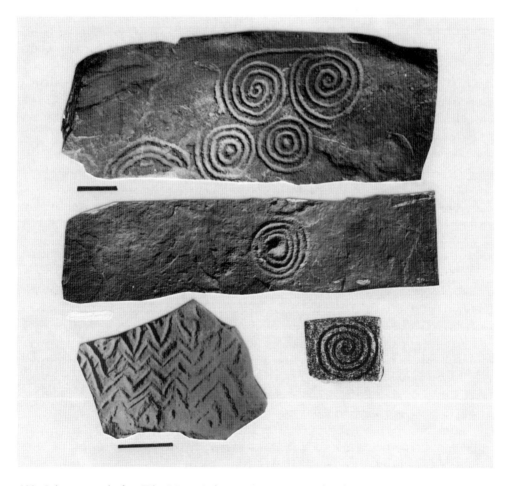

100 *Orkney: examples from Eday Manse, Pickaquoy, Papa Westray and Frith* (R.W.B.M. archive).

6 Rock Art in context

The main emphasis so far has been on art in the landscape, where its position indicates its use by people who were mobile pastoralists and hunters rather than settled farmers. As such, they left little of their presence, as they would have used temporary shelters in their camps. People who practised arable farming became more settled as they established fields, walls and fences. Their circular-based huts become more obvious to us. The transition to this more settled way of life was gradual, and the hunting and pastoral territories would continue to be used extensively. Population gradually increased, and the pressure on land intensified. The practice of arable farming would have brought a different way of using the land; people would have begun to see landscape in a different way. Rock art was in the open air, looking up to the sky, marking special places in the landscape that included in some regions the entrances to ritual centres. Such panels cannot yet be dated; art used in a firmer context and associated with ritual structures allows us to come closer to a time-scale.

There are two main groups of monuments in which rock art is found: on standing stones and stone circles, and in burial cairns, either as parts of cists or as an integral part of the mound material. In Northumberland there are rock-shelters where decoration is used, and there are some house sites in Britain where rock art is buried.

The presence of rock art in these contexts represents a very small proportion of monuments, so there is a danger of drawing general conclusions from a few sites. From many of the examples, however, it is possible to say that a change takes place in the way rock art is used and its incorporation in some ritual sites shows that it is taken out of the open air and buried with the dead. It retains a ritual/religious significance within these sites and reminds us not to make a sharp distinction between the religious and the secular. What follows is an examination of some of the sites, but not this time in order of regions. Rather, the use of rock art in different groups of monuments will be examined to see if there are any common trends.

Standing stones and circles of stone

Cumbria has so far not been included in the text regionally because it has very little rock art outside monuments (Beckensall 1992a)

The famous and accessible site at Long Meg (NY 571 372) is a good starting point. Long Meg is a 12ft (3.66m) pillar of Eden Valley red sandstone that stands outside the stone circle of her 'daughters', all reputedly turned to stone for dancing on the Sabbath.

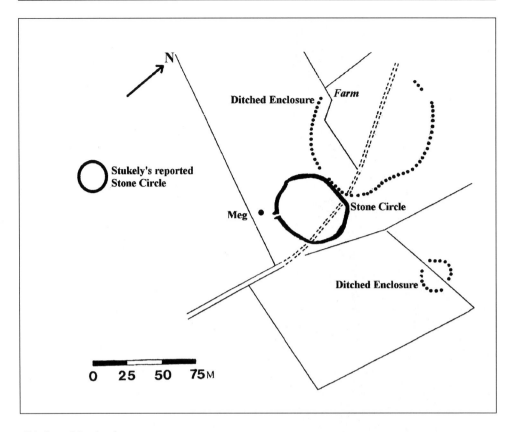

N

Ditched Enclosure

Farm

Stukely's reported
Stone Circle

Stone Circle

Meg

Ditched Enclosure

0 25 50 75M

101 *Long Meg site plan*

The ice-borne volcanic rocks of the circle vary considerably in size, and at the NE arc their alignment flattens because they respect a buried ditch of a huge enclosure that takes in the present farm buildings. The ditch cannot be seen at the site, and was discovered and recorded from the air with infrared photography. Another circular buried ditch lies to the SE, and to the NW is the site of a stone circle recorded by Stukely in the eighteenth century, now destroyed and invisible.

Inside the main stone circle burial cairns were reported, but this has not been tested by excavation. In some similar stone circles such burials are usually later than the circle itself, arranged in the early Bronze Age for individual rather than communal burial. The sandstone pillar is covered on only one face with linear grooves, concentric arcs, spirals and cups and grooves, not all finished, and there is some recent graffiti. There is a possibility that some marks on two of the stones of the north arc may be artificial. Despite the problem posed by natural markings on some metamorphic rock, there are two ill-formed spirals discernible on the fallen rock 7.

From the west the first stone to be seen is Long Meg, which has a 360° view around it. Seen from the centre of the circle, over the two western portal stones (and not through the portal itself), it is aligned on the axis of the midwinter sunset.

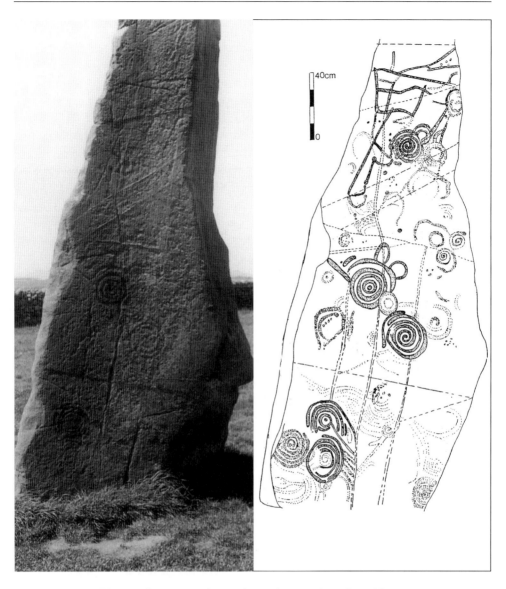

102 *Long Meg and her Daughters stone circle, Cumbria.* (Photograph Paul Frodsham)

Both the visible and buried circles occupy gently sloping land away from it; there is a drop of about 6m to the edge of the stone circle. The motifs speak of the outstanding importance of the monolith, but as yet we do not know of its relationship in time to the stone circle. Most probably it was quarried from a cliff face in the Eden Valley near by. Some of the motifs may have already been on it when the slab was brought to the site; as it lay horizontally, more motifs could have been added. It may have preceded the stone circle, or could be related to some earlier, buried structure. We don't know. It could have been added after the stones were erected.

119

Before ... during ... after?

As no part of this site has been dated by modern excavation, we are left with a vague, vast time span. But what is clear is its importance to, or its predominance over, other stones there — bigger, more colourful and decorated.

Close by is <u>Little Meg</u> (NY 577 375) with concentric circle motifs linked directly to a spiral — two different traditions of rock art. The motifs are on a large boulder that forms part of the kerb of a cairn that contained a burial at its centre and two eroded, transported, sandstones with cups and rings. Before it was all dug out, a mound of stones was reported to have covered the whole thing, perhaps with the kerb still visible.

<u>The Glassonby Circle</u> (NY 5729 3934) is not so well known. It lies on a field slope before the land drops away to a valley and the Pennines. Today it is an interrupted kerb of stones that encloses an oval cairn that has been robbed. Two marked stones were reported, but one has gone: a red sandstone block with a spiral on it like that at Long Meg. The other, still in position, has motifs that are well executed with a finely pointed tool. There are pecked lines, curves, concentric rings to which concentric arcs are joined, and four parallel chevrons, like Irish Passage Grave art. This, like the stone at Little Meg, appears purpose-made for the cairn. Neither has been cut from other rock, and the pattern fits the boulders. Whether the Glassonby decorated stones were open for all to see or covered with cairn cobbles it is impossible to say.

Modification of sites like these is always strongly possible; an example of the development of a site is best seen at <u>Temple Wood circle</u> (NR 826 978), Argyll, for this site was covered with peat and abandoned in prehistoric times (RCHMS 1988). It has also been thoroughly excavated by J.G.Scott from 1974-79. Although we cannot generalise from one site, it has a very interesting tale to tell that makes us aware of what might have happened elsewhere.

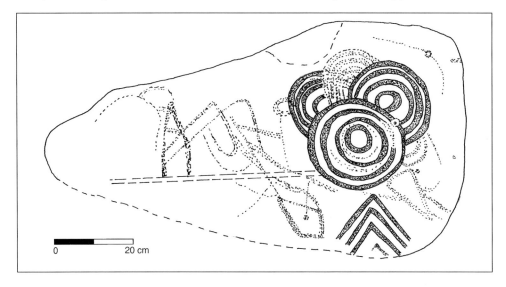

0 20 cm

103 *Glassonby*

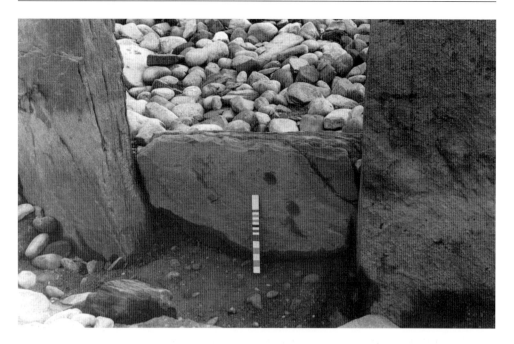

104 *Temple Wood*

It enters this account because one of the remaining monoliths of the stone circles has a double spiral spread over two faces of one stone and another has two concentric rings. Stones placed horizontally between the uprights included one with two cup marks. The excavator revealed two circles. One was originally a ring of timber posts that were replaced by freestanding monoliths before it was demolished. The more spectacular circle that we see today has spaced upright stones, like Long Meg but on a smaller scale. It meant that people who used it could be inside and see for miles into the valley or could watch what was going on from the outside. This openness gave way to the circle being fenced in by slabs of stone placed horizontally between monoliths.

The next phase was that the interior was used for burial, the earliest being in large cists, with Beaker pottery. The cists had kerbs of small vertical stones, and were covered with a mound of cobbles. Cremation burials followed. Then the whole area was covered with cobbles, perhaps even over the tops of the monoliths.

It is likely that the spirals belong to the late Neolithic, and we may link development of the stone circle to a cemetery with what was happening in other places in the Kilmartin valley. The massive cairns that line up in the valley have been modified. At <u>Nether Largie North</u> (NR 830 984) there is a large cist capstone that has cup marks and superimposed axes. The axes, pecked into the rock with a fine-pointed tool, have no hafts, and their expanding cutting edge identifies them as metal, belonging to the copper age. An end-slab decorated with a small and a large axe faces into the same cist. Seven pecked axes appear in a cist attributed to the Early Bronze Age at <u>Ri Cruin</u> (NR 825 971), again from an end-slab facing into the cist.

0 50 cm

105 *Badden slab re-used in a cist*

Other art in burial contexts in mid-Argyll indicates a long tradition. The chambered cairn known as <u>Nether Largie Mid</u> (NR 830 983), on a low terrace, excavated in 1929, includes a slab with five cups, a cup on the end-slab of a cist and an axe. At <u>Badden</u> (NR 858 890) the side slab of a cist was ploughed out; it has a design of double and triple lozenge motifs. The decoration has been sliced through to make slots for the end slabs, showing later use for that decoration. A similarly decorated slab was found in a cist under a round cairn at <u>Carn Ban</u> (NR 840 907).

Temple Wood demonstrates a large time-scale of building, modification and reuse of a monument, and the cairns in the same region have the same characteristic, with 'Passage Grave' motifs being used in the same mounds as decorations from a metal age.

<u>Recumbent Stone Circles</u> are a specialised variety found in north-east Scotland and are given this name because their stones rise in height to the south-west to two tall pillars, between which lies a horizontal slab. <u>Loanhead of Daviot</u> (NJ 747 288) is a recumbent stone circle with a ring-cairn and cupped stone east of the flanker. <u>Sunhoney</u> (NJ 716 058) is a very good example of such a circle, and it has a large number of cupmarks clustered on the recumbent. The circles are concentrated in territories of four to six square miles (1000-1500 ha) in Aberdeenshire and lie alongside fertile soil on terraces with extensive views to the southwest. The recumbent stones were positioned horizontally into line with the southern moonset, and quartz was scattered around. Ten or eleven stones were erected in a perfect circle, and at some stage cremation burials placed in a central ring cairn. Such recumbent stone blocks exist in Ireland, as part of Passage Graves, but not elsewhere. There is a special choice of type of rock and colour in the circles. There does seem to be a deliberate use of cup marks connected with phases of the moon.

A recent excavation of a recumbent stone circle at Tomlavowerie (Bradley, pers. comm.) echoes the kind of construction sequence that was found at Clava: the ring cairn with its

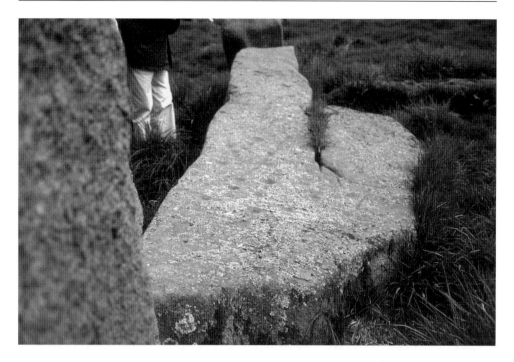

106 *Sunhoney: a cup marked recumbent slab.*

radial walls and its relationship to the circle show that all features were built simulta-
neously, and so far the only pottery to emerge is Beaker.

There has been much discussion about the connection between astronomy and standing
stones, which this book will not attempt to pursue, except to note sites where cups and
rings appear on standing stones. To return to the Kilmartin valley for a moment, some of
the standing stones are decorated with cups, with the occasional single ring or arc. Some
are thought to be important markers in astronomical alignments, and lie close to other
prehistoric monuments. There is a large group of standing stones at Ballymeanoch (NR
833 964) close to a kerb cairn and small henge. Four are in a line, one with cups, and
ringed cups and partially ringed cups. The southwest face of its neighbour has cups, linked
cups and three ringed cups. West of these and two unmarked stones is an excavated stone
that has an hourglass perforation below two large cups, 15 small cups, and two linked
cups. There was cremated bone around its base, probably a foundation deposit.

 Nether Largie (NR 828 976) has a cluster of standing stones, all accessible. Of the two
most southerly, standing side by side, one has three cups, and one of a group 24m NNE
has about forty cups, cup and ring, two cups with gapped circles and ducts, on its SW face.
Torbhlaran (NR 863 944) has 30 cups on the SW face and nine on the NE.

The marked standing stones of mid-Argyll fit comfortably into a large ritual landscape that
has been fortunately quite well preserved, where there are many different contexts for

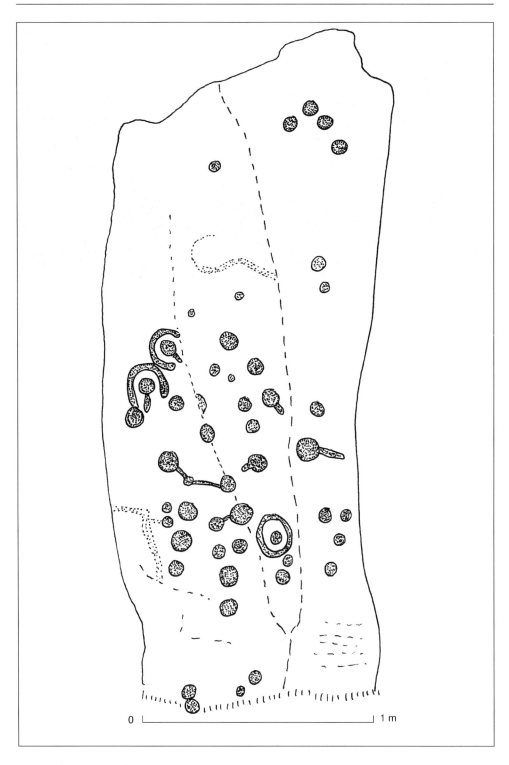

107 *Nether Largie standing stone*

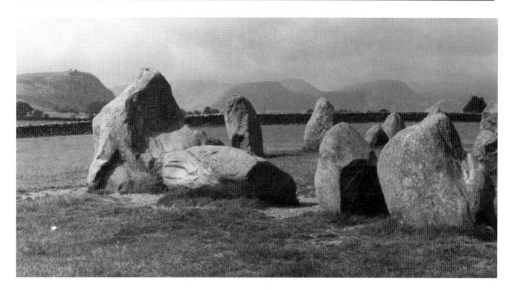

108 *Castlerigg*

rock art. Marked standing stones elsewhere in the country may be isolated. This is true of the impressive Matfen stone (NZ 032 705) in south Northumberland which has a profusion of cup marks near its base on three sides. In Cumbria two stones known as The Giant's Grave, Kirksanton (SD 136 811), lie together on a coastal plain that opens inland to a valley and hills, and one has a single cup and the other two small cups.

The Shap Avenue in Cumbria was reported to have been a row of huge stones extending for nearly a mile, and today five of the survivors include the Goggleby Stone (NY 559 150), with a well-made cup, and a stone in Asper's Field (NY 558 152) with a cup and ring, leaning towards the hollow way of the destroyed avenue.

Castlerigg stone circle (NY 292 236) in Cumbria was until quite recently without any recorded rock art. The author recorded one cup marked stone built into a modern wall nearby, and then two students from Newcastle University, Nick Best and Neil Stevenson, photographed a spiral on one stone in late afternoon winter sunlight in 1995. Later they found incised lozenge motifs on two other stones, and I found a cup and ring at the top of another.

Castlerigg has a more impressive setting than Long Meg. It is like a circle within a circle, the mountains ringed around it. A distinctive feature is a rectangular setting of spaced standing stones that project from the circle towards its centre. No one knows what this was used for, but the discovery of the spiral on the flat surface of a stone facing into it gives added distinction to the structure. The lozenge, on a boulder next to it, is incised.

There has been a real problem with this spiral. I have made a time-consuming wax rubbing of it, the spiral appeared, but I have not been able to see it on the rock itself! Opposite the rectangular setting is a small fallen stone with an incised lozenge, and near the entrance, Stone 5 has a cup and incomplete or broken ring.

In 1998 Richard Bradley and his team spent a week on Orkney recording the faintest of incised/scratched lines formed as zigzags, triangles and lozenges in megalithic tombs, with the aid of special lighting and enormous patience, so it is possible that other monuments have undiscovered markings.

To return to Scotland, a site that combines stone circles with passage graves and a ring cairn, The Balnuaran of Clava (NH 756 444) (Bradley CA 1996), has been recently excavated to establish a sequence of events. It has produced unexpected results, not the least the carbon date that places them in the early Bronze Age (c.2, 000 BC) instead of the expected Neolithic. The SW and NE cairns are identical in structure: a circle of spaced standing stones surrounding a passage grave (a long tunnel leading to a circular burial chamber). The passage

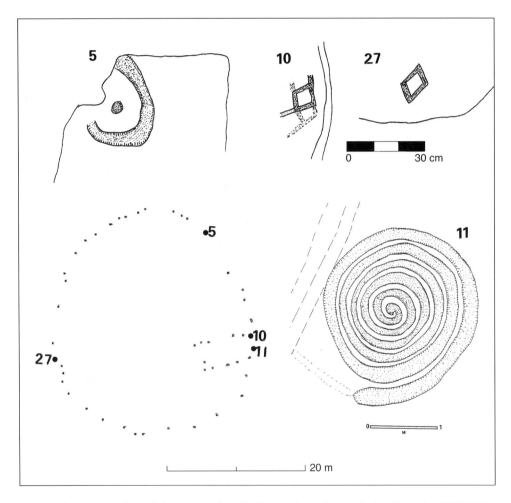

109 *Castlerigg stone circle, with the position of motifs. The spiral was photographed in September 1985 by N Best and N Stephenson, but few people have been able to see it, as it is very faint. The other motifs, pecked and incised, have been overlooked until very recently.*

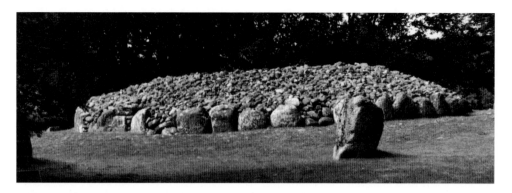

110 *Clava*

had originally been covered over. The excavation established that a platform between mound and stone circle was contemporary with both, and that the platform supported the standing stones. A kerbstone of the NE cairn has cups and single rings pecked on it, and this was inserted at the time of the rest of the building. Other cups and cups and rings were incorporated in the monuments, including cups at the base of the ring cairn kerb. The site, where the cups and rings go right through the fill, has produced many dates, not one being Neolithic. All the primary contexts are early Bronze Age (Bradley, pers. comm).

The axes of the graves along the passages are illuminated by the midwinter sun, and red boulders are concentrated on the surface of the SW cairn facing directly into the sunset. The largest stones are at the back of the burial chamber, and where the roof slopes down to meet the end of the passage is a decorated stone. Richard Bradley wrote: 'Every structural device at Clava had a symbolic role, and every piece of symbolism required for the correct understanding of these monuments necessitated a structural solution.' It is within such a structure that the rock art, simple as it is, takes its place. Whether it was made specifically for the monument or reused is not clear, but its symbolism was important to the tomb makers.

The site at Clava combines ring cairn, chambered tomb and stone circle; this combination makes it impossible to treat all stone circles in isolation. Aubrey Burl, whose work on stone circles is outstanding, has identified another monument called a Four Poster (Burl 1988). A Scottish phenomenon, there is however one in Northumberland at Goatstones (NY 829 747) that has a cluster of cups on the inclined top surface of one, and fainter cups on others. There are three cup marked rocks in rough grass nearby. Aubrey Burl regards these settings, from the burials associated with them, as early Bronze Age.

The question is often asked why there is so little rock art in the south of England. One factor is that the region lacks outcrops suitable for marking, and that had the symbolism been current it may have appeared on perishable material such as wood, cloth, or on people's skins. However, Stonehenge has over 40 axes picked onto some of the sarcens and one dagger, all concentrated at the base of three stones of the outer ring and the horseshoe setting of trilithons. Actual metal axes and daggers are found around Stonehenge in rich graves, and the types of axes depicted are dated to c.1500 BC. There is no question of the

127

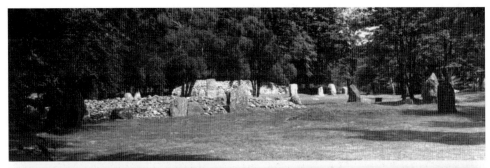

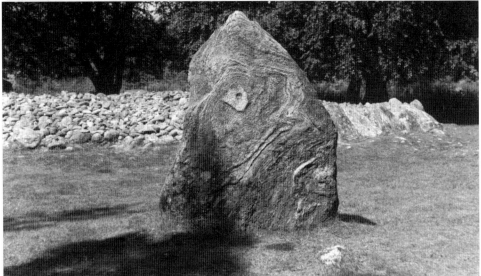

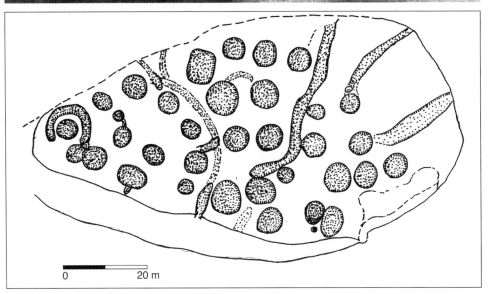

0 20 m

111 *The Balnuaran of Clava: the site and a drawing of a decorated kerbstone*

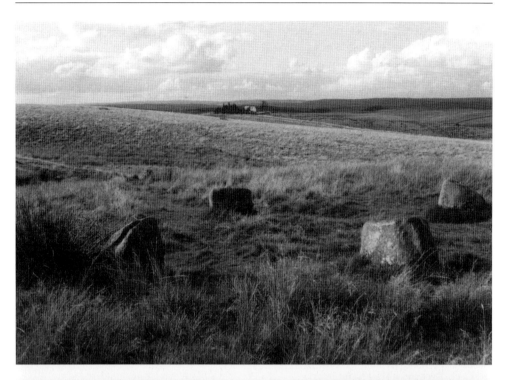

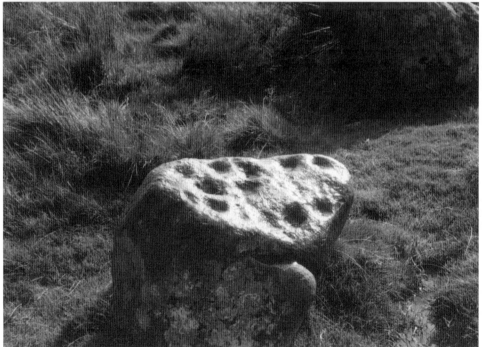

112 *Goatstones, Northumberland: the 'four poster' and cup marks*

late date of these motifs, but it is not known whether they were put on the stones before or after they were erected.

Aubrey Burl (1999) regards Stonehenge as anything but British, and any markings on the rocks are atypical: 'In Bronze Age Britain Stonehenge was as out-of-place as a Babylonian ziggurat would have been in Mycenaean Greece.'

Horseshoe arrangements of stone in British stone circles are rare, but not so in Brittany. The arrangement of the Four Stations is a rectangle, even rarer than the horseshoe, but more common in Brittany. The rock art is also unusual, for there is nothing on rings of stone south of the Lake District until we come to the clusters of axes and one knife-dagger. Metal axes, however, do appear in the Kilmartin valley, as we have seen. Stone 57 has a heavily worn quadrilateral etched into it, a smaller replica below it, and there is a weathered third rectangle on the underside of Stone 120. Such rectangles appear in Breton passage graves, as Burl explains:

> The authenticity of the 'rectangle' as an anthropomorph is confirmed conclusively not only by its close likeness to those known in Prehistoric contexts in Brittany, but also by the proximity of the 'crook' just above it.

The crook is supposed to represent a handled stone axe, but this is not likely to be the case for those at Old Parks in Cumbria any more than the presence of axes in Kilmartin graves proves a Breton connection.

He sees the symbolic use of rock art at Stonehenge 'enhancing this impression of sacred space, redolent of life, death, fertility and sunset'.

He sees the rare internal Altar Stone as a Breton import. Bryn Celli Dhu in Anglesey has a freestanding pillar in its passage tomb comparable to the decorated menhirs of Brittany. It is the organisation of the stones and the occurrence of unusual rock motifs that leads Burl to be convinced of the Breton connection and to conclude:

> The entire design of the final Stonehenge was foreign, revolutionary and inimical to indigenous styles. It may well have been the handiwork of intrusive and powerful leaders from Brittany.

Burial Monuments

It has been made clear that not all stone circles can be treated separately from burial sites. The circles are in places not necessarily where people lived, but were accessible to people living in the region. They were most likely used as meeting places, not only for religious ceremonies, but for trade, exchange of children in 'marriage' — as a kind of community centre. They would be invaluable to mobile pastoralists as well as to the more settled but scattered agricultural communities. They might also focus tribal and ancestral identity. A change takes place in the use of some of them when burials began to focus on them, not just in foundation pits, but with the building of round cairns in the middle of the stone circle. The separate function of a burial place and a meeting place was not clear-cut as it is in our society; both functions took place in a circular structure.

The Chambered Tombs or Passage Graves already referred to may have begun with a mound covering a single burial, then more were added and were made accessible through a passage to the chamber. In Ireland the Boyne valley tombs have an exuberant use of rock art that is echoed in Westray, Orkney, particularly with the use of spirals. 'Passage Grave art' means patterns based also on serpentine grooves, chevrons, zigzags, lozenges, triangles, and a few rare motifs like rayed circles, and historians and artists have looked for parallels in England, Wales and Scotland.

Spirals provide a typological link, but may be conceived locally rather than being 'imported'. One of the finest sites for spirals has been referred to: on the cliff face at Morwick (NU 233044), but it is a site at <u>Lilburn</u> (NU 013 256) in the same county that a possible long barrow context occurred, dug out in the late 19th century. There were two rows of pits, one above the other. The upper row had seven shallow depressions with three small whinstones over each, containing cremations, with teeth and bits of jaw. 10cm. (4in) below was a row of five circular depressions, rather longer than those above. Four had three small whinstones over them, and the largest pit at the north end had five. Again there was evidence of cremation, with larger bones included.

A marked stone set into the pit like a pillar was found at the west side of the line of pits, and the tenant farmer thought that it had suffered partial demolition at some previous period. The stone that is now in store at Newcastle University appears damaged, and it has motifs of concentric rings, curved grooves and a horned spiral on one face, and a spiral on another.

The area of Lilburn has evidence of many burials and some decorated stones; the position of the rock buried in a pit with cremations, and the location of the site on a slope below the field horizon makes it a very likely candidate for a long barrow.

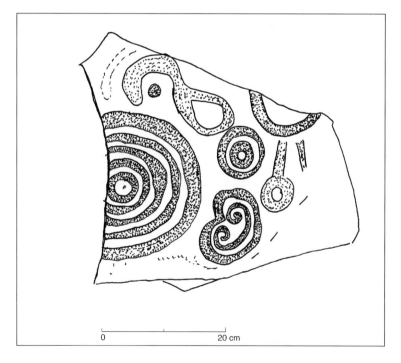

113 *Lilburn*

0 20 cm

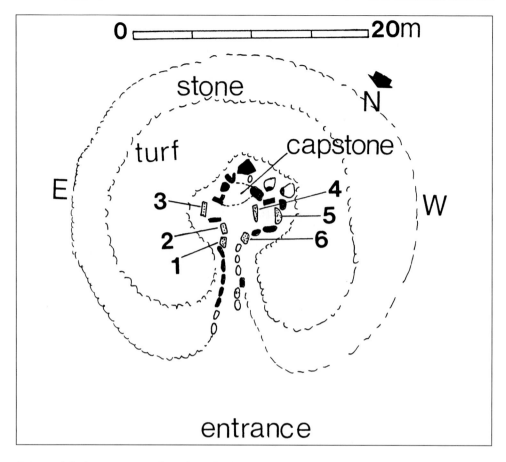

114 *Barclodiad y Gawres mound, Anglesey, sketch.*

The type of monument known as a Passage Grave is sometimes characterised by the use of decorated stone built into it. These are generally regarded as late Neolithic, but the recent discovery that some of the Clava cairns are early Bronze Age gives us pause for thought about their chronology unless it has been scientifically established.

Some areas of the north, where there is rock art, such as Northumberland and Durham, do not have Passage Graves. Where they do exist, only a few have rock art.

There are six decorated stones at Barclodiad y Gawres (SH 328 707) (Powell and Daniel 1956) on Anglesey. The reconstructed dome stands on a cliff above the sea, and its position and the decorations seem to link it with the Irish tradition.

The sketch shows the layout of the passage and chambers and the position of the marked rocks, four of which have spirals. Nos. 3 and 6 are illustrated here. 6 stands imposingly and disturbingly at the passage entrance, and although it has faint spirals at the top, its main motifs are serpentine grooves, chevrons and lozenges, which makes it look anthropomorphic. No.3 has spirals on a horizontal rock at the back of the east transept. Three spirals are well defined; others are fainter.

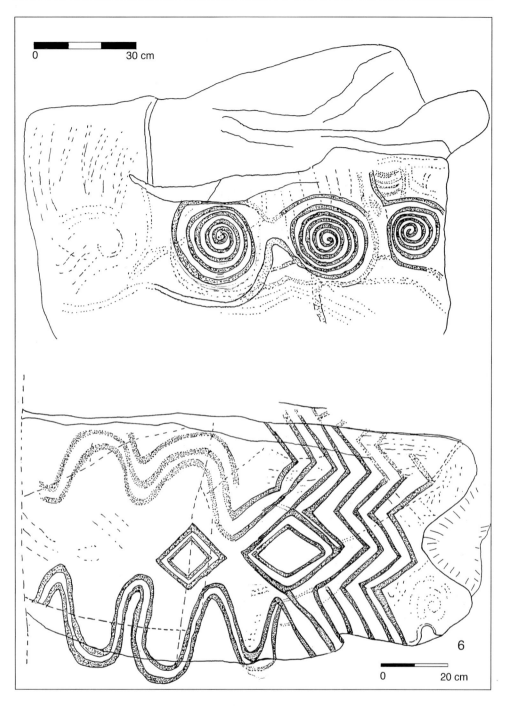

115 *Barclodiad: spirals on a horizontally placed rock.; serpentine grooves, lozenges and faint spirals on the upright stone No 6.*

Excavation has not explained how the structure was used, but it does not seem to be solely for the burial of the dead. If people were to enter through the passage, the positioning of the marked rocks must have conveyed something to them. The chamber would not have allowed many to enter at the same time to view its contents or to conduct ceremonies. It is very clear, though, that this kind of art was hidden from all except those specially allowed to view it and, unlike open-air rock art, it was dark and underground, perhaps accessible occasionally when the monument was open. The mound was prominent from a great distance by land and sea, and could have marked territory sanctified by the presence of ancestors.

The Clava Cairns in northern Scotland are similar in some ways to that at Barclodiad y Gawres, but the group known as Balnuaran of Clava shows striking differences of design and date. There is a passage leading into a chamber, but the mound that covered it is kerbed and surrounded by a platform that holds a gapped circle of standing stones in place. In Scotland, a long barrow at Dalladies produced a cupped slab in a timber mortuary structure beneath a long barrow. The use of the site was lengthy, and the radiocarbon date given for the placement of the marked rock was at the end of the fourth millennium BC, and there is a time gap of about 1000 years between this phase and the date of the Balnuaran. One hopes that all these radiocarbon dates are reasonably accurate.

At a Neolithic settlement and ritual complex at Beckton Farm, Lockerbie (NY 1305 8245), (Pollard, A, 1997), three small cup marked stones were found, one with a single cup, one with four domino-arranged cups, and another with two parallel ovals. The cups had been pecked into sandstone. The site produced Neolithic carbon dates from pits containing Grooved Ware and cremated bone. The excavator writes: 'Their incidence here — like the burnt human bone and the ritual deposit of Grooved Ware — can be cited as further evidence for episodes of funerary as well as settlement activity.'

In Cornwall, a megalithic tomb at Tregiffian (SW 430 244) has cup marks on its entrance. Now visible, the marks were hidden inside the Neolithic tomb until it was reconstructed during the Early Bronze Age.

A generally accepted range of dates for Irish Passage Graves is 3,700–3,000BC, many of them having been decorated more than once, as some superimposed motifs reveal. Passage Grave art is distinctive, but not without links with open-air rock art.

In Cumbria on the moors at Askham at Moor Divock (NY 4940 2196) there is a variety of ritual monuments, including a cairn circle. The structure incorporates spaced monoliths, one of which has a cup and ring facing into a central burial area. The cairn was excavated in the last century. It had a 0.6m deep pit at the centre, with ashes and sherds of a broken vessel. A Food Vessel lay above this in the sand, with a cup marked rock still in situ at the centre of the cairn.

In the same county, a double-circled cairn at Hardendale (NY 5965 1475) has an inner circle made of granite boulders and one of sandstone on which there are six smooth cups.

At Redhills (NY 5018 2777) a cist was excavated that had a capstone with cups, cups and rings, and interconnecting grooves and pick marks facing into the cist. The stone and the site have been destroyed.

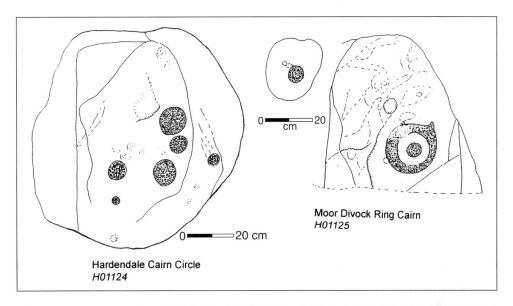

Moor Divock Ring Cairn
H01125

Hardendale Cairn Circle
H01124

116 *Moor Divock and Hardendale, Cumbria*
117 *Hardendale*

One of the most intriguing burial sites in Cumbria was at <u>Old Parks, Kirkoswald</u> (NY 569 398) where a huge mound was gradually removed for road building. There was a line of five earthfast slabs under a mound c.1.22m (4ft) high that spread out over a distance of 4.5m (14 ft 9in). Two had motifs on the east face, and one on the west, and were unusual 'shepherds' crooks' and some serpentine grooves. The crooks are similar to those in Breton tombs. The designs, to be seen in Tullie House Museum, Carlisle, seem incomplete, but the pick marks are clear, for they were not exposed and the mound over them prevented erosion. The motifs and the mound structure appear to be Neolithic, and it attracted burials much later in the form of 32 deposits of burnt bones in hollows in the ground, Beakers, 'Incense Cups' other urns and beads. If the spirals are very early, the mound could have been venerated for centuries, as the additions are c 2,000 BC. The problem of making any precise statement here is that the modern destruction of the mound has been most unscientific!

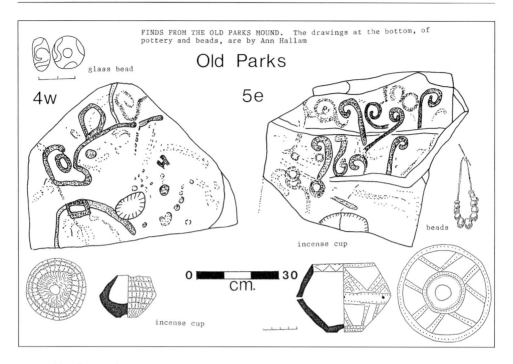

FINDS FROM THE OLD PARKS MOUND. The drawings at the bottom, of pottery and beads, are by Ann Hallam

Old Parks

glass bead

4w

5e

beads

incense cup

0 ▮▮▮▮▮▮▮▮▮ 30
cm.

incense cup

118 *Old Parks, Cumbria*

Few burials with marked rocks have been examined or excavated using modern archaeological methods, so when the opportunity happens, it is of great value. One of the best examples that provides a rare opportunity to date rock art is the excavation of the Fulforth Farm cist at Witton Gilbert, County Durham.

This was a chance discovery, when a large decorated slab of sandstone was dragged from a field in 1995. The site has an extensive view over a valley. The slab was first removed to a barn at Fulforth farm, and later became a focal point at the Northern Prehistoric Rock Art Exhibition at Durham Art Gallery during the summer of 1996, when work began on the excavation of the site, directed by Fiona Baker and supervised by James Wright. The operation included other professionals and local people. The author was fortunate to help with this.

There were two major discoveries. There was an oval pit packed with stones, containing cremations and flints. At the base, aligned on the axis, was a splendid plano-convex knife, generally associated with Food Vessels and urns in this area.

A few metres away, at the place where the slab had been dragged out was a complex pit divided into two, roughly east to west. The north half formed a rectilinear box, lined with stones that supported the cover; two of these had motifs.

These are illustrated. One is a flat slab with a pattern of cups, rings and parallel zigzags or serpentine grooves associated with Passage Grave art. All the pick marks are visible, including the tentative beginnings of another design, and there were no signs that it had been taken from outcrop. The other stone was a small sandstone boulder with fresh pick

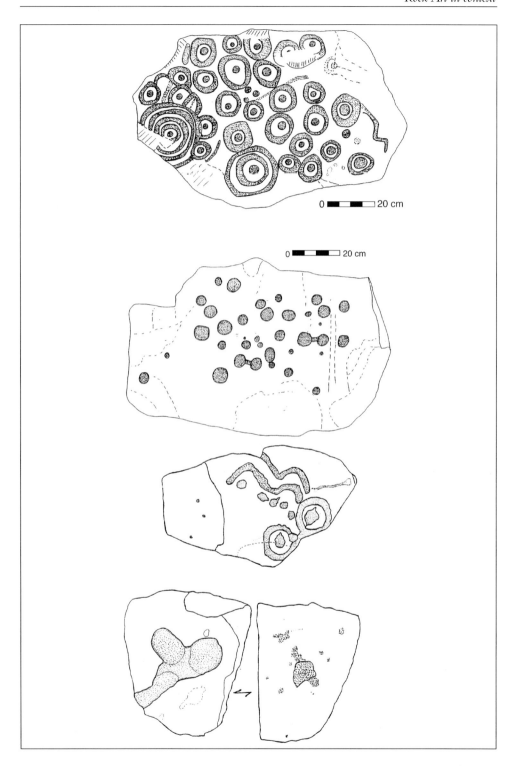

119 *Fulforth Farm: the decorated cist stones*

marks on two faces. Both stones had been tamped down into the pit, the flat one fractured as a result. The boulder had been pressed so hard into the gravel that it left an impression of its linked deep cups. Inside this 'box' two rough flint blades were deposited, and there was a piece of charcoal.

The south half of the pit was a rectangular mass of small sandstone cobbles, among which were cremations, and in the SW corner of this arrangement a polished stone axe had been set up on end, its edge facing upward. The capstone sealed the first deposits, and was thus later than everything underneath it.

Dating of the deposits is early Bronze Age/late Neolithic. The cist cover is not re-used outcrop. On the more decorated side the surface had been prepared by pecking all over what became the under-surface, by using cups, cups and rings, and a short zigzag. On the obverse, upper surface, simple cups, two joined by a groove, were made. This extensively decorated rock was placed face downwards over the cremation deposits, and has suffered no erosion since it was made. When it was dragged out in 1995, parts of it were broken off, but most fragments have been recovered and planned into the drawing.

There is now nothing to be seen at the site, which was thoroughly excavated well beyond the limits of the two pits. It has given more food for thought about other slabs found in County Durham which have no firm provenance. At the Bowes Museum is a slab that is decorated on two sides, illustrated here, known as the Gainford stone or cist cover. It was found during deep drainage excavations. It is more elaborately decorated than the Fulforth farm stone, but has a relatively simpler decoration on the obverse side. At the same museum is the Greta Bridge stone, found during the widening of the A66, 400m east of a Roman fort. It had been reused as a cover for a Roman burial. There is a scatter of cups, and it has central motif of linked grooves, with unusual chevron motifs near one edge.

It must be stressed that although the laying of a slab over a cist can mark the final episode at a site, the slab itself could have been marked earlier and reused. This is less likely when two sides of a slab are decorated, and when a design appears unbroken and pristine. We shall see a similar situation in the use of marked cobbles in round barrow structures. The Fulforth farm burials mark the latest use of purpose-made decoration on a cist cover, and give a date of about 4,000 years ago. This slab can be seen in the Fulling Mill Museum, Durham, along with other decorated stones found in the area.

The Cairnholy Cairn (NX 517 538) (Piggott, S and Powell, T 1949), built at the head of a valley away from the coast, and in an area of open moorland, is a Neolithic chambered tomb. The Galloway monument appears to have been reopened to admit not only early Bronze Age (?) pottery and cremated bone, but a panel of decorated stone that was propped against the wall of the chamber. A large decorated slab with concentric rings, now in a fragile state and still on the site, had been used to cover the inserted deposit. The local area has many decorated rock outcrops, but in Galloway as a whole the association with burials is non-existent away from this site. Why should there be such a concentration of open-air sites and no art incorporated in monuments?

We have seen examples of rock art in burial sites, and there are many decorated stones reputed to have come from cairns all over Britain. Some are quite clearly reused, as we see

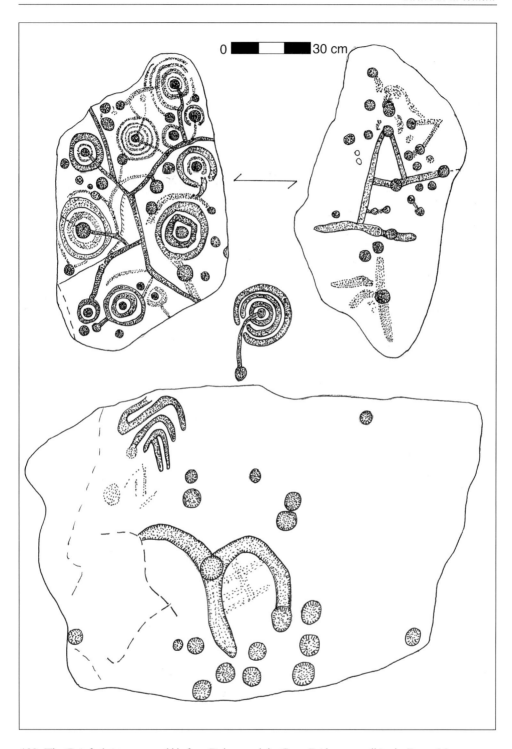

120 *The Gainford cist stone, a cobble from Dalton, and the Greta Bridge stone: all in the Bowes Museum*

at the oft-quoted example at <u>Balbirnie</u> (NO 285 030). Inside a stone circle that had later been converted into a cairn were several cists, one of which had been decorated on the inside of the side slab with cups and rings. Another cist had clusters of cups on a packing stone in a burial that included a Food Vessel. The cup and ring stone was not purpose made, but was broken off a patterned block. Its position was important, facing into a burial. The decoration was still recognised as being important, but there was a change from its use and meaning from open-air decoration to its burial with the dead. As with many of these reused blocks, cups and rings are far more widely represented than simple cup marks. Used in cists, they are not meant to be seen, and appear to have been put there for the dead. One must remember, however, that this use applies only to a small minority of all the round barrows. We have seen in Chambered Tombs/Passage Graves that decoration is an integral part of the structure, buried, but still accessible if the tomb is reopened. There was no likelihood of viewing taking place in a small round barrow, although burials continued to be inserted into such mounds.

The author and Paul Frodsham, Northumberland National Parks Archaeology Officer, analysed specific burials in Cumbria, Northumberland, Durham, Swaledale and Wensleydale to examine the evidence for an early Bronze Age date or for an earlier date (Beckensall and Frodsham, 1998). We concluded that there was no *absolute* proof of any date. Of course there were pointers to specific periods through association of artefacts and the nature of the structures.

Only a very small percentage of <u>excavated cists</u> have decoration. Canon Greenwell's excavations in Northumberland, for example, produced only two pieces of rock art in 32 barrows, and neither was characteristic of Northumberland rock art. An interesting comparison is with Ireland, where in County Donegal there are no marked cists, despite its having one of the greatest concentrations of rock art.

Some decorated stones cover cremations. At <u>Ford Westfield</u>, Northumberland, (NT 939 370) in 1850, 20 cremations were found in hollows during ploughing, each covered with a stone, and three were decorated, one with an elaborate cup and ring motif and the other two with cupmarks only. They are undated.

Much more general is the incorporation of decorated <u>cobbles</u> within burial mounds. Cobbles are small pieces of sandstone that lie on the surface, and many of them have been pick-marked in prehistoric times and either form part of the kerb of a cairn (usually as small boulders) or are built into the mound itself. We have seen, for example, that the <u>Hinderwell Beacon</u> had 150 in the mound. The prominent <u>How Tallon cairn</u> (NY 057 064) had at least 8 cup marked cobbles that were thrown out during excavation and built into a wall over the Early Bronze Age burial cairn. Nearby are two unexcavated cairns at <u>Frankinshaw Moor</u> and <u>Osmonds Gill</u> that have decorated stones embedded on the surface, and three other cairns on the same moor have simple cup marks visible. There are others recently identified in County Durham (Laurie, T, forthcoming)

We have seen that Northeast Yorkshire and Cleveland have a high proportion of rock art in barrows. It is, however, in Northumberland, in two cairns excavated by the author that the best examples of buried cobbles have come to light.

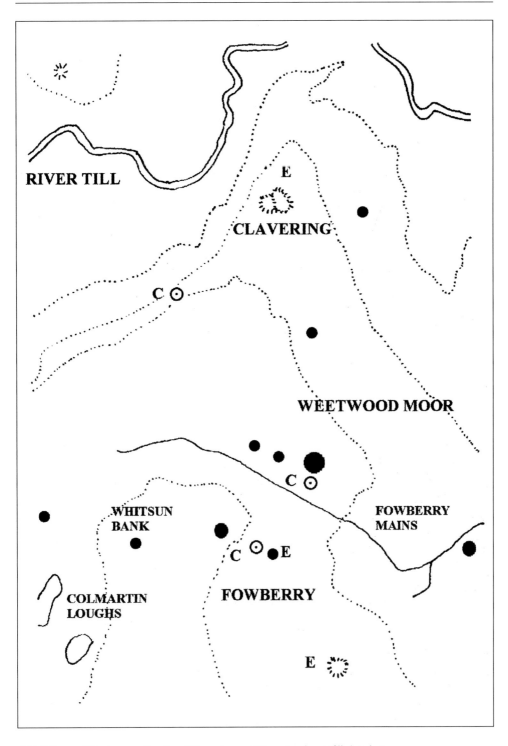

121 *Weetwood/Fowberry, with cairns (C), enclosures (E), and rock art (filled circles)*

Fowberry and Weetwood

Sites at Fowberry and Weetwood are located on a sandstone massif that is bounded on the east by the River Till, on the north by the Milfield Plain, on the west by the valley of the Wooler Water, and to the south by a continuation of the sandstone. Part has been forested, some is arable, and the rest is pasture and moorland. At Coldmartin there are two 'loughs' which act as waterholes; this vital area is overlooked by a decorated outcrop (NU 0103 2803). There are enclosures, probably of the Iron Age, including a fortified one at Clavering overlooking the place where the Till enters the Milfield Plain. Thin soils scarcely hide panels of rock art, many of which were recorded over a century ago. There have been reports of burial cairns and some inexpert digging of them in the past.

The motifs arranged on outcrops are interesting, but even more interesting is the way in which motifs appear both in the open air and in cairns. Two cairns have given a great deal of information out of all proportion to their size, despite both having been disturbed. Fowberry Cairn (NU 0197 2784) is a small doubled-kerbed round cairn that was built on outcrop rock covered with motifs, including cups, grooves, cups and rings and a rectangle, with some interesting variation on themes. There was very little soil between cairn and outcrop, just enough to contain a flint scraper, and had there been a burial it must have been a body covered with stone, without a cist. The site was disturbed by quarrying, like the rest of the area, and by tree growth, but most of the cairn was intact. It was built of two kerbs of cobbles, four of which were cupped. The outer kerb made use of erratic granite boulders that made a colour change. Between the kerbs was a packing of small stones, and the centre was filled with small cobbles. Twenty stones from the mound and its spread were marked, including a countersunk cup, and double penannulars with

122 *The excavation of Fowberry cairn*

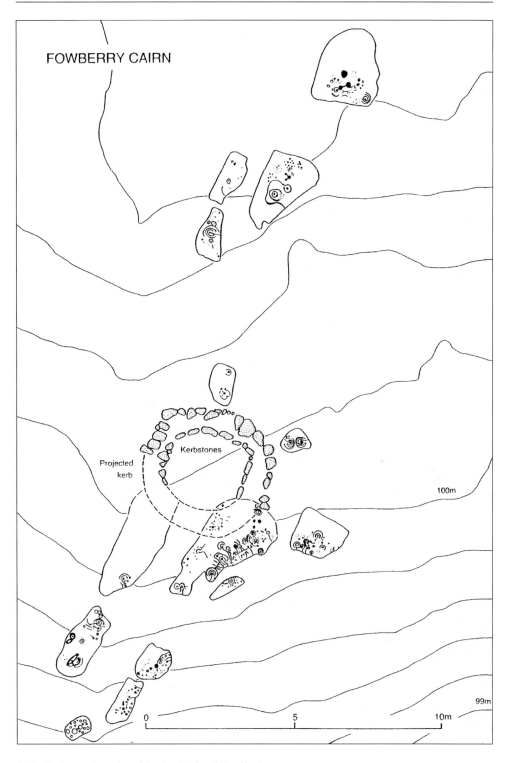

123 *Fowberry cairn: plan of the site* (Richard Bradley)

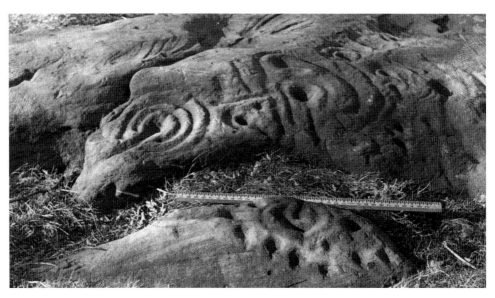

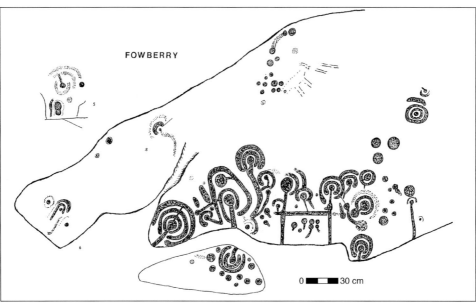

124 *Fowberry: the main decorated outcrop on which the cairn was built*

radiates ('complex' by any standards). They were all in fresh condition, with pick marks clear. The main quarrying activity fortunately did not disturb much of the mound, but to the north of it the outcrop had been dug out in steps until there was no more suitable rock. There may have been other cairns removed as the surface was prepared for quarrying.

The Weetwood cairn (NU 0215 2810) was discovered after the Fowberry cairn when the heather was removed and the land ploughed to make rough pasture. It was sheer

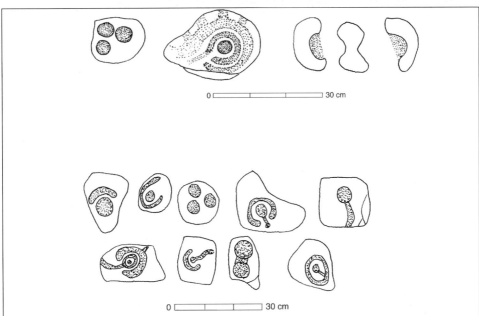

125 *Decorated cobbles from Weetwood mound (above) and a selection from Fowberry and Weetwood (below).*

chance that I happened by during this disturbance and persuaded the farmer to co-operate by allowing an excavation and by helping to search for any disturbed decorated cobbles. The mound had been three-quarters bulldozed.

The cairn lies just below a gently sloping high outcrop that has many decorated surfaces. It was an oval, kerbless mound with one large boulder in its circumference that is decorated with concentric rings and three radial grooves. This same motif also occurs

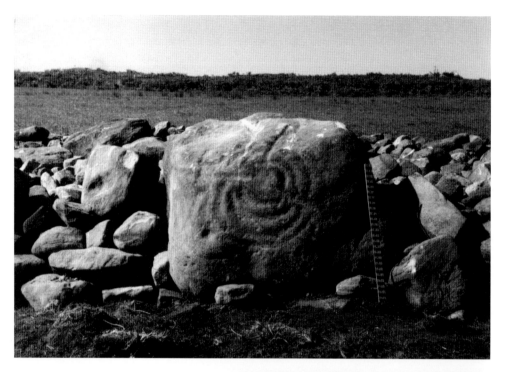

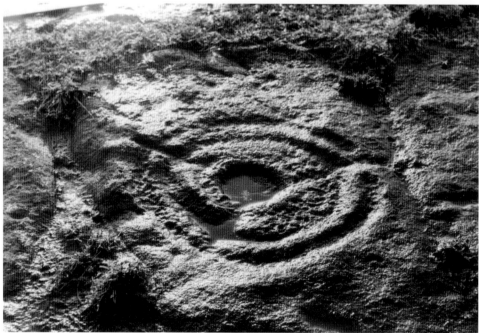

126 *Weetwood: the tri-radial motif on the cairn kerb is echoed on the outcrop at Whitsun bank*

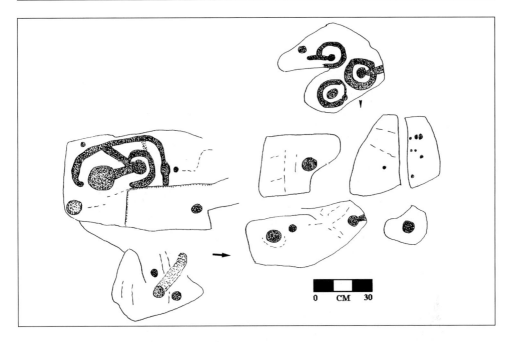

127 *Weetwood: decorated parts of a recently-recorded cairn built against outcrop rock.*

on outcrop on <u>Whitsun Bank Site 2</u> (NU 018 279). The boulder originally faced into the mound, so it was not meant to be seen, and its complex decoration was appropriate for its size and position. 37 decorated cobbles were recovered from the cairn, those *in situ* being facedown, mostly on the ground surface. There were signs of disturbance prior to bulldozing, which may reflect the interest in barrow digging in the last century in this area. The decorated cobbles, with those from Fowberry, are now in Berwick Museum, but the large boulder, with its decoration facing outward, remains with the reinstated cairn.

What do these two cairns and their outcrop rock art tell us? The decoration at the time of the mound-building had taken on a different meaning, for it was no longer meant to be seen. If these were burial cairns, the decorated cobbles may have been brought in during the building like wreaths at a funeral. It was an intimate matter between the living and the dead. The 'offerings' varied in complexity of design; all were as fresh as the day they were made. Many were unfinished, as if the act of making the marks, however tentative, was sufficient for the ritual purpose. These decorated stones had not just happened to be lying around, waiting for someone to use them as building material.

There are cairns with marked stones in them that do not lie in areas so heavily decorated as Weetwood and Fowberry. The whole area must have been of great ritual importance, and the open air rock art commands wide vistas. The Fowberry cairn is particularly well placed at a viewpoint, more than the Weetwood cairn.

A third cairn on Weetwood Moor, dug into at some unknown time, has decorated stone included in its construction. Ian Hewitt located it. It appears to have been built against a decorated outcrop with cups, rings and grooves. A piece broken off this outcrop is in the

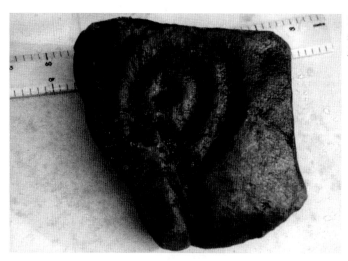

128 *Weetwood: a marked rock used as a coping stone on a wall. Now in Berwick Museum.*

cairn material, and there are two other cup marked rocks, one a cobble. To the west, just outside the cairn, is a small outcrop decorated with three cups with single rings. This all points to the cairn being later than the decoration on outcrop, and there is a good case for making the site a priority excavation to see if a sequence can be established.

As more decorated cobbles are discovered in modern field clearance, and built into walls, it is vital that any excavations should pay attention to every single stone. This was certainly the case at the Blawearie Cairns excavation from 1984-88, which Irene and Ian Hewitt and I directed (Hewitt and Beckensall, 1996). This 12m-diameter cairn, though in an area of rock art, did not produce a single decorated stone. We are constantly reminded that decoration in cairns occurs in only a tiny minority of cases, but we cannot be sure that excavators have been aware of decorated stones. This happened at the excavation of the How Tallon Cairn on Barningham Moor, where several decorated cobbles disturbed during the excavation were built into a wall over the cairn afterwards, without any record being made of them.

Each discovery of a marked cobble is significant, for there is always the chance that it may have come from a demolished cairn. A superb example came to light in May, 1999, when Jim Robson, a local shepherd, gave me a piece of stone that had been used as a coping stone on a wall beside the Weetwood Moor outcrops. The decoration, two penannulars around a deep cup and groove, is in pristine condition, and can now be seen in Berwick Museum. Much of the rock in the area has been quarried away, and this is an example of what happens to some of it.

In County Durham there are many cairns, some hopefully undisturbed, where marked rocks lie embedded on their surfaces. We have seen that this occurs too in Cumbria.

There is another phenomenon that northern England has revealed: a decorated surface that has been removed and the new face of the rock surface re-marked. Only a few metres away from the Fowberry cairn is an outcrop that forms part of the wall of an Iron Age enclosure. The surface of the decorated rock is eroded, but a slab of the rock was cut out in Prehistoric times and the new surface marked with a fresh cup and ring motif with a groove from the central cup running down the new surface. On Gayles Moor, (Rock 3 in

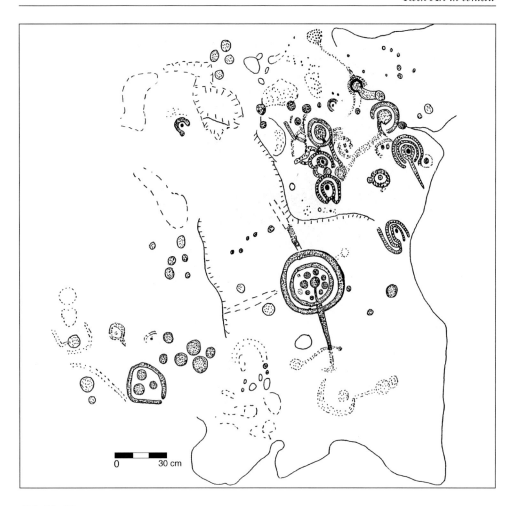

129 *The Ringses outcrop*

Folly Enclosure), a similar example occurs, and the famous <u>Dod Law</u> rock in Northumberland (NU0049 3173) may have been used in the same way, for the rectangular and heart shaped motifs are below the level of simpler, eroded cups. A similar occurrence is at <u>Lordenshaw</u> (NZ 052 991) on the large west rock, and at <u>West Horton</u> (NU 0214 3155).

Northumberland has instances of other cairns that are built on outcrop already decorated, like the Fowberry example. Two of these are at <u>Lordenshaw</u> (NZ 0502 9918 and 0557 9942). On the same site are two decorated cobbles in the intersection of two of the arms of a radial cairn (NZ 0525 9905), a type of cairn only recently recognised. Another cairn on complex decorated outcrop lies across the Coquet valley: <u>Football Cairn</u> (NU 0459 0303), where a dilapidated cairn with a massive cist at its centre is built on outcrop. Another is at <u>The Ringses 1a</u> (NU 0164 3287), where a shallow cairn overlies a richly-decorated rock where there is a rosette of cups enclosed by two

130 *Corby's Crags excavated rockshelter*

concentric rings, and many pick marked, apparently unfinished motifs. Finally, there is a dispersed cairn at the top of Dod Law at a very prominent place (NU 0077 3165) with a central decorated outcrop.

All the above sites are comparatively recent discoveries, within the past 30 years, and are not so well known as examples of rock art in a context other than the landscape that are used over and over again. Hopefully, this process of discovery will go on.

Rock shelters

Northumberland has another unique feature in the placing of decoration on and in rock overhangs.

Cuddy's Cave (NU 0036 3103) part of the Gled Law area of rock art, is a cave cut into the sandstone that projects above the Milfield Plain from the scarp. In the 19th century it was reported that there were prehistoric and 'medieval' markings in this cave associated with St.Cuthbert, but the rock art cannot be seen today. There are drawings of it.

 Cartington Cove (c. NU 044 091) was blown up by quarrying, and was reported to have had cups and rings.

On firmer ground, Corby's Crags (NU 1280 0965) (Beckensall, S. 1976) was excavated by me. The rock shelter overlooks Edlingham Castle and an Iron Age enclosure at one of the best viewpoints in the county. On the top surface is a large basin and surrounding groove with a duct. The dome of rock has been a boundary in recent centuries, with steps

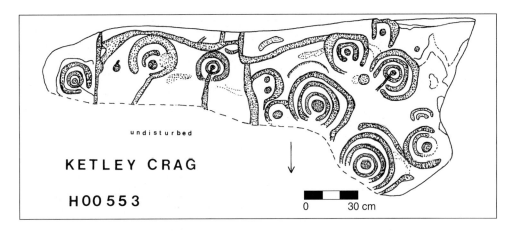

undisturbed

KETLEY CRAG

H00 553

0 30 cm

131 *The floor of Ketley Crag rockshelter*

carved out of it, but the secrets of the shelter below were revealed 20 years ago. The shelter had been used by Mesolithic hunters, a cremation in a Food Vessel covered with a triangular stone had been buried in the soil of the floor, with a pecked groove on the base rock directed at it. Bell pit workers or shepherds then cut an armchair with their metal tools and ledges to hold their bottles and food (we found their glass, pot, clay pipe and an old penknife). This continued use of a site is not unusual; in a nearby wood are prehistoric rock motifs on the same outcrop as three runes!

We cannot say that the rock art and the pot (2,000BC) belong together, but it is likely. Another recent discovery comes from another region rich in rock art, from Ketley Crag (NU 7043 2978) at Chatton, in a rock shelter that looks over a long wide valley. Badgers scraped the floor to reveal a long, connected flow of motifs that run the length of the shelter. The soil is shallow, and not likely to reveal artefacts. It is a most impressive panel. The rock shelters at Goatscrag Hill have already been discussed. The deer motifs cannot be ascribed definitely to the prehistoric period, the joined cups on the top of the overhang cannot be linked definitely to the Early Bronze Age burials under the overhang, but they could all be the same period. The site was chosen by many for many reasons.

House sites

In considering the change from a 'ritual landscape' formed in earlier prehistory to an agri-cultural landscape Bradley says that 'even the most practical activities, such as building a house or enclosing a settlement, drew on a symbolic code of considerable antiquity.' (Bradley, 1998). He points out that examples of cup marked stones come from settlement sites, like the one found at the centre of a round house at Trethellan Farm, Newquay, Cornwall (Nowakowski 1991) in a pit near the central hearth. This house was of Middle Bronze Age date, and two other cupped rocks were deposited in a complex feature of 'ritual hollows', hearth bases and deposits of pottery, animal bones and organic material found outside the domestic buildings. Perhaps the tradition of using such potent symbols had run its course from the open air to burials to a domestic setting.

7 The Future

English Heritage has at last launched a project that is designed to document and assess existing records on rock art in England. The Royal Commission on the Ancient and Historical Monuments of Scotland produced in 1988 an inventory of the monuments of Argyll that includes in Volume 6 a splendid example of how rock art in a region can be recorded in a context of other Prehistoric sites and monuments. Fortunately, Historic Scotland is also involved in the English project, and representation may widen even further.

A programme of analysis of current records, record enhancement, survey and field recording is essential. Though Ronald Morris's survey of 1989 was of great value to this recording, it was not able to include rocks with cup marks only, and even in the short time since that list was compiled, there are hundreds more to add.

With the recognition that rock art is a valuable national asset, it has posed questions about how it is to be preserved and displayed. Being an Ancient Monument is no guarantee that panels of rock art will be protected from animals wandering all over them, for example, which is what happens in some places. There are records of many panels having been blown up, and quarrying has taken its toll.

Scientific studies are to establish what the threats are, including the effects of acid rain or the effect of lichen and mosses growing on the rocks. Those panels that are considered most at risk will have to be protected at once, including their being covered over.

Because rock art has been a public phenomenon in the landscape, there should be panels of rock art open to the public, and displayed tastefully and intelligently.

The project has to include many different groups locally and nationally that will cooperate. In modern parlance, the resource has to be well managed.

British rock art must not be seen in isolation, and it is important to learn from other countries that have faced problems of conservation, recording and display. We have a great number of rock art panels to share with others, and hopefully the new project will be so expertly carried out that we may have much to offer them. Perhaps the universal nature of rock art will bring us closer to an understanding of how it originated and how it is used. Britain and Ireland are well placed to help in the pursuit of this objective.

Meanwhile, the Pilot Project, launched later than expected, is in the hands of Bournemouth University and University College, London. By the end of 1999 a strategy should be in place that will direct thought and resources to a future for British rock art. Hopefully it will enable more people to share the delight of these images from our past and the places where they are situated.

Acknowledgements

In addition to those already mentioned in the text, I wish to thank Stephen Hope of Corbridge for the considerable help and expertise that he has brought to the production of this book on my computer.

There are many other people: shepherds, farmers, landowners, professional archaeologists and independent archaeologists, for example, who have helped considerably to bring the information and ideas in this book to light. Among them, the late Ronald Morris deserves special thanks.

I am grateful to Ian Hewitt, Edward Vickerman, Paul Brown, Graeme Chappell and David Lyons (Kilmartin House Trust) for allowing me to use their photographs and to Richard Bradley for his maps. The cover photograph of the author is by Matthew Hutchinson.

I am sorry that it was impossible to cover every site of interest. I have concentrated on those of which I have most direct experience.

At the proof-reading stage of this book, I have discovered that there is an extensive marked outcrop at Patterdale, Cumbria, thanks to the vigilance of people who look beyond the plants in their gardens and animals in their fields. I am recording it.

In another Lake District valley a major panel of Rock Art has just been found by Paul and Barbara Brown. This being recorded, and will be published as soon as possible.

Bibliography

This Bibliography is selective. Many of the books listed contain extensive references for those who wish to read more. Some of them are now out of print, and may only be available from a library.

General surveys

Beckensall, S. 1983. *Northumberland's Prehistoric Rock Carvings.* Rothbury
Beckensall, S. 1986. *Rock Carvings of Northern Britain.* Shire. Princes Risborough
Beckensall, S. 1991. *Prehistoric Rock Motifs of Northumberland.* Vol.1. Hexham (Privately printed)
Beckensall, S. 1992. *Prehistoric Rock Motifs of Northumberland.* Vol.2. Hexham (Privately printed)
Beckensall, S. 1992. *Cumbrian Prehistoric Rock Art.* Hexham (Privately printed)
Beckensall, S. and Laurie, T. 1998. *Prehistoric Rock Art of County Durham, Swaledale and Wensleydale.* County Durham Books.
Beckensall, S. 2001a. *Northumberland: The Power of Place.* Tempus
Beckensall, S. 2001b. *Prehistoric Rock Art in Northumberland.* Tempus
Beckensall, S. 2002. *Prehistoric Rock Art in Cumbria.* Tempus
Bradley, R. 1993. *Altering the Earth.* Edinburgh.
Bradley, R. 1997. *Rock Art and the Prehistory of Atlantic Europe.* Routledge.
Bradley, R. 1998. *The Significance of Monuments.* Routledge.
Burl, A. 1999. *The Stone Circles of the British Isles.* Yale.
Hadingham, E. 1974. *Ancient Carvings in Britain: A Mystery.* London.
Ilkley Archaeological Group 1986. *The Carved Rocks on Rombalds Moor.* Wakefield
Morris, RWB. 1977. *The Prehistoric Rock Art of Argyll.* Poole.
Morris, RWB. 1981. *The Prehistoric Rock Art of Galloway and the Isle of Man.* Poole.
Morris, RWB. 1979. *The Prehistoric Rock Art of Southern Scotland.* BAR 86, Oxford.
RCHMS 1988. *Argyll,* Vol. 6. Edinburgh: HMSO
Shee Twohig, E. 1981. *The Megalithic Art of Western Europe.* Oxford.
Van Hoek, MAM. 1995. *Morris' Prehistoric Rock Art of Galloway.* Oisterwijk, (Privately printed)

General articles

References to Prehistoric Rock Art are often scattered, but there are some journals that have recorded new finds and published valuable contributions to Prehistory generally. These include:

The Antiquaries Journal. London
Archaeologia Aeliana. Newcastle upon Tyne
British Archaeology. Council for British Archaeology

Cambridge Archaeological Journal
Current Archaeology. London.
Durham Archaeological Journal
Glasgow Archaeological Journal
Northern Archaeology. Northumberland Archaeological group. Newcastle upon Tyne.
Oxford Journal of Archaeology
Proceedings of the Society of Antiquaries of Scotland. Edinburgh.
Proceedings of the Prehistoric Society.
Transactions of the Cumberland and Westmorland Antiquarian and Archaeological Society.
Yorkshire Archaeological Journal

Some important articles on prehistoric rock art directly relevant to this text

Some articles have been integrated by their authors into larger publications, and are not listed here.

ApSimon, A. 1973. 'Tregiffian Barrow' *AJ* 130,241-3

Ashbee,P. 1958. 'The excavation of Tregulland Burrow, Treneglos parish, Cornwall' *AJ* 38, 174-96

Barnatt ,J. and Reeder,P. 1982. 'Prehistoric rock art in the Peak District' *Derbyshire Arch. Journal* 102,33-44

Beckensall,S. 1976. 'The excavation of a rock shelter at Corby's Crags, Edlingham' *Arch.Aeliana* (5), 4, 11-16.

Beckensall, S. and Frodsham, P. 1998. 'Questions of Chronology: the case for Bronze Age Rock Art in Northern England' *Northern Archaeology* 15/16.

Beckensall, S. 1995. 'Recent Discovery and Recording of Prehistoric Rock Motifs in the North' *Northern Archaeology* 12.

Bradley, R. 1996. 'Learning from Places – Topographical Analysis of Northern British Rock Art' *Northern Archaeology* 13/14. Newcastle.

Burgess, C. 1990. 'The chronology of cup and ring marks in Britain and Ireland' *Northern Archaeology* Newcastle.

Edwards, G. and Bradley, R. in press. 'Rock carvings and Neolithic artefacts on Ilkley Moor, West Yorkshire.' in Cleal, R. and MacSween (Eds), *Grooved Ware in Context.* Oxford. Oxbow.

Frodsham, P 1996. 'Spirals in Time: Morwick Mill and the Spiral Motif in the British Neolithic.' *Northern Archaeology.* 13/14. Newcastle.

Harding,A. 1981. 'Excavations in the prehistoric ritual complex near Milfield, Northumberland.' *PPS.*47, 87-135.

Hewitt, I. 1991. 'Prehistoric rock motifs in Great Britain.' Unpublished research thesis, Bournemouth University.

Mackie, E. and Davis, A. 1989. 'New light on Neolithic rock carvings: the petroglyphs at Greenland (Auchentorlie) Dumbartonshire. *Glasgow Archaeological Journal,* 15.

Morris, RWB. 1989. 'The Prehistoric Rock Art of Great Britain: a survey of all sites bearing motifs more complex than simple cup marks.' *PPS.*Vol.55.

Nowakowski, J. 1991. 'Trethellan Farm, Newquay: the excavation of a lowland Bronze Age settlement and Iron Age cemetery.' *Cornish Archaeology* 30, (5-242)

Piggott, S. 1972. 'Excavation of the Dalladies long barrow, Fettercairn, Kincardineshire.' *PSAS*. 83, 23-47.

Piggott, S. and Powell,T. 1949. 'The excavation of three chambered tombs in Galloway.' *PSAS*. 83,103-61.

Pollard, A 1997. 'Excavation of a Neolithic settlement and ritual complex at Beckton Farm, Lockerbie.' *PSAS* 127 (69-121).

Powell,T. and Daniel, G. 1956. 'Barclodiad y Gawres.' *Liverpool UP*.

Ritchie, J.N.G, 1974. 'Excavation of the stone circle and cairn at Balbirnie, Fife.' *AJ* 131, 1-32.

Sharples,N. 1984. 'Excavations at Pierowall quarry, Westray, Orkney.' *PSAS*. 114, 75-125.

Sherriff, J. 1995. 'Prehistoric rock-carvings in Angus.' *Tayside and Fife Archaeological Journal* 1,11-22.

Simpson, D. and Thawley, J. 1972. 'Single Grave Art in Britain.' *Scottish Archaeological Forum*, 4.

Spratt, D.A. 1982. 'Prehistoric and Roman Archaeology of North-East Yorkshire' (BAR 104)

Stewart M. 1958. 'Strath Tay in the second millennium BC.' *PSAS* 92, 71-84.

Trudgian 1976. 'Observations and excavation at Titchbarrow, Davidstow.' *Cornish Archaeology*. 15, 31-47.

Vyner, B. 1988. 'The Street House Wossit: the excavation of a late Neolithic and Early Bronze Age ritual monument at Street House, Loftus, Cleveland.' *AJ*. 145,173-202.

Waddington, C. 1996. 'Putting Rock Art to Use. A model of Early Neolithic Transhumance in North Northumberland.' *Northern Archaeology*. 13/14. Newcastle.

Waddington,C. 1998. 'Cup and Ring Marks in Context.' *CAJ* 8,No.1,29-54
(Dr. Clive Waddington received his PhD in 1999 for his analysis of Prehistoric Rock Art, and the publication of his thesis will add considerably to the debate, especially on the chronology).

Warne,C 1886. *Celtic Tumuli, Dorset. 'My Own Personal Researches.'*

Index

Numbers in **bold** refer to illustrations.